Takaya

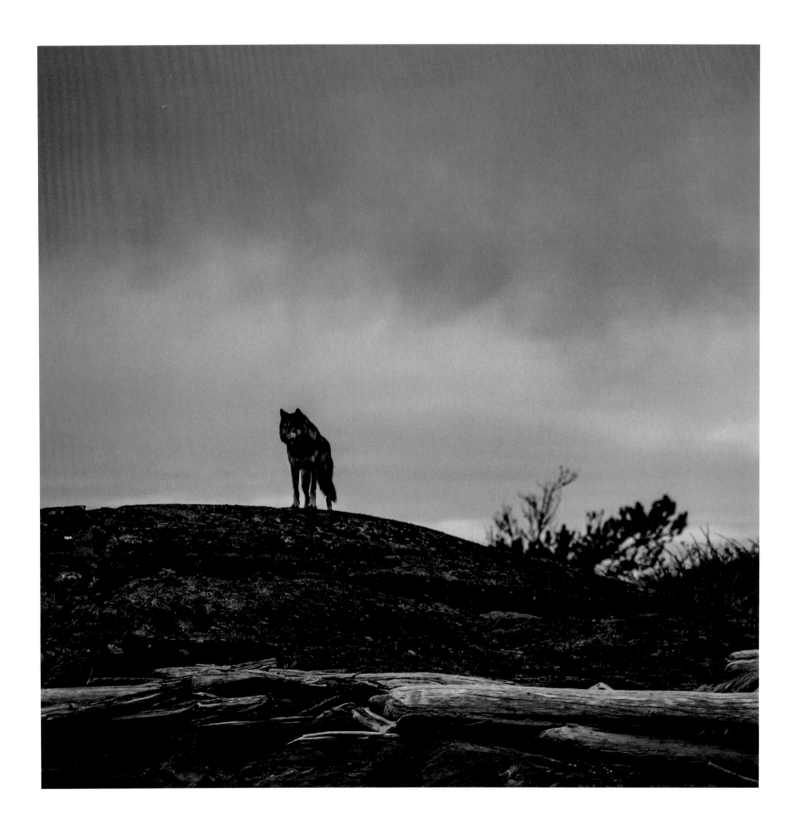

TAKAYA

LONE WOLF

Cheryl Alexander

RMB

For information on purchasing bulk quantities of this book, or to obtain media excerpts or invite
the author to speak at an event, please visit rmbooks.com and select the "Contact" tab.

RMB | Rocky Mountain Books Ltd.
rmbooks.com
@rmbooks
facebook.com/rmbooks

Cataloguing data available from Library and Archives Canada
ISBN 9781771603737 (paperback)
ISBN 9781771603744 (electronic)

Edited by Alex Van Tol
All photographs are by Cheryl Alexander unless otherwise noted.
Frontispiece: Takaya walking on shore at daybreak
Maps © opensteetmap.org

Printed and bound in Canada

We would like to also take this opportunity to acknowledge the traditional territories upon which we live and work. In
Calgary, Alberta, we acknowledge the Niitsítapi (Blackfoot) and the people of the Treaty 7 region in Southern Alberta,
which includes the Siksika, the Piikuni, the Kainai, the Tsuut'ina and the Stoney Nakoda First Nations, including
Chiniki, Bearpaw, and Wesley First Nations. The City of Calgary is also home to Métis Nation of Alberta, Region III.
In Victoria, British Columbia, we acknowledge the traditional territories of the Lkwungen (Esquimalt, and Songhees),
Malahat, Pacheedaht, Scia'new, T'Sou-ke and W̱SÁNEĆ (Pauquachin, Tsartlip, Tsawout, Tseycum) peoples.

We acknowledge the financial support of the Government of Canada through the Canada
Book Fund and the Canada Council for the Arts, and of the province of British Columbia
through the British Columbia Arts Council and the Book Publishing Tax Credit.

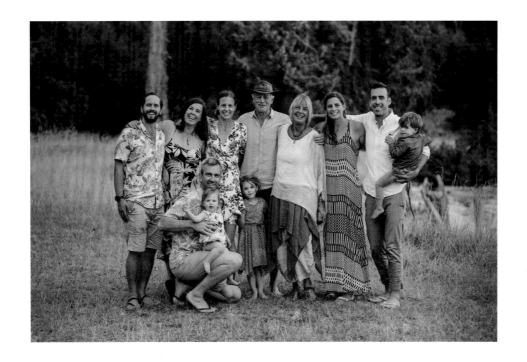

Dedication

For the two alpha males in my life, Dave and Takaya.

For my family – my pack.

And for all those who will fight to ensure the wilds of our shared Earth survive.

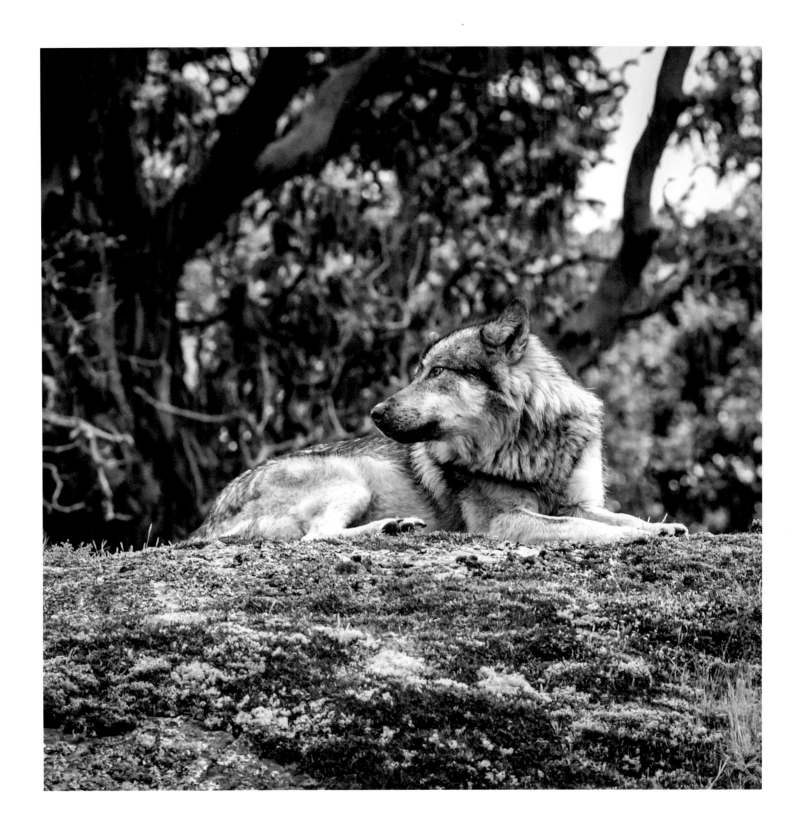

Contents

OPPOSITE Takaya, alone in the islands

List of Maps

Foreword

BY CARL SAFINA

Wolf.
The word alone conjures emotions.
Through emotions, we project judgments.
Good. Bad.
Through it all, a wolf remains a wolf. Neither more nor less.
Is it possible to really see – a wolf?
Is it possible to see a real wolf?
Almost no one has.
Think about that. Quite possibly the world's most famous species.
Perhaps the world's most hated.
Imagine being loved and hated. By people who have never seen you.

Cheryl Alexander has really seen a real wolf. She got to know him. To look straight into his eyes as he was looking so powerfully into hers. And because Cheryl had no fear, she really *saw* a wolf. Not just *a* wolf. *This* wolf. Takaya.

Takaya's life was very odd for a wolf. Wolves are very social. They usually live in families, just as we humans usually do.

Takaya came, alone, to a small island without typical wolf food or reliable fresh water. Yet this unusual, mysterious, different wolf found his way to survive, for years.

Cheryl got to know Takaya better than anyone. They had trust in each other. Often, he'd approach her. There was, for them, no fear. And thanks to Cheryl, Takaya's life has become a gift to us.

It would be nice if we decide to return Takaya's favour.

Some people detest wolves with a hatred so deep it feels racial. Such people have never seen a wolf. They are expressing fear.

When Takaya approached some hikers who'd brought a dog to a place where dogs had been banned, he might, in his loneliness, have been merely curious. He might have been seeking the company of someone more like himself. After all, the ancestors of all dogs are wolves. Dogs know how to live with us because wolves live in families. That's why dogs instinctively know how to fit into a family. Chimpanzees are more closely related to us. But they don't understand family living. That's why we have modern-day wolves – our dogs – in our homes, rather than our closer relatives, chimpanzees. Humans and dogs have been hunting partners and have protected each other for many thousands of years. Dogs are wolves who evolved to be with humans. And there is good reason to believe that dogs affected human evolution too. In no other animal does the mere movement of a body part affect our emotions like a dog's wagging tail. We react instinctively to that tail just as we react instinctively to a human smile. Dogs accompanied and even escorted humans to the farthest ends of the earth. Humans and dogs have come to an understanding. But modern, civilized humans stubbornly cling to a medieval European fear of wolves.

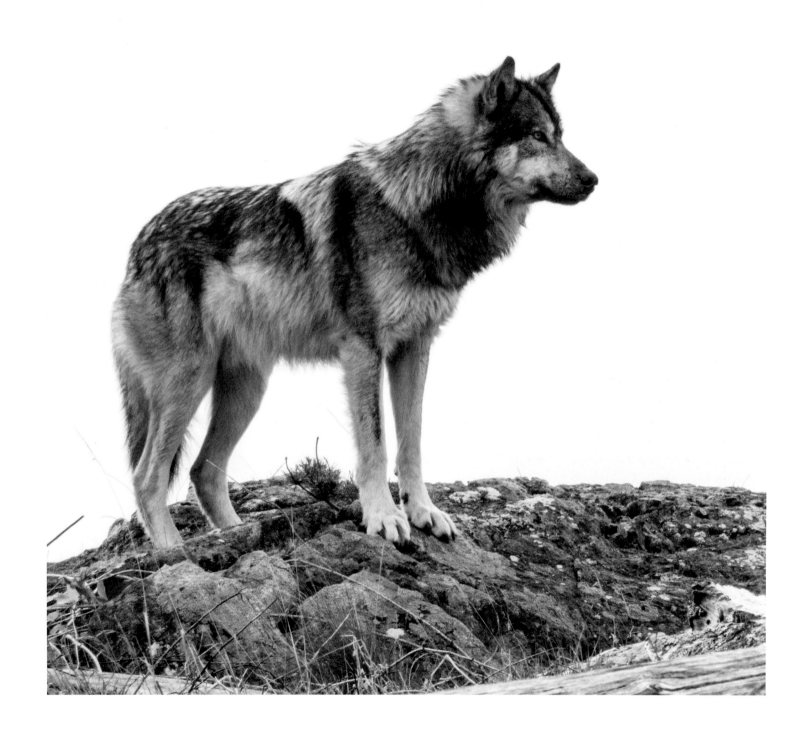

And so, even though the hikers themselves said Takaya showed no aggression, they reacted in fear. They radioed for rescue. And the press presented to viewers and readers a potentially dangerous, snarling wolf. But that wolf was not Takaya. It was a wolf that people had only imagined. It was the wolf of an anxiety dream, not a dream of a better world, of a humanity more accommodating and more in tune with the reality of wolves and wild places and life on Earth. Takaya merely trotted back into the trees. What took over the conversations that followed was fear, talking.

Native, tribal peoples know no such fear.

For a long time, the power in other creatures instilled in humans deep respect and a working détente. For a long time of truce and magic, during thousands of years, humans asked the stronger, craftier creatures such as wolves, orcas, bears, lions, elephants and tigers to merely hold their peace, and nothing else, against us. As human technology increased, respect eroded. Our weapons became stronger. The creatures' strength and intelligence no longer compelled our respect. We kill wolves and whales and elephants and others not because they are inferior but because we can. Because we can, we tell ourselves they are inferior.

Yet – and isn't this so odd – as our killing power increased, so did our fears. Now, most people who will never see a wolf, fear wolves. Fear comes most from not knowing.

Indigenous peoples have had a more sensible, more spiritual, closer-to-truth view of wolves and other hunters. Native American groups have worked against wolf killing and bear hunting. The Western view often reflects goals of domination or extermination. The Indigenous view of other animals is often compatible with a long-term accommodation. It's not that the native view is more scientific, but in sensing deep relation, their belief web is a truth-catcher. Native peoples have *seen* wolves for who they are.

In the 1940s, American conservationist Aldo Leopold wrote hauntingly of how his fear and hatred of wolves turned to respect only when he saw the fire dimming in the eyes of a wolf he had shot. In that moment, he gained wisdom from the dying wolf. He concluded, "Only the mountain has lived long enough to listen objectively to the howl of a wolf."

Let us seek wisdom the way Cheryl Alexander has gained it. From seeing the real wolf – *alive*.

OPPOSITE Takaya in the islands

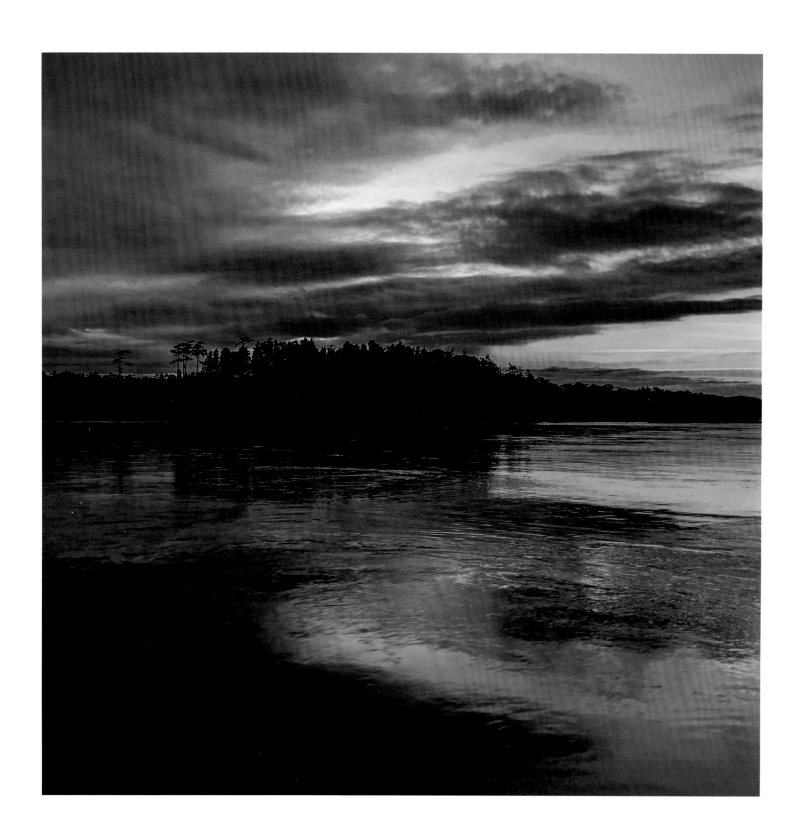

WILD

He was unheeded, happy and near to the wild heart of life.
He was alone and young and willful and wild hearted, alone
amidst a waste of wild air and brackish waters and the sea
harvest of shells and tangle and veiled grey sunlight.

JON KRAKAUER

He arrived on the island shore alone. Possibly at dawn. Likely exhausted. Probably exhilarated. Perhaps fearful. Certainly on a mission.

He was searching for three things — the three things that he needed to survive and thrive in life: A reliable source of food. An exclusive and safe territory that he could call his own. A mate.

Was this where he would find those things? Should he stay?

Now, almost nine years on, he remains on these island shores. It was predicted that he wouldn't survive here, with limited food resources and no year-round source of water. Yet he has survived and is thriving. He has found two of the three things he was searching for: food and a safe territory. The third remains elusive.

Over the years since he arrived, I have come to know him and to learn much about his chosen, and most unique, life. Many questions have been answered, however mysteries still abound.

This is his story. And mine.

He was a young wild wolf.

As many wolves do, he probably left his natal pack when he was between 2 and 3 years old, looking for a territory and a family of his own. Or maybe he was just looking for adventure — a real pioneering wolf.

No matter the reasons he left his early home, in May 2012, as he got out of the sea, shook himself off and climbed up onto the shores of the isles that were to become his territory, he likely had little idea of what his journey would mean.

This young wolf had arrived in a small archipelago just off the coast of Victoria, British Columbia, Canada, with no deer to hunt, no other wolves, and very near to a city of over half a million people. He had left what we consider normal

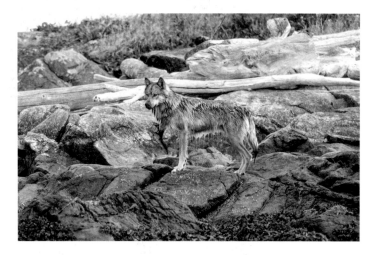

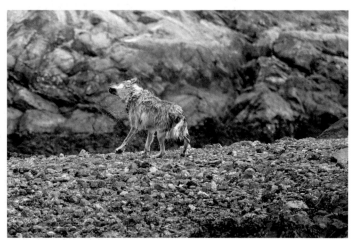

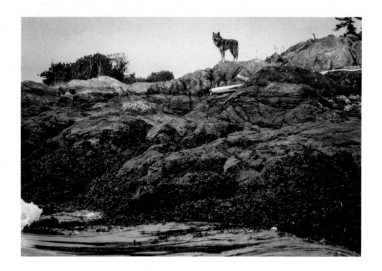

wolf wilderness habitat, and had instead crossed over 40 kilometres of urban areas and city suburbs in search of his new home.

He's now almost ten years old and I've come to know him well. I have gained this wolf's trust and documented his life, shooting thousands of still images and hundreds of hours of video footage.

It is almost impossible to document the life of a lone wolf in the wild. They travel vast distances and are rarely spotted. Mostly on the move, lone wolves are difficult to follow unless radio-collared, and so their lives are largely unseen. This wolf's unique situation allowed me to gain his trust, and to observe and document his life.

I became intent on understanding his life and wanted to solve his many mysteries, such as: Why did he cross ocean and city to get here? How did he adapt and thrive in such an unusual habitat for a wolf? Why does he stay here, choosing a life of solitude? And what will his future be?

After a while I grew tired of just calling him *the wolf*. I chose to call him a name which means wolf in the language of the Coast Salish Indigenous people who historically inhabited this area.

His name is Takaya.

TOP Takaya dripping wet after a swim

MIDDLE Takaya shaking off the sea

BOTTOM Takaya surveys his islands after arriving on the shore

OPPOSITE Takaya watches me from one of the island bluffs ... curious, calm and majestic

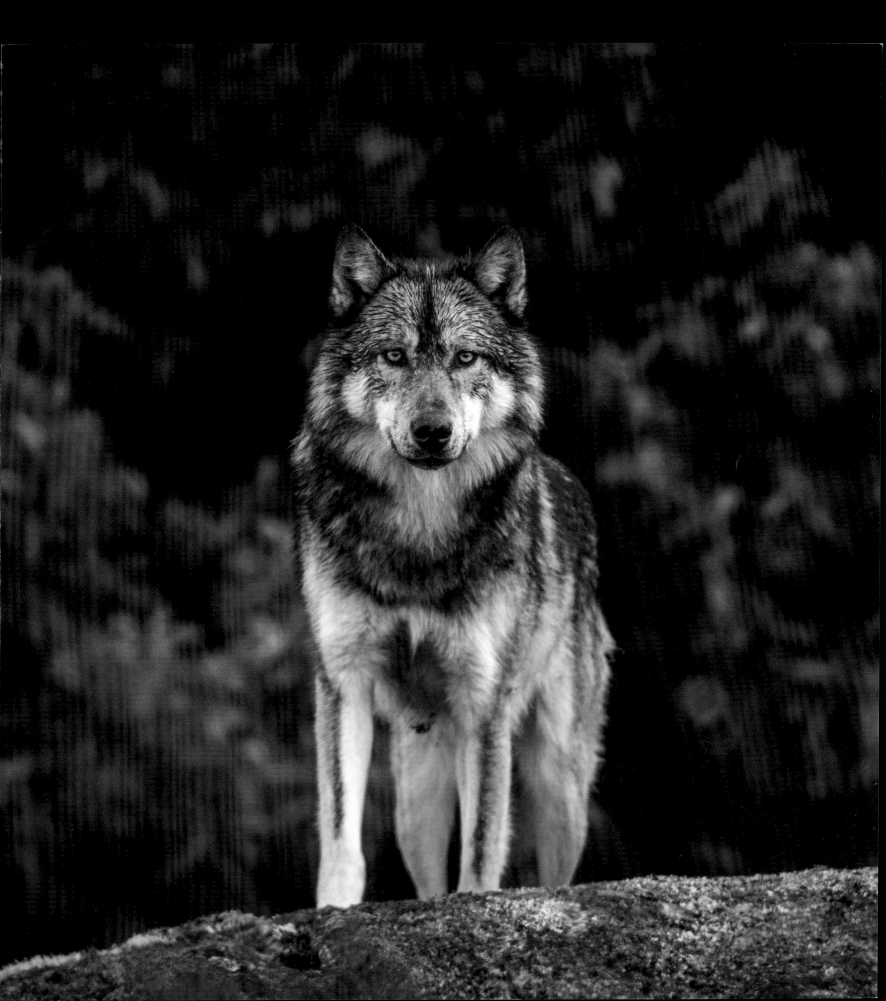

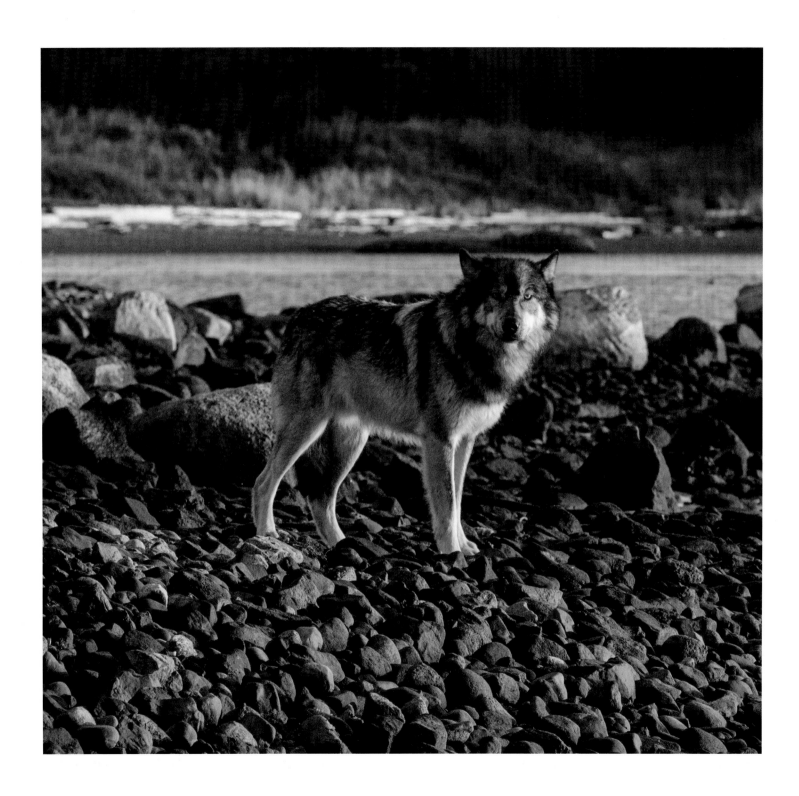

PATHS

Anything is one of a million paths ... for me there is only the traveling on paths that have heart, on any path that may have heart, and the only worthwhile challenge is to traverse its full length ... and there I travel looking, looking breathlessly.

CARLOS CASTANEDA

To find and follow a path with heart has been a guiding principle throughout my life. Yet how did choosing a path with heart lead me to falling in love with a wild wolf?

Beginning in childhood, I spent a lot of time in nature, camping with my family and exploring the magical woods near my early home in North Vancouver. My first intense wilderness experiences occurred when I took a job as an Outward Bound instructor in a high-risk wilderness correctional program for young offenders during the mid-1970s.

Then, in 1978, as a university lecturer in Environmental Studies, I developed a fascination with nature and the complex webs we live in. I worked for many years as an environmental educator and consultant, focused on designing decision-making processes that were inclusive of all stakeholders. After retiring from this work, I decided to pursue what had always been passions of mine: photography and nature.

It had become obvious to me that Earth's wilderness areas were disappearing quickly, so I decided to dedicate myself to creating visual images that would educate and inspire action to protect and save what remains of her wilderness.

I am now a conservation photographer, filmmaker and amateur naturalist. Through my visual work I aim to inspire others to love and conserve the natural world, and to encourage a sustainable human relationship with the Earth that nurtures and sustains us. It is really important to me that people understand the value of wilderness and the wild creatures who depend on it.

I have spent a lot of time in wilderness and have come to understand that it is in these wild spaces that we are most able to understand our deep connection with, and reliance on, the Earth. I believe that many of us have a deep longing to be more closely connected to nature — to experience the natural world and the many mysteries and miracles that it contains.

I now live in Victoria, British Columbia, Canada, on the

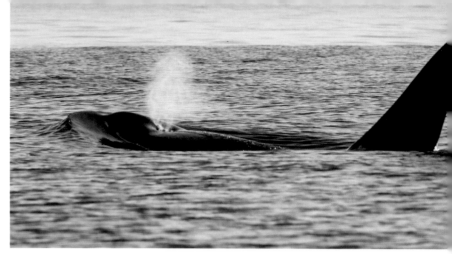

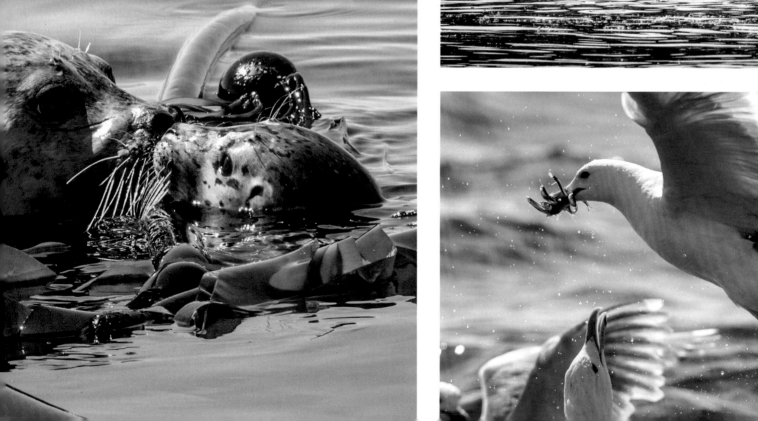

edge of the Salish Sea, surrounded by my immediate and extended family. My husband, Dave Green, a scientist and inventive entrepreneur, shares my life. He is my rock. Our three daughters, Maia, Lara and Alexa, are all grown, with wonderful partners and families of their own. To date, three grandchildren — Dana, Elliott and Lila — share my heart and time in nature. We live a communally rich life, and all of us are passionate about the natural world.

Just off the coast, about two kilometres from our backyard, sits a small archipelago of uninhabited islands. They are situated at the southern entrance to the Salish Sea. Here, the rich waters of the Pacific Ocean flow into the Strait of Juan de Fuca and then northward through Haro Strait, filling up

OPPOSITE A sampling of my wildlife photography in the islands

ABOVE My family enjoying an evening on Discovery Island

the Salish Sea and waterways between Vancouver Island and mainland British Columbia. The surrounding waterways are heavily used by freighters, tankers and other boat traffic moving into and out of the busy harbours of Seattle and Vancouver.

The island archipelago is an oasis in a sea of human commerce. Because they are all nearly connected at low tide levels, the Songhees Nation called these islands *Tl'ches*, meaning *one island*. The islands are mostly ecological reserve, park and Indigenous lands — a small gem of wilderness close to our large urban area.

For me, these islands are a spiritual place, and often have provided me with refuge from the demands and crises of daily life.

I've been visiting these islands for over 40 years. They are stunningly beautiful, richly diverse ecologically and rarely

North America

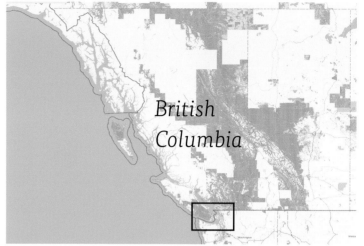

British Columbia

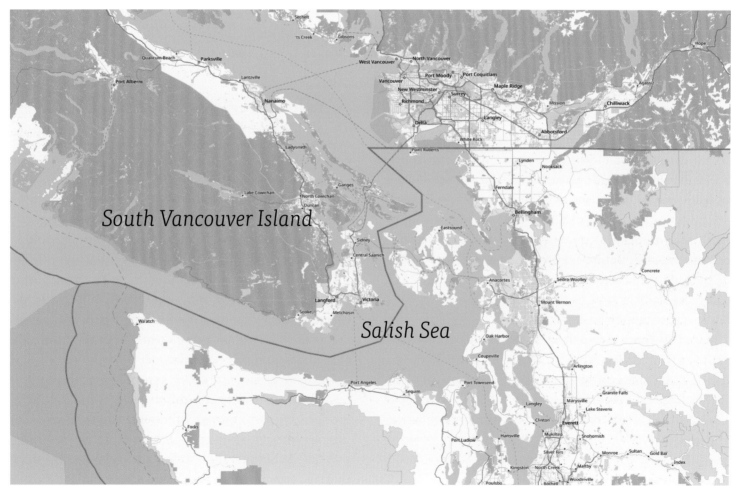

South Vancouver Island

Salish Sea

Gathering Treasures

"We are all harvesters and hunters, always looking and hoping for something that will give pleasure to the senses or might be worth keeping for some reason, and just possibly be good to eat. Many – and perhaps countless – generations will pass before this urge disappears. It is my wish we will never lose it, that every trip away from home will be one of adventure and excitement, for no matter what we gather, deep within us is the same primitive satisfaction our ancestors knew."

—*Reflections from the North Country*,
Sigurd F. Olson, page 12

Baby Lara and I during a kayak trip to Chatham Island in summer 1987

visited by people, even though the city is relatively close. Strong currents and difficult-to-navigate waterways defend the islands from a large onslaught of visitors. Most of those who do come arrive by kayak or small pleasure craft. Paddlers and boaters must be highly skilled, as the seas can be dangerous. A few visitors will actually camp in the park during the summer months. But for the most part, the islands are the domain of oceanic and terrestrial wildlife like Steller sea lions, orcas, harbour seals, bald eagles, osprey, river otters and mink. And now, a top predator: the wolf.

Since 1974 I have visited these islands in all sorts of watercraft. My first visit was when we anchored the MV *Tamarack*, a 50-foot recommissioned forestry boat, and used it as a base for teaching young offenders to sail navy whalers as part of the Metchosin Camp Outward Bound correctional program. Subsequently I have travelled into the island archipelago by canoe, kayak, Zodiac, fishing boat, sailboat and now a small rubber inflatable.

One of my first kayak trips out to the islands was in 1987 when Dave and our growing young family — at that time two daughters, Maia, aged 5, and Lara, merely 8 months old — paddled out for a picnic. Over the years, the island beaches and forests became a favourite spot for being in nature, for picnics and for exploring with our three children and friends. Now I visit the islands frequently with my extended family and have the joy of introducing three tiny grandchildren to this wild and beautiful world.

Out in the islands, I pursue my love of wilderness and photography, documenting the stunning array of wildlife living there. I have always loved gathering small treasures from the wild places I visit: shells, rocks, a bit of gnarled wood, a feather that has escaped from a passing bird. These small collected items are rich with memories and bring a bit of

the wild into my home. I believe that gathering is deeply ingrained in us from the days of our hunting and gathering past.

As time passed, I became more excited about gathering and collecting memories of the wild through my lens. This was a way to document and preserve unique moments in the natural world and make it accessible to people who live far from wild areas, perhaps to help more of us fall in love with the wild landscape.

I have always felt a strong drive to capture the essence of a world where humans have had little impact, where our rampant consumerism has not destroyed or permanently scarred the landscape and decimated species. Where it is still possible to sense the primal energy of something mysterious and powerful.

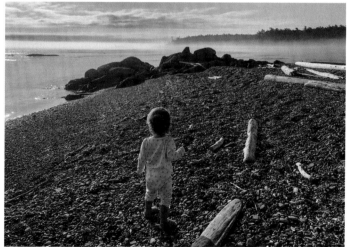

OPPOSITE Granddaughter Dana exploring the islands

TOP Photographing from my boat at sunset

BOTTOM My granddaughter Dana explores the island shores with me

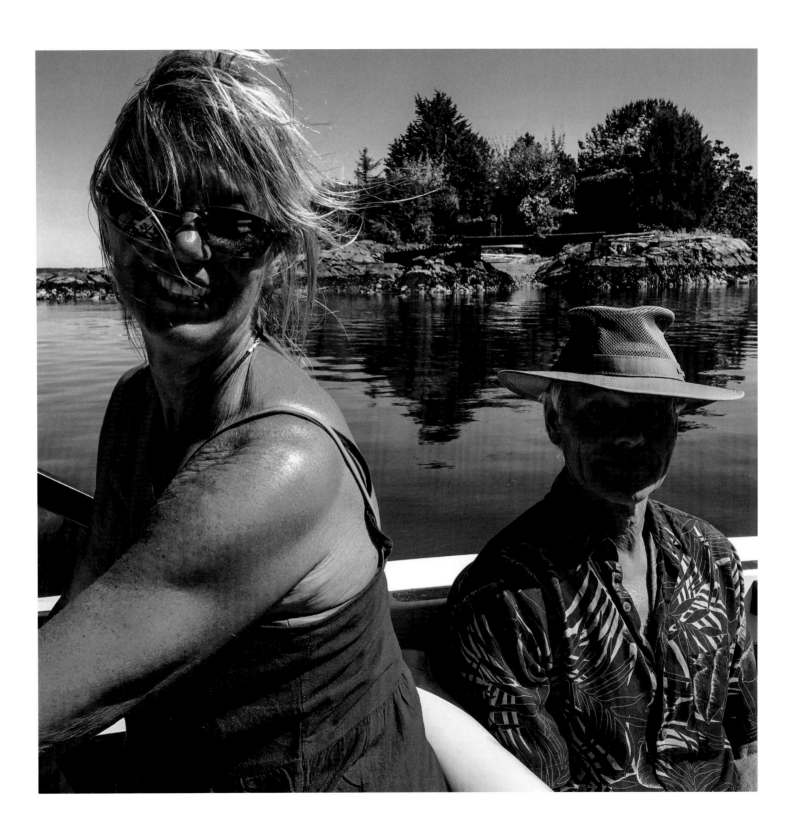

JOURNEY

Knowing an animal at a deeper level does not diminish its mystery but opens our hearts to the unknowable and, in a sense, the divine.

RICHARD LOUV

In May 2012, my path with heart took on a strange and unexpected direction. On the local news, I heard that local kayakers and campers had reported a wolf in the islands. Initially it was thought to be a stray dog, however a photo taken by whale-watching guide Jim Zakreski showed that it was a wolf. This was big news for Victoria. A wolf was not a common visitor in the area, and certainly unheard of out in this small, uninhabited archipelago.

This wolf's early life was initially unknown to me. It was only later, as I began to follow the questions and mysteries surrounding his appearance, that I began to unearth and piece together what little could be known of his journey and decision to settle in these islands.

Although it had been reported, it seemed improbable to many people — myself included — that a wolf was now inhabiting these tiny islands so close to my city. And then, in the spring of 2013, I was camping in the islands and heard what sounded like a wolf howl. Around the same time, biologist friend Paul Harder and I spotted wolf tracks on a beach on Discovery Island. This was very exciting!

OPPOSITE Dave and I heading to the islands in our boat, MV *Rover*

My husband Dave, however, doubted that there really was a wolf on the islands and made a lot of fun of us for thinking that there was. He later said, "People take their dogs out to the islands all the time, so the logical thing for a physics guy like me is: *It's a dog, not a wolf.*"

When I showed Dave the tracks he would say, "Yeah, those are just big dog tracks."

But then I saw him — and Dave heard him howl.

It was Mother's Day, 2014. Dave and I, with our eldest daughter Maia and our family friend Anna Lisa, were drifting through the islands at sunset, enjoying a happy hour in our boat, MV *Rover*. I glanced back and saw the wolf getting out of the water after a swim across the channel. It was a surreal moment. I exclaimed, "Oh my god, there's the wolf!" He disappeared into the woods and began to howl — a most poignant, moving experience.

From this moment on, Dave had to accept that there was a wild wolf living in the islands. What he didn't yet understand was how this moment was to change my life, and ours. In Dave's words, "She was over-the-top excited and very enthusiastic. I didn't realize that we were starting a whole new chapter in our marriage."

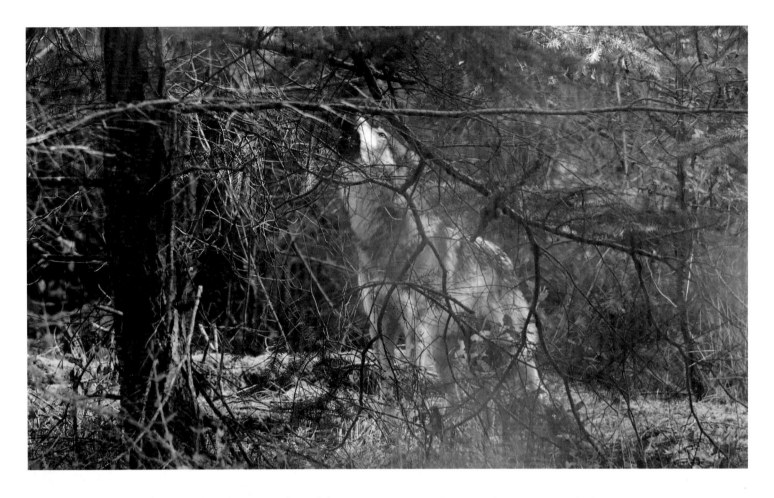

ABOVE Takaya howling at ravens in the forest

OPPOSITE Takaya giving a lonesome howl at sunset

Although I had spent countless hours in the wilderness, I had never seen or even heard a wolf. This is not unusual; rarely does anyone catch even a furtive glimpse of a wolf in the wild. Initially, I was simply curious about the presence of a wolf. But then when I heard his howl — a haunting, somewhat mournful sound — it awoke something deeper in me. I sensed a portal into a wild world. It was at this moment that my journey with this wild wolf really began.

This first glimpse set me on a path — a quest to discover more about this wolf, his behaviour and his inner world. I wanted to understand and know this wild animal, a creature who was living a life so different from mine. A creature who embodied the very essence of wilderness, freedom and our ancient connections with the primeval world.

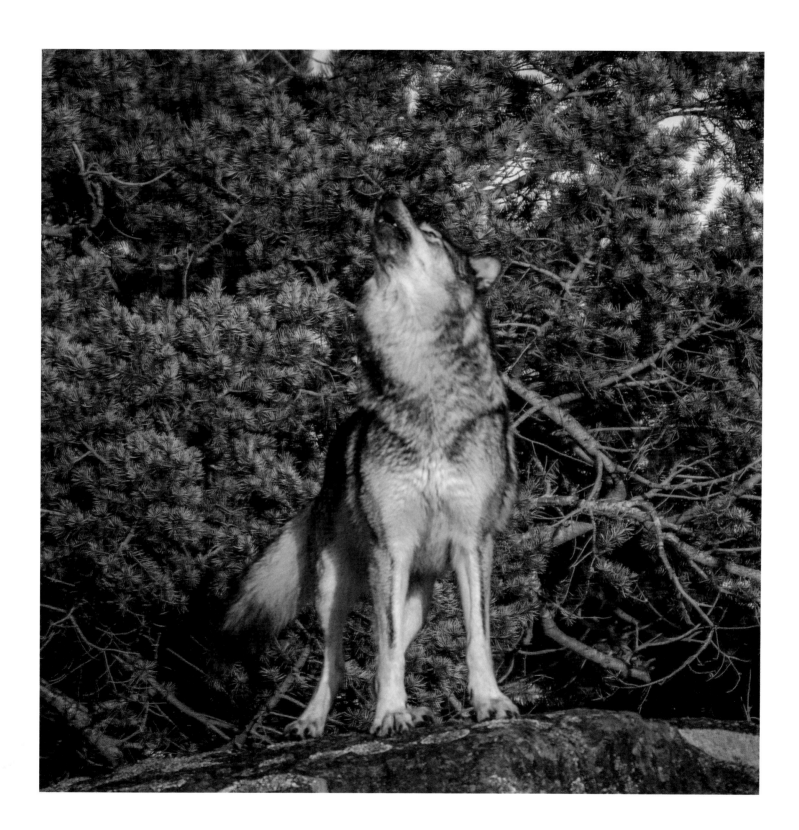

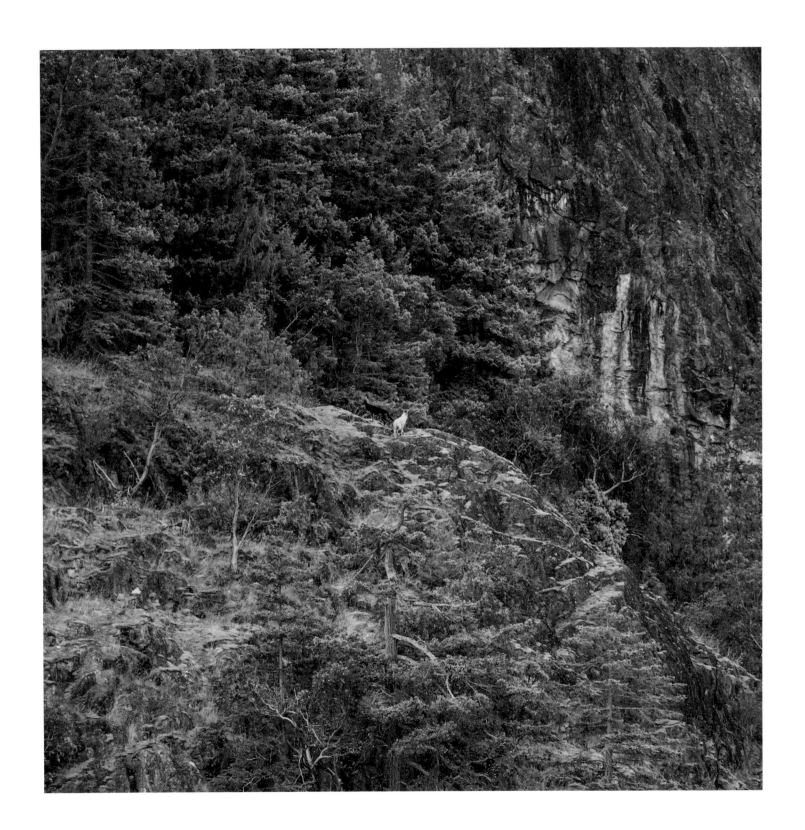

SYNCHRONICITY

I am open to the guidance of synchronicity,
and I do not let expectations hinder my path.

DALAI LAMA

Shortly after my first encounter with the howling wolf, I travelled to Desolation Sound in the Strait of Georgia at the north end of the Salish Sea. Dave and I camp there each year with our two close friends Paul and Jutta. Paul is a fisheries biologist turned bronze wildlife sculptor and shares my passion for all things wild. That year, Paul and I were determined to see wolves. We knew of some living in these northern islands.

I had gotten a quick glimpse of the island wolf and that had intrigued me. They are one of the most elusive of all creatures, and few people will actually see a wild wolf in their lifetime. I wanted more.

We camped on tiny, uninhabited Martin Island just off the south shore of the much larger island of West Redonda. Our plan to see wolves involved travelling by boat to nearby Cortes Island, where we knew wolves lived. But we didn't spot a single wolf. After a day of searching, we found only scat (poop).

The next morning, however, we were awakened at dawn by wolves howling behind our tents. They were on our tiny island! It was a stunning and unexpected development. The wolves had come to us. What were the chances of that!?

Leaping out of my sleeping bag, I scanned the outside environment, but couldn't see the howling wolves, even though they sounded so close. They were invisible to us. They appeared to be howling to a young wolf that we could see high up on a bluff just across the narrow channel. He seemed to have been left alone while they, possibly the alpha pair, were off hunting.

At the end of the day, the two alphas swam across the channel, emerged sea-drenched, shook, and climbed high into the

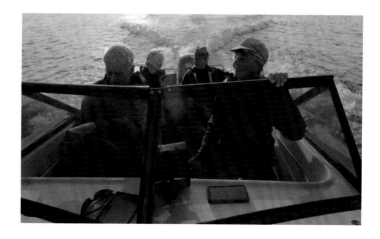

OPPOSITE An alpha pair climb the bluffs of West Redonda island

ABOVE Dave and I en route to Desolation Sound with friends Paul and Jutta

29

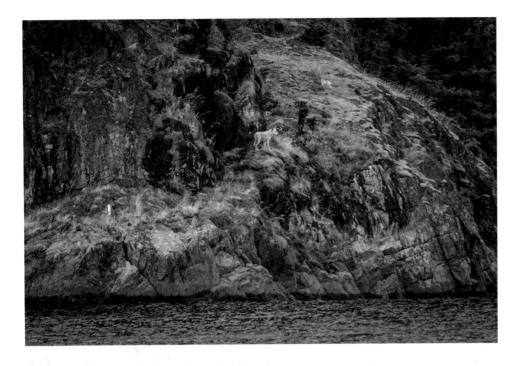

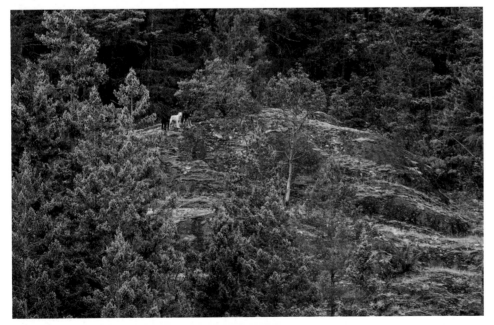

ABOVE Alpha wolves return to West Redonda Island after a swim from Marten Island and reunite with their family

OPPOSITE Harriet and I watching Takaya on the opposite shore

hills for a joyous reunion with what we imagined to be their pup. One was a beautiful, glowing white wolf that I could easily track as they ascended the cliffs. Reunited, they greeted each other by playing and chasing each other around the bluff, and then the three sat together and howled a chorus toward us — what wildlife ecologist Durward Allen called a "jubilation of wolves."

It was incredibly moving seeing the strong family relationships and the closeness of the pack expressed with such clarity and elegance. It reminded me of my own family.

This wolf family unit stood in stark contrast to the situation of the lone wolf living on the islands near my home. I was struck by this, and at that moment knew that I had to learn more about wolves, and about Takaya's life: what had brought him to the islands; how he lived there; why he stayed and lived alone.

Because I knew little about wolves and their lives, I immediately wanted to get a book and learn more. When our camping trip was over, we boated into Refuge Cove, a rustic island outpost with only a gas dock, a small grocery store and a gift shop. In the gift shop I asked for a book on wolf biology, but they had none. I explained that I'd just had a remarkable wolf encounter and wanted to understand more about wolf packs and family relationships.

There were only three other women in the shop at the time. "You could ask my friend Harriet here," one of them said to me.

As fate would have it, Harriet Allen had just retired as a wildlife biologist from the Washington State Department of Fish & Wildlife, where she had managed the endangered species program for 25 years. Harriet had led the effort to develop the wolf conservation and management plan for the state.

I couldn't believe my luck. I had a lot of questions for Harriet Allen that day. She subsequently became my friend as well as a great source of information about wolf biology and related issues. Over the years that followed our first meeting, Harriet has travelled out to the islands with me numerous times and has shared a number of exquisite encounters with Takaya.

As we motored back to Vancouver Island, the synchronicity of the weekend came full circle when our friend Paul received a call from a client saying he wanted to commission Paul to sculpt a howling wolf.

I returned home and to the islands with a determination to learn more about wolves, and this lone wolf in particular.

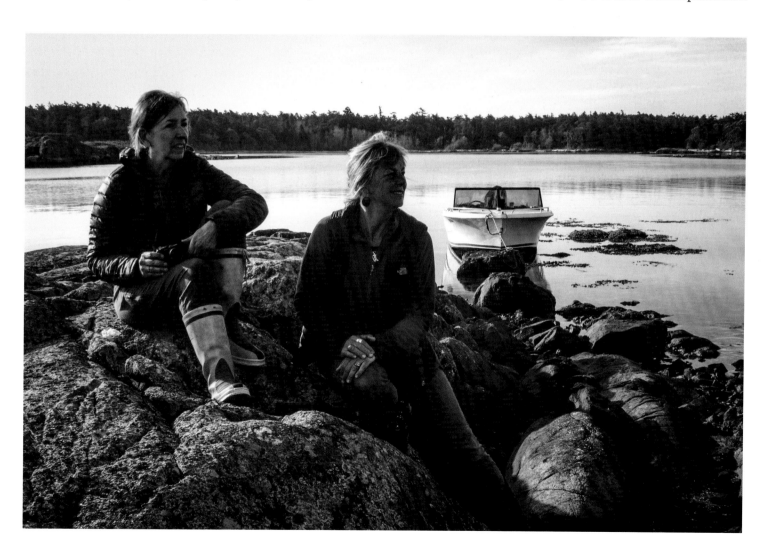

Never did I imagine, however, that I would eventually fall in love with a wolf.

Once back home, I mused on my life's path. How had I gotten to this place? As a young woman, I had been passionate about the sea. I had imagined that one day I would study whales.

My family genes are strongly connected to the sea and to the West Coast. My great-grandfather, Captain Josiah Gosse, was the first listed coastal pilot of BC and piloted the historic ship MV *Karluk* up the inner coastal waterways on its historic journey into the Arctic under the command of Bob Bartlett. My great-uncle, also a Josiah Gosse, was the last keeper of the Fisgard Lighthouse near Victoria.

In my 20s I had travelled to Hawaii, absorbing the magic and mystery of the whales that came to breed in those waters. I sailed the area looking for the humpbacks. I bought books about whales and dreamed of one day studying them.

I knew nothing of wolves. I had honestly never given them much thought.

I still observe and learn about whales, and am fortunate to have had many amazing encounters with the orcas, humpbacks and grey whales that frequent the west coast and Salish Sea.

However, it was to be a wolf that captured my focus — and my heart.

Six years on, I have come to know so much more about wolves than I ever imagined possible. My first sighting of Takaya marked the beginning of my journey. It set me on a path, a quest to discover more about this wolf: his behaviour, his past, his future. I wanted to know where he came from, what he was living on and why he stayed alone on these islands. I realized how special his life was — how deserving of recording and documenting. I decided to photograph and film as much of his life as possible.

Although I didn't need to go on land much in order to study and document Takaya, I knew that much of his territory was on the traditional lands of the Songhees Nation, descendants

Wolf People

All Coast Salish are wolf people. Unlike others, we don't have clans or houses. When we are born, we are part of the wolf people ... The wolf is actually the foundation. It's the culture. The wolf itself is a symbol. It's part of the oral teaching in the longhouse. So, it's not actually a clan sign, it's the foundation of our culture.

—Butch Dick, artist and cousin of late Chief Robert Sam, Songhees Nation

of the Lekwungen — Indigenous peoples who have lived in this area for over 10,000 years. I sought and received permission from the Songhees chief and council to be on their lands to photograph and film Takaya.

The Songhees call this wolf *Staqeya*, which is the word for wolf in their Lekwungen dialect of the Coast Salish language. They consider the presence of the wolf on the island auspicious, as he arrived just before their beloved Chief Robert Sam died in August 2012.

The wolf is an important symbol in the culture of Indigenous peoples living up and down the coast of North America. For the Songhees people, the wolf is integrally linked with their respect for the land and all that live on the land.

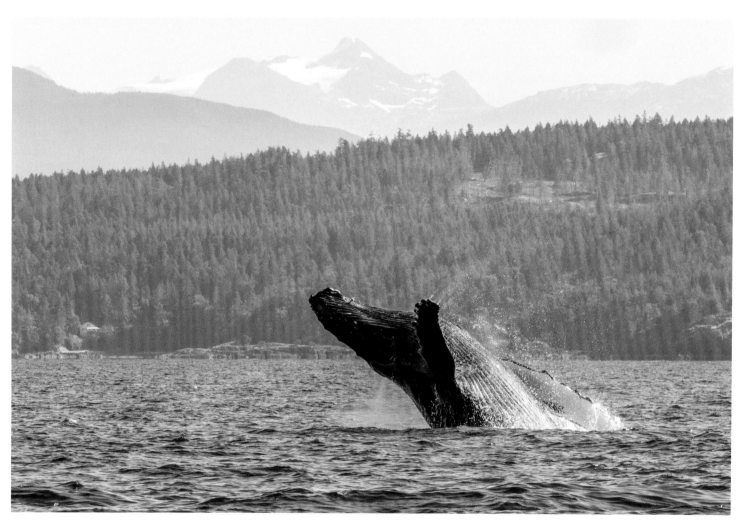

Humpback whale breaching in Desolation Sound

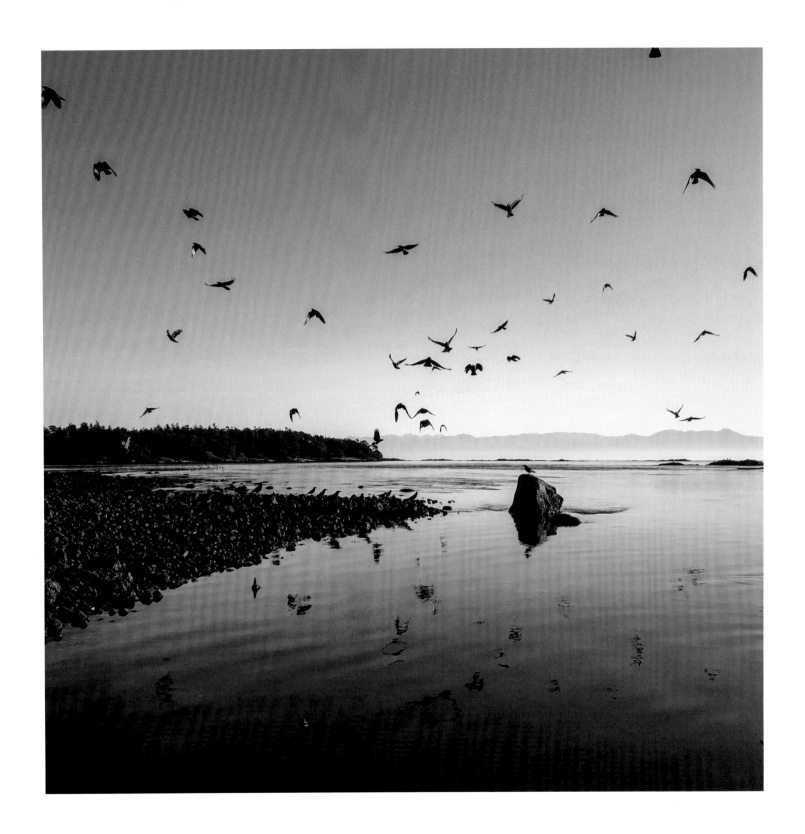

EXPLORATION

All living things contain a measure of madness that moves them in strange, sometimes inexplicable ways. This madness can be saving; it is part and parcel of the ability to adapt. Without it, no species would survive.

YANN MARTEL

Takaya has been a lone wolf for almost nine years. That makes him rare, possibly unique, among wolves. Wolves are one of the most highly social of animals and are extremely dedicated family animals. They almost always live in packs of up to 20 or more individuals. Some young adults will disperse (leave their family) in order to form packs of their own, however these lone wolves are not usually alone for long. It's known that most dispersing wolves will settle and find a mate within months of leaving their pack.

A few wolves, however, are known to disperse far beyond the range of their populations; these individuals are known as pioneering wolves. Peter Steinhart, in his book *The Company of Wolves*, describes these wolves as "gamblers on the future of the species, like humans who go off to cross unknown seas or explore remote frontiers; they are, in an evolutionary sense, probes sent off to try to establish wolf genes on new ground." Perhaps Takaya is one of these. He certainly has pushed into foreign territory for a wolf and is living at the very edge of his ecological niche (the environment a wolf typically occupies).

Takaya's odyssey is similar to what is known as the archetypal hero's journey. The hero's path, as articulated by American literature professor Joseph Campbell, includes: deciding to leave the familiar world; going on an adventure alone; having to face tests of endurance and strength in the face of adversity; surviving ordeals that challenge; evolving and adapting; and finally, obtaining a reward and perhaps returning to the familiar world.

Takaya has yet to complete the final part of this journey — a return to his known world — and maybe never will. His path, however, has certainly been one of a hero.

I was curious about Takaya's origins. Where had he come from? What drove him onward? What was his journey? What challenges did he face? Why, unlike most wolves who stay far away from people, did he move through heavily populated areas in the heart of a city? Why choose a small group of islands as his home?

The BC mainland coastal wolves, or sea wolves as they are

OPPOSITE Crows gather as the sun sets over the Strait of Juan de Fuca and the Olympic Mountains

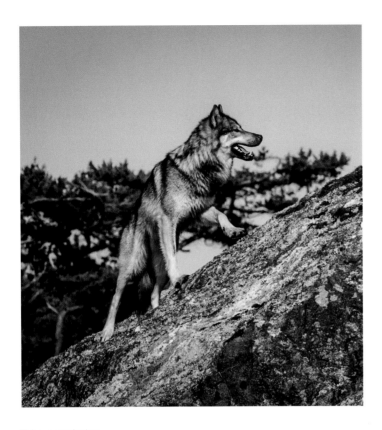

Takaya exploring

often referred to, are an example of an evolving species. Recent studies indicate they are a genetically distinct population from their inland relative, the grey wolf. Those wolves living along the coast are behaviourally different and have distinct DNA. These populations have developed different survival strategies and skills from the inland grey / timber wolves, and use marine resources quite extensively.

I was appalled to learn that on Vancouver Island, wolves were considered completely wiped out between 1950 and 1970. Most of them were killed off as a result of government-sponsored extermination campaigns. Wolves were wiped out up and down the west coast states of the United States at this time as well. Since then, coastal wolves have been slowly recolonizing Vancouver Island by swimming across from mainland BC, primarily in the northern regions.

Barbara Scott, a PhD student from the University of British Columbia, began to study these newly returning wolves in 1979. At that time, the few wolves that had returned were mainly on the north end of Vancouver Island. The two wolf packs in her study hunted elk, deer and beaver, criss-crossing their territories over the span of about three weeks. By the second season of Scott's research, seven of the fifteen wolves had been shot. Her study lasted only two years.

In the last few decades, wolves have been spotted more frequently on the West Coast and in southern areas of Vancouver Island. Total population numbers and current wolf distribution is now being assessed as part of a project led by the British

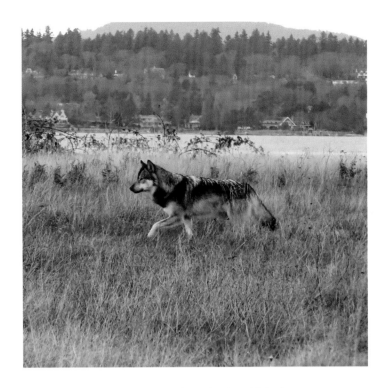

Takaya finds a home, just across the water from Victoria

Columbia Ministry of Forests, Lands, Natural Resource Operations & Rural Development. Recent government estimates are that there are approximately 250 wolves on Vancouver Island, with ongoing movement of wolves to and from the mainland. They are not currently considered to be a species at risk.

A few wolf packs live in the wilderness areas to the west and north of Victoria, on the southern end of Vancouver Island. It is possible that Takaya came from one of these packs, dispersing and travelling through various wilderness corridors until he found himself in the midst of human populations.

It is also equally possible that he undertook a longer trek of 400 kilometres or more, coming from as far away as the north end of Vancouver Island or from the mainland areas of BC, crossing the various island bridges over to Vancouver Island. Wolves are known to easily swim between the northern group of islands in the Desolation Sound area and the mid-island coasts.

In the Victoria community in 2012, there arose many rumours and theories about how Takaya had arrived on these islands. It was hypothesized that he could have swum from the Race Rocks / Sooke area (20 kilometres away), or crossed over from the Olympic Peninsula in Washington State (40 kilometres away, where no wolves have lived for years). Other possible theories included being trapped on a log boom and jumping off as it went by the islands, or that he was deposited there by the local First Nations. One carnivore specialist even proposed that, because he looked so good in the photographs I'd been taking, he was maybe a trained movie wolf that had been abandoned there.

It is most likely that one morning Takaya woke up in the midst of his natal pack and for some reason decided to leave. He would have struck out alone, not knowing where he was going. It's possible he followed old wolf trails and scents. Perhaps a wolf had forged these paths before him. Before long, however, he would have been in unfamiliar territory. For some reason he decided to keep going and ended up on the Saanich peninsula, the 40-kilometre landmass that stretches north from Victoria, which is very much populated by humans and not wolves. It is possible that he had been wandering for months before reaching the south end of the peninsula.

Local resident John Gibson lives in an area called Deep Cove, 35 kilometres north of Victoria. After hearing about my work, he contacted me about an encounter he had had with a wolf in January 2012, only a few months before Takaya was spotted a bit farther south. It is very likely that this wolf sighting may have been Takaya before he travelled farther toward Victoria and his eventual home on Discovery Island.

We may never know exactly where Takaya came from or where his family originally lived. I looked into using DNA analysis to figure this out, but it turns out to be difficult and complicated to determine his genetic origin. It would require that Takaya's DNA be compared with a good set of reference samples of wolves on Vancouver Island — something that does not currently exist.

Vancouver Island Coastal Wolves

The wolves living on Vancouver Island are considered a variety of the grey wolf, *Canis lupus*. The have come to be known as sea wolves or coastal wolves. Genetically distinct from the inland grey wolf, sea wolves have evolved to suit their coastal ecosystems and climates, and have adopted a different diet. They hunt marine-based prey as well as ungulates, whereas the inland wolves primarily hunt terrestrial species like deer and elk. Coastal wolves tend to be smaller and slighter, with shorter coats. The climates they live in tend to be milder, with more rain and less snow. Their coats also have taken on different hues — reddish, brown and golden tones, likely reflecting their environment, especially the golds, reds and browns of the intertidal algae-encrusted coasts.

When the coastal wolves began to recolonize Vancouver Island in the 1970s, they had to share their territories with an increased population of people who also shared the coast. This meant more potential for conflict. Still, for the most part, they have remained largely invisible to humans — until recently. The way forward for the wolf will necessitate co-existence. We humans will need to try to understand the best way to do this.

Through speaking with local government officials, however, I was able to sleuth out some of the latter part of his journey just before he arrived in the islands.

The Wanderer

Wolves can quickly cover vast distances, a fact well illustrated by Barbara Scott's research as a young graduate student in the early 1980s. Scott studied wolf packs on northern Vancouver Island and collar-tracked a dispersing wolf from the north end of the island to the Sooke area just outside of Victoria. The collared wolf covered almost 500 kilometres in only a few days. Wolves are great long-distance runners and can lope almost endlessly at about 10 kilometres an hour. Their ability to swim is almost as good. They have been known to swim long distances across seas and lakes, even in conditions of strong currents and rapids. Recently, in summer 2019, a lone wolf was spotted swimming easily from Quadra Island to northern Vancouver Island — a distance of several kilometres.

Beginning on May 4, 2012, police received a number of eyewitness reports of a wolf on the Saanich peninsula, a suburban area north of Victoria. These sightings were clustered around Elk and Beaver Lake parks, as well as a main highway leading into the city. It isn't known how long Takaya may have been living in this suburban area, however it is possible it was for quite a long time. Wolves are capable of living well under the human radar.

I eventually spoke with one of the people who had reported seeing the wolf near Beaver Lake in 2012. Saanich resident Doug Paton shared his story with me, and I was blown away by his experience. Speaking with him seven years after his encounter, in 2019, it was clear that this experience with

Wolf Spirit

Meeting a wolf the way I did that night was a singular event. It wasn't the fact of meeting Takaya (that's cool all by itself); it was the way he behaved that blew me away. Still does. I learned a life lesson from him in about 30 seconds that has stayed with me to this day ... for me, wolf spirit is about survival.

—Deep Cove resident John Gibson's account

Takaya had profoundly affected him. Takaya changed Doug's life, just as Takaya was changing mine.

On May 12, 2012, Doug had been sitting in his RV on his sister's rural property when he saw movement out of the corner of his eye. An animal, perhaps a dog. Upon closer inspection, Doug realized that it was a wolf standing no more than 10 feet away. Doug locked gazes with the wolf — a peaceful encounter that changed his life utterly. It only lasted a few seconds, but looking into the steady, calm eyes of the wolf was powerful for this man. Doug reports that Takaya then turned and, with grace and confidence, loped silently across the field. Upon reaching a six-foot-high gate on the other side of the pasture, Takaya jumped and cleared it with an almost vertical leap.

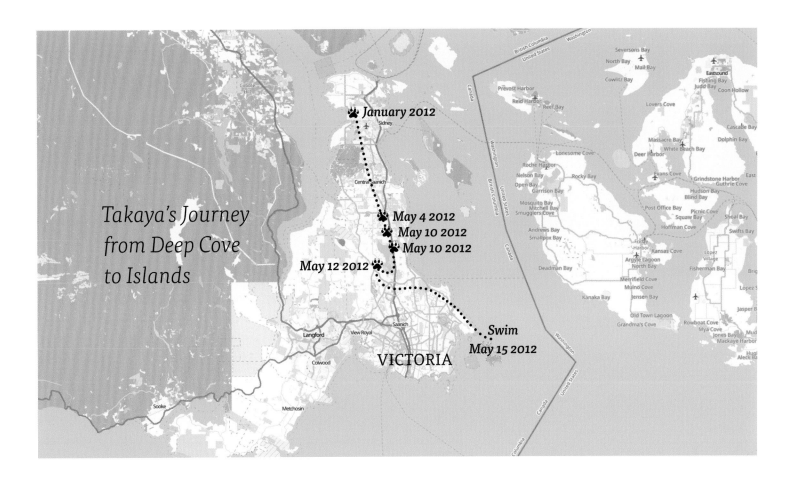

Takaya's Journey from Deep Cove to Islands

January 2012

May 4 2012
May 10 2012
May 10 2012

May 12 2012

Swim
May 15 2012

VICTORIA

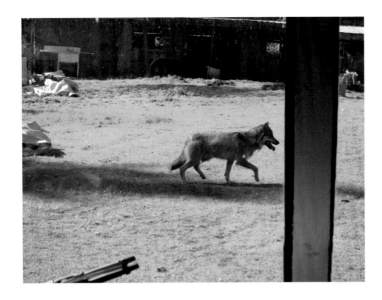

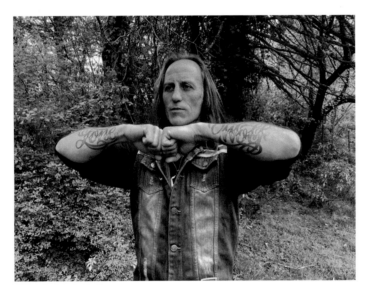

TOP Takaya taken by Doug as he crossed the Saanich peninsula in 2012

BOTTOM Doug with *LONE WOLF* tattoos

For Doug, this experience was pivotal. He confided that he had been in a difficult phase of his life, with his marriage ending and his life prospects uncertain. He explains that somehow, gazing into the eyes of the wolf changed things for him. He saw this lone wolf getting on with life, and thought that if the wolf could survive alone, then so could he. As a result of this encounter, Paton changed his life for the better. He commissioned a substantial tattoo to commemorate the turning point. Seven and a half years later, Doug still attributes the positive changes that he made in his life to this encounter with the wolf.

Fortunately, Doug thought to take some photos of the wolf at that time, which helped me to confirm that it was, in fact, a young Takaya.

Takaya covered at least 40 kilometres on his journey through homes and gardens before reaching the tip of a headland at the end of a neighbourhood and geographic region called Ten Mile Point, on Victoria's southeastern edge. Then he did something rather extraordinary: he swam across a 1.5-kilometre channel — home to some of the strongest tidal currents on the BC coast — to the group of islands that he now claims as his territory. The first reported sighting of him there was on May 15, 2012.

The Discovery Island group of islands represents an uninhabited wilderness archipelago, which must have been appealing to a dispersing wolf looking for a territory. What Takaya likely soon realized, however, is that none of his customary prey resided here. It is most likely that Takaya came from an area where his pack hunted primarily deer, elk and small land mammals. Here, he had ended up by the sea in a world where there were none of these at all. His life in the islands would have required adapting to a very different kind of diet requiring a different set of hunting skills than he had learned while living with his pack.

There is an overabundance of Sitka black-tailed deer in nearby areas of Vancouver Island, but apart from the occasional carcass that has washed up, deer have not moved onto the islands.

Water may have also proved a challenge. Takaya would have been used to drinking from the many streams, lakes and rivers that are found all over Vancouver Island. Significantly, the islands he had swum to had none of these, either.

Changed by the Gaze of a Wolf

As both Doug Paton and John Gibson have recounted, something changes a person after an encounter with a wild wolf. Their eyes hold us, and take us places we don't expect. An account from Troy Bennett, a shepherd who is largely responsible for the reintroduction of the wolf in France, captures the impact of a wolf encounter:

> Late one evening Troy Bennett, a member of the livestock cooperative that suffered the loss of so many sheep, was carrying a paralyzed lamb over his shoulders when he glanced into a treed area and saw a wolf watching him. "Our eyes met and were locked, I was drawn into them. People talk about a wolf's stare, how it holds you, how it holds its prey," he says. "When a wild wolf looks into your eyes it looks deep and you cannot look away. Something holds you there. Whether it is hypnotism or fear or something else I'm not sure. I didn't feel fear, but I was held. In that look I felt something change in me." When Bennett locked eyes with the wolf, he saw a beautiful, mystical creature. When he thought about the sheep, he knew that creature was also a ruthless predator.

—*Return of the Wolf,* Paula Wild, page 121

The islands certainly did not seem an obvious place that a wolf would choose as his home territory.

Due to concerns about the lack of adequate food and water for the new resident, Chris Darimont, a wolf scientist from the University of Victoria and science director of the Raincoast Conservation Foundation, felt that the long-term prognosis for this wolf was not good. He believed that the islands were "too close to humans and there is not enough land to comfortably support the animal." He was concerned that the wolf would run out of food, or that there would be a conflict with humans.

Parks and conservation officers also worried that the presence of a wolf in a provincial park could pose a danger to people. They were concerned that kayakers and campers might feed the animal, as had happened on Vargas Island farther north, resulting in the dire outcome of a camper being attacked by a wolf and ultimately leading the government to have to shoot two of the resident wolves that had become food-conditioned by humans.

Based on these various concerns and the fact that there were no other wolves living nearby, in 2012 the government made a decision to trap and relocate Takaya. In late summer of that year, BC Parks conservation staff made a first attempt to trap the wolf. They put out a deer carcass, which he ate. Enticement confirmed, they then set out a large box trap using a deer carcass for bait. The wolf did not take the bait, and the trapping effort failed.

Takaya had prevailed.

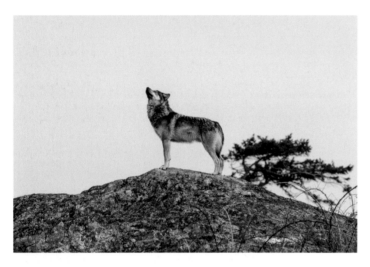

TOP Aerial view of islands as sun sets over the Sooke hills

BOTTOM Takaya stands proud atop a favourite bluff in his territory

OPPOSITE Takaya looks at the city just across Baynes Channel

To Trap or Not to Trap

An extract from an article that appeared in the local *Times Colonist* newspaper illustrates the diverse opinions around what to do about the wolf that appeared on the island.

Traps have again been set on Discovery Island in an effort by the BC Conservation Service to catch the lone wolf that has been island-hopping off the Oak Bay waterfront since last July.

However, the Songhees First Nation, whose reserve includes part of Discovery Island and Chatham Island, wants the wolf left where it is, said band councillor Ron Sam. "Council met yesterday, and we have taken it to the membership and passed a motion that the wolf should be left alone," Sam said. The wolf showed up for a reason, and there is no need to interfere with nature, he said ... B.C. parks and conservation officers agree that relocating the wolf is in the best interest of the animal and public safety, according to the statement. "It is also agreed that relocation of the wolf prior to this year's high visitation season is a priority."

—*Trap Set for Discovery Island wolf, but Songhees want it left alone,* by Judith Lavoie, *Times Colonist*, February 6, 2013

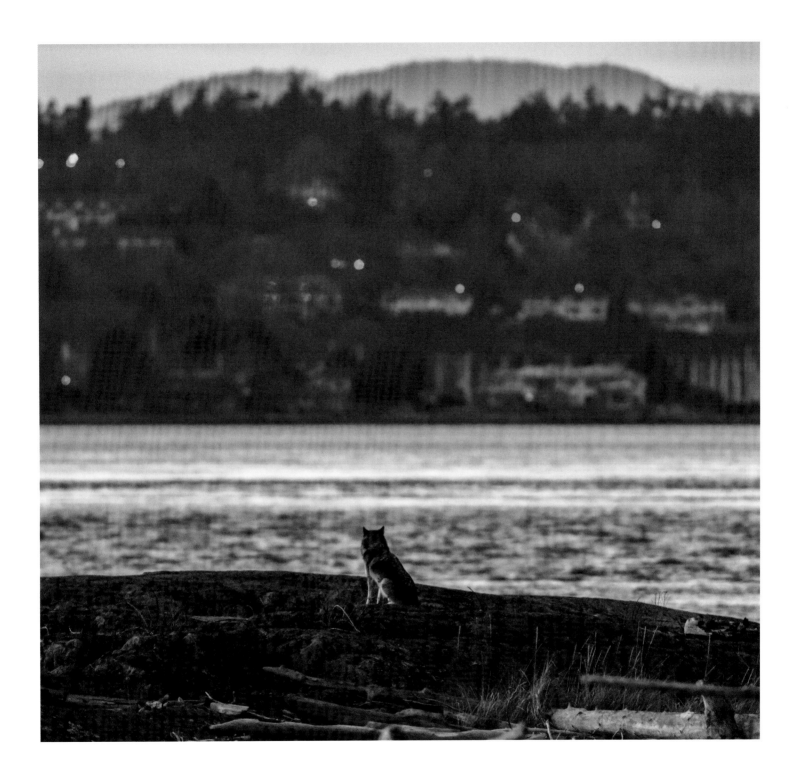

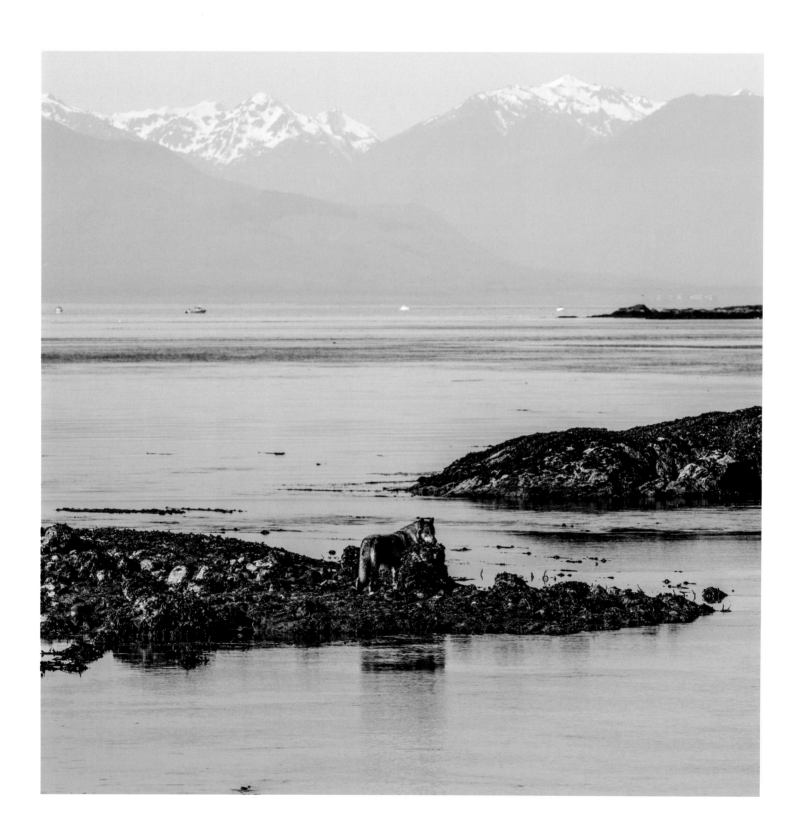

RESILIENCE

Only those who will risk going too far can possibly find out how far one can go.

T.S. ELIOT

Perhaps it was the human attention and trapping activity, or perhaps it was the lack of any of his normal food sources, or maybe it was his adventurous spirit, but for whatever reason, Takaya decided in August 2012 to leave the islands and continue his epic journey.

He likely stood on the rocky intertidal shore, body tensed and tail down, warming in the early morning sun, two paws already in the sea. He may have waited for quite a while looking out to the west, across the large body of open water, glassy and still, for the moment. He needed to make sure he was not going to be seen, or encounter humans while en route.

How long before he made his decision and began his long swim? Did he wait until he could hear no boat engines and believed it would be safe? Did he aim for the small, rocky and treeless Chain Islets, 2.5 kilometres away, the domain only of seabirds and seals?

On August 16, Takaya again plunged into the icy waters of Baynes Channel. Two ears and black nose visible, tail trailing, he headed west and swam a remarkable 5.5 kilometres across a busy boating channel to nearby Trial Island, a tiny island with only a lighthouse and no forest lands of any kind.

OPPOSITE Takaya waits on shore for the right moment to swim

RIGHT Takaya swimming in the icy waters of the Strait of Juan de Fuca

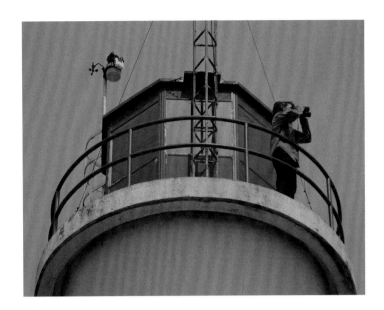

ABOVE Meredith checks the shores from the top of Trial Island lighthouse

OPPOSITE Takaya fights his way back to Trial Island through a dense bed of kelp

Amazing Wolf

Something caught my eye out on the water. I first thought, a seal, no. And it's not a sea lion. Then realized that it was a wolf out there! And behind him you could see a fishing vessel coming towards him and he was swimming towards the island, right into a kelp bed. He kept turning his head and looking back at the fishing vessel, trying to figure out how far away it was and he seemed a little agitated about that. I knew he had to be really quite intelligent to be able to negotiate his way through the kelp beds the way he did, like working his way through a maze. When he got to the shore he climbed up and trotted a few feet, and stopped and gave himself a big shake, then he continued on along the shoreline. He hadn't been aware of me at all. Then all of a sudden, he looked up and right at me. He realized I was there. Once he saw me, he took off up the island. He was just gone.

–Meredith's account of Takaya's return to Trial Island

What triggered him to dive again into this cold water? Where was he headed? What did he imagine waited for him at the end of his journey?

Did he see the tall mountains on the Olympic Peninsula — the wilderness in the distance across the strait? Was it possible that this was his target?

Meredith Dickman, the Trial Island lightkeeper, saw Takaya emerge from the water onto the island briefly and then, leaping back into the sea, continue his swim toward the west into the open waters of the large Strait of Juan de Fuca that leads out into the Pacific Ocean.

As she watched him through her binoculars from the top of the lighthouse, he turned around and swam back toward Trial Island. It seemed to Meredith that he had become frightened by a large fishing vessel that was bearing down on him.

Navigating a maze of large bull kelp beds, the wolf struggled to make his way back to the lighthouse. Meredith watched as he zigzagged through and pawed over the kelp. Once free of the kelp-entangled sea, he shook himself off and then loped toward the north side of the island. She didn't see him again, but reported that she later heard dogs barking in an unusual manner all along the nearby shore of Vancouver Island.

A couple of days later, it was reported that the wolf was once again heard howling back in the island archipelago. As far as anyone knows, he has not left these islands since.

The wolf remained on the islands over the winter of 2012 and then, in February 2013, the BC Conservation Service made another attempt to trap him, with the help of a

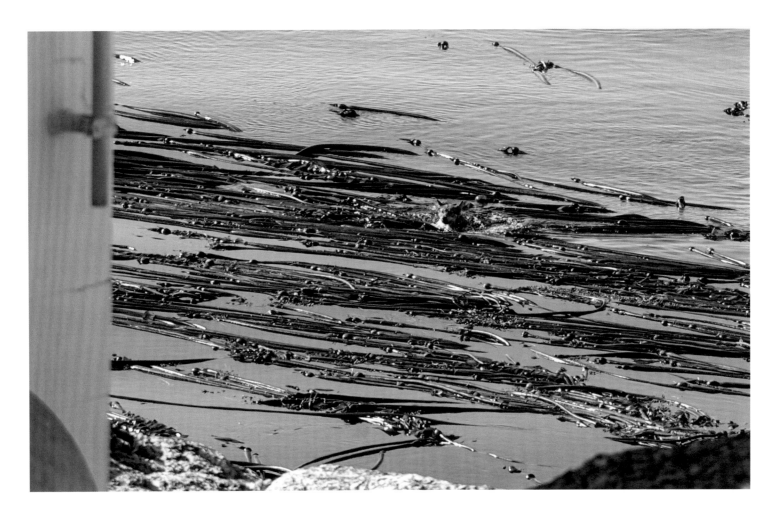

professional trapper. This time, they buried a more sophisticated soft leg-hold trap in-ground along a main trail that Takaya had been using. He somehow recognized the presence of the trap, however, and did not go anywhere near it. Trail camera footage shows him walking along the trail, stopping to investigate the area where the trap was buried, then avoiding the trap by walking into the bush and back onto the trail, completely circumventing the trap.

But Takaya's life was in danger at this point. The BC provincial government had, in 2016, enacted a policy on human / wildlife conflict that stipulated: "Capture and relocation of cougars and wolves will not occur, other than juveniles that may be taken into permanent captivity, if appropriate." In other words, an adult wolf would be destroyed rather than trapped and relocated.

At this time, however, the Songhees First Nation, upon whose traditional territory the wolf roamed, advocated that the wolf be left alone. They asked the government not to interfere with nature and to allow the wolf to remain free.

And so, in early 2013, the parks service removed the traps and made the decision to leave the wolf alone. They chose to follow a course of public education and information, erecting signs on the park lands about the presence of a wolf and how humans should behave in order to avoid conflict.

Takaya had prevailed for good this time.

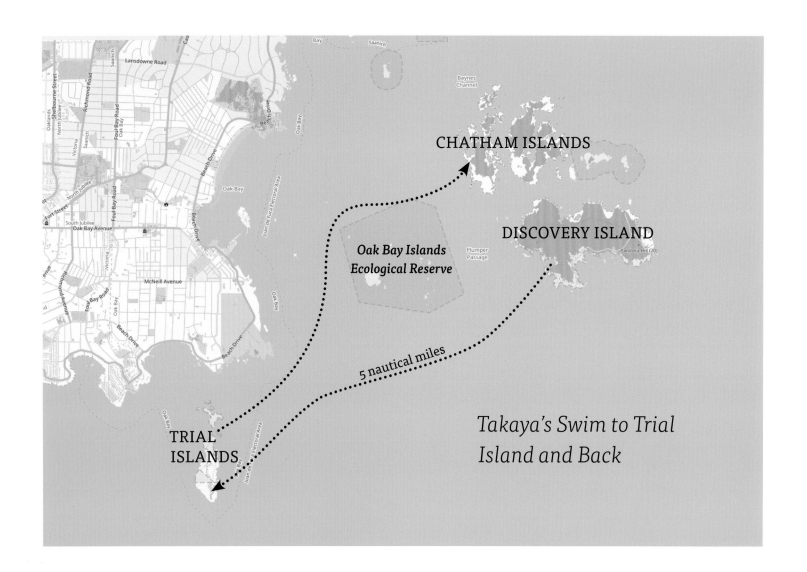

CHATHAM ISLANDS

DISCOVERY ISLAND

Oak Bay Islands
Ecological Reserve

5 nautical miles

TRIAL
ISLANDS

*Takaya's Swim to Trial
Island and Back*

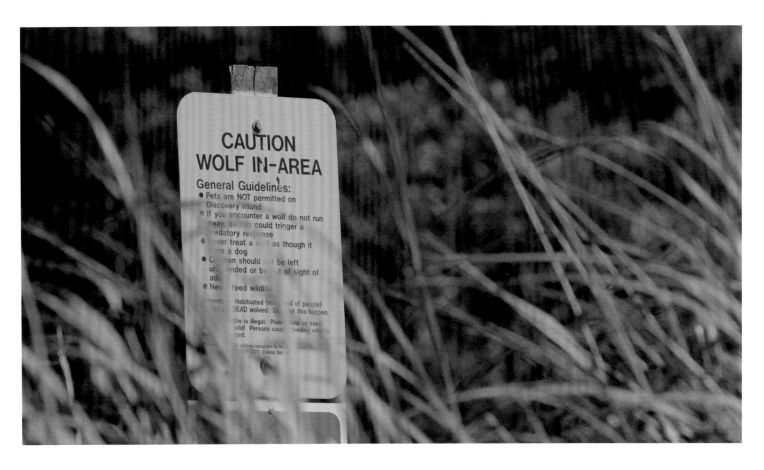

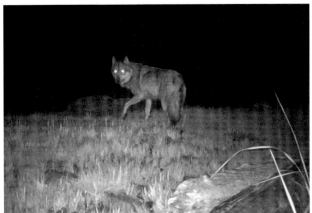

ABOVE Wolf warning sign in Discovery Island Park

LEFT Takaya moves cautiously along a trail at night

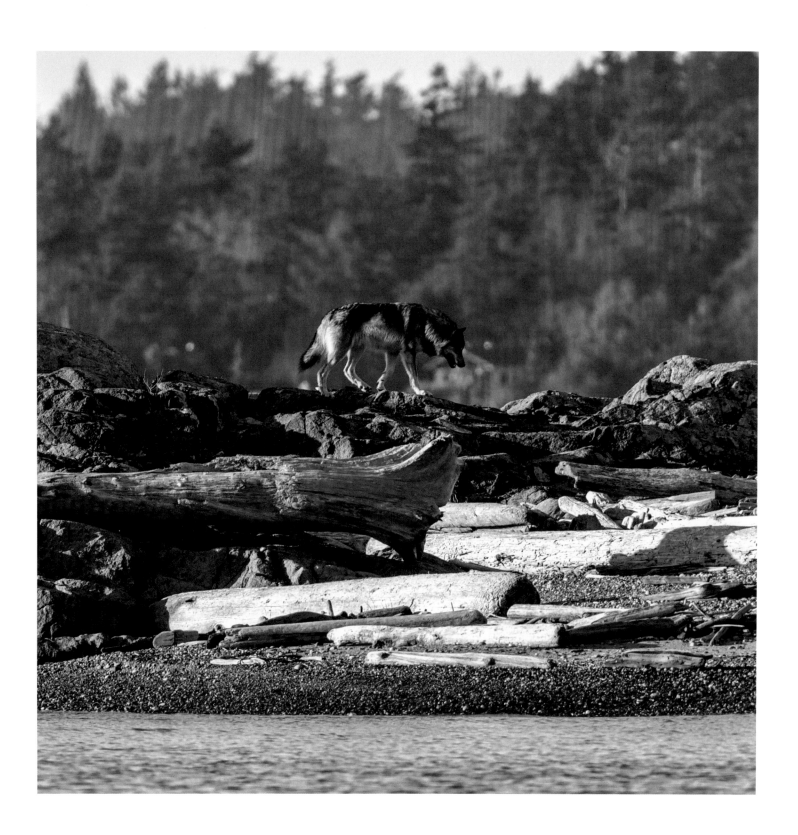

TERRITORY

We shall not cease from exploration, and the end of our exploring will
be to arrive where we started and know the place for the first time.

T.S. ELIOT

As a dispersing wolf, Takaya had found the first of the three things he was searching for: a territory to call his own. He likely very quickly began the ongoing process of marking his home territory. Although a tiny one, it was his.

His new home of 1.9 square kilometres is much smaller than the smallest recorded home range of a wolf pack in North America (33 square kilometres in Minnesota) and the smallest recorded on northern Vancouver Island, which was 64 square kilometres. It is estimated that wolves generally require a territorial size of between 150 and 1500 square kilometres in order to survive.

Takaya's new territory near the southernmost tip of land of British Columbia contains habitat unique to this area of the province. The forests are largely coastal Douglas fir, arbutus woodlands and Garry oak meadows, which are some of the most at-risk terrestrial ecosystems in Canada. Tidal lagoons, vernal wetlands and coastal bluffs dot the terrain.

Wolves generally live in the more northern areas of the island and province, choosing forested lands where the ecosystems do not include arbutus trees or Garry oak meadows.

OPPOSITE Takaya traverses his territory, a suburban area of Victoria visible in background

- ■ *higher wolf density*
- ■ *lower wolf density*
- □ *Takaya's Territory*

Wolf Distribution
on Vancouver Island

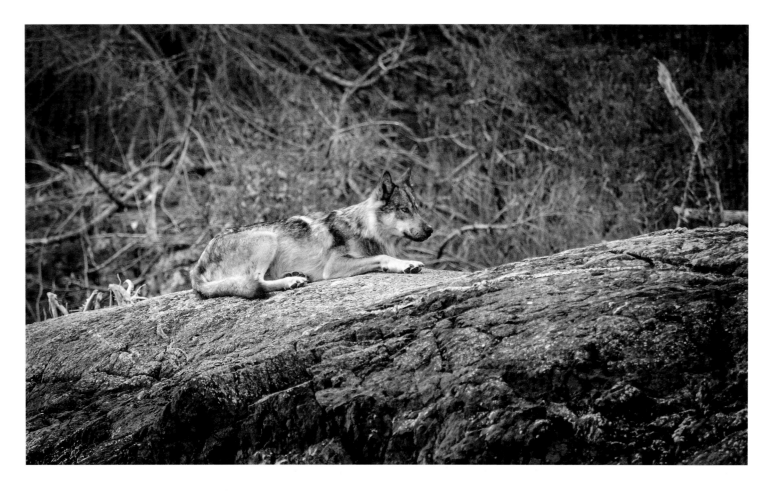

This makes Takaya's choice of home a rather unusual habitat for a wolf. It is rare to see a wolf against a backdrop of the beautiful reds of the arbutus tree, or lounging in meadow grasslands. Takaya's coat fits this ecosystem in a most remarkable way, blending with the coastal intertidal and arbutus colours, making him virtually invisible to anyone passing by. The fur behind his ears glows red, almost as if reflecting the rich auburn hues of the arbutus bark under which he lies.

Takaya's territory is unique in another way from most other wolves: his life on the islands has also required that he adapt and live with constant reminders of humans and their activities. He sees and hears the hum of the city, of hammers at construction sites, of dogs barking in neighbourhoods, of cars and sirens, of airplanes and helicopters constantly overhead. Kayakers, paddle-boarders, boaters and whale tours make visits to his islands, yet he has learned how to maintain a safe and healthy boundary, preferring to avoid rather than approach people. He has had to figure out how to safely coexist.

The second thing that Takaya was searching for was territory that contained a reliable source of food. A stable food base is really significant for a wolf — especially one on his own. This was likely a little challenging for him in this island ecosystem. It is most likely that his early life with his natal pack primarily involved hunting deer, elk and other small land mammals. This new territory required that he adapt to and figure out how to hunt a new kind of prey, and rely on an almost completely marine mammal diet.

Making a Mark

Wolves are intensely territorial and patrol large home ranges. Areas are chosen where there is adequate prey and where there is little over-lap with the territories of other wolf packs. The wolves will then define their own territory through a number of strategies. One of the pri-mary ways is to use scent-marking as they travel the boundaries and important routes of their ar-eas. This involves urinating and/or depositing scat (feces) at trail junctions and along bound-aries every few hundred metres. Other wolves will then smell the scents and know that the ter-ritory is occupied. A pack must also be prepared to defend their territories and will howl to warn intruding wolves away.

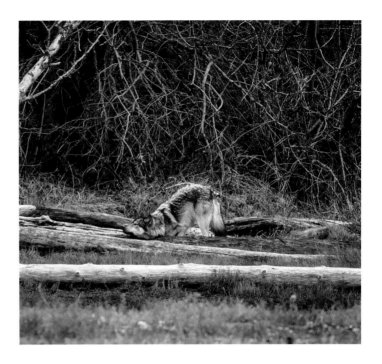

OPPOSITE Takaya blending with coastal colours of his ecosystem

ABOVE Takaya scent-rolling in an unknown substance

Takaya's new chosen habitat had no deer or other ungu-lates like elk or moose, and no small land mammals like rab-bits, squirrels, racoons or beaver. His typical prey didn't ex-ist, so what was he going to eat?

Very quickly Takaya would have begun to develop a com-plex understanding of his territory. He would have traversed each nook and cranny of it and begun to learn every detail of the landscape. It is obvious now, after almost nine years, that he knows every stone and tree as well as the movements and possible locations of his potential prey: under which pile of beach logs he will find otters; where the seals will haul out; where they may leave their pups. He knows where, when and how to lie in wait. To begin with, however, he would have had to observe and learn.

These islands also have no year-round source of fresh wa-ter. There are some swamps and vernal ponds on three of the larger islands which fill during rains, but in times of drought during the summer and fall months, these often completely dry up. What would Takaya drink then?

And then there was the third item on Takaya's list — a mate. But there are no other wolves in this territory, or even very nearby. The nearest wolf packs live more than 40 kilo-metres away and the sea and a city separates him from them. Where would he find a mate?

In the 1990s, Jamie Dutcher, with her husband, Jim, had dedicated her life to raising a pack of wolves in Idaho, filming and studying them in intimate detail over six years. The pair developed extensive knowledge of the social lives of wolves.

I invited Jamie to the islands to see Takaya and to get her thoughts on why he came to the islands, as well as why he stays. She told me a wolf will most often leave its natal pack at about 2 to 3 years of age because of a deep-held urge to strike out and start its own family. These are the would-be

Takaya stakes his claim – continually

I do a lot of work on the island, clearing invasive species (mostly ivy). It seems pretty clear that I am working for Takaya. Each night after I leave, he comes by and checks on my work. When I go back the next day, there will be scratch marks and other signs. As far as I can tell, scratch marks are signs of approval, and scat is, well, a sign of disapproval. I do my best to keep him happy. Oddly, humans feel that they own the island. It's pretty clear that Takaya thinks he owns the islands. And, for all practical purposes, he does.

—email communication from David Green

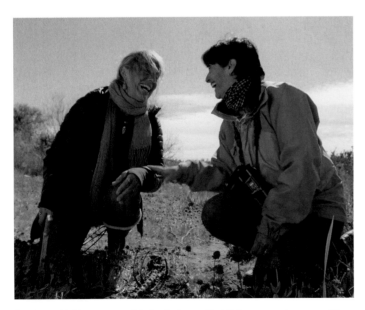

Jamie and I discuss possible techniques that Takaya may have used to turn seals inside out

alphas who recognize that their pack already has a strong alpha, a fact that prevents them from becoming one.

Females and males disperse from their packs in approximately equal numbers. A dispersing wolf will generally look for another dispersing wolf of the opposite sex and start a family. "Being a lone wolf is not a situation that a wolf wants to be in for a long time, because they are such deeply devoted family animals," Jamie told me. "To be a single wolf for an extended period of time is incredibly difficult. There are stories of wolves that have struck out on their own and have gone searching for territory and a mate, usually for several months or possibly a year or so, but not as long as this wolf. He is pretty remarkable."

Another iconic lone wolf known as OR7 undertook a similar journey in the western U.S. That wolf wandered many hundreds of miles over nearly three years before eventually finding a territory and mate.

It would seem, then, that despite being alone, Takaya is a leader — an alpha male in waiting. Lone wolves usually have the strongest personalities and are the risk-takers best equipped to adapt to new challenges. This certainly seems to be the case with Takaya. He has proved his mettle by remodelling his behaviour to survive at the very edge of normal.

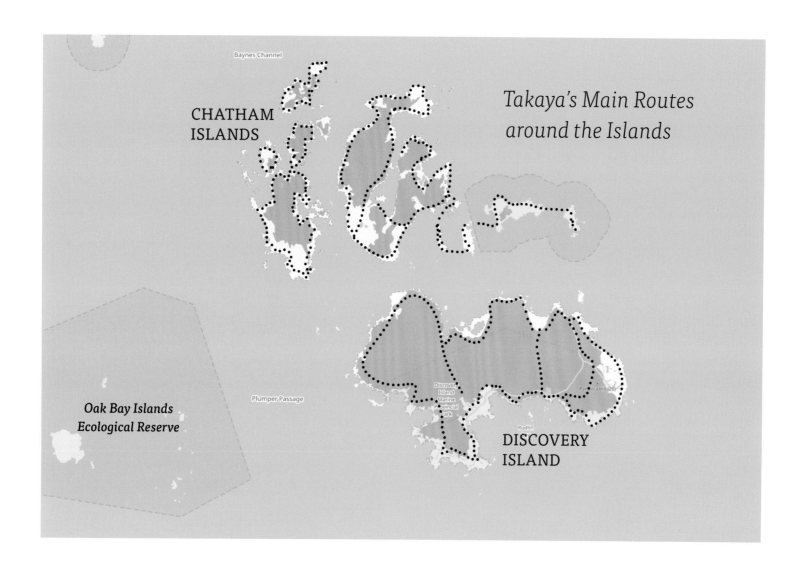

CHATHAM
ISLANDS

Takaya's Main Routes
around the Islands

Baynes Channel

Oak Bay Islands
Ecological Reserve

Plumper Passage

Discovery
Island
Marine
Provincial
Park

Rudlin

DISCOVERY
ISLAND

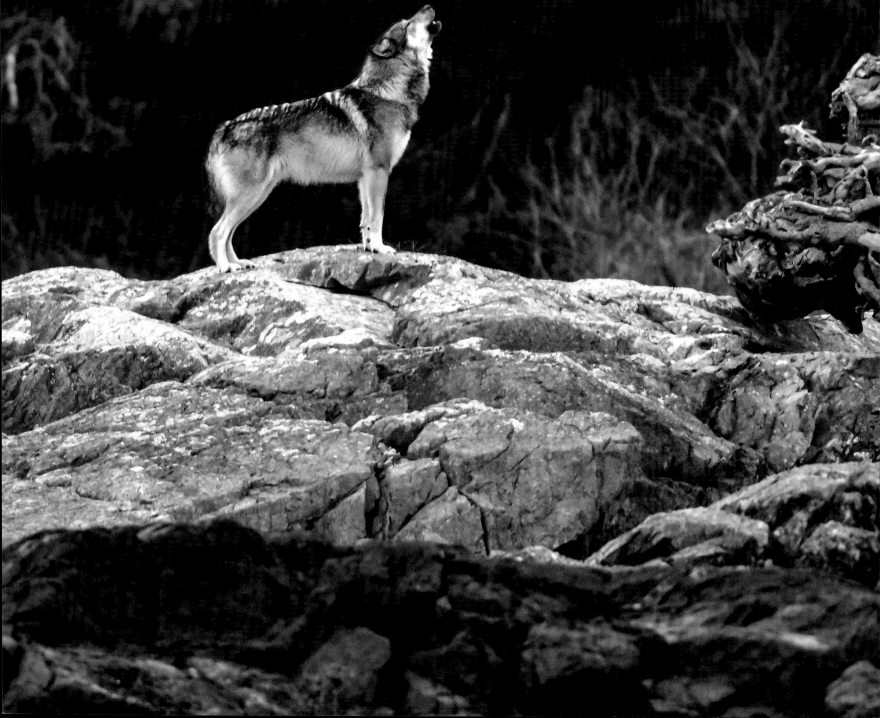

A Wolf Odyssey – OR7 "Journeys" South

OR7, aka Journey, is an American wolf that achieved celebrity status. Conservation groups who followed his life made his story public in an effort to make him 'too famous to kill'. Journey was born in northeastern Oregon and at around 2 years old made the decision to disperse, or leave his family. He was radio-collared and therefore his journey could be tracked. Journey travelled a meandering route of over 1600 kilometres south through Oregon and into northern California. He remained a lone wolf for approximately two years before eventually finding a mate and having pups. It is unusual for a wolf to survive or stay alone for long. Without a pack it is difficult for a lone wolf to hunt large prey, and there is also the risk of being killed by other wolves. A lone wolf has an innately strong drive to find a mate and have a family.

What's in a Pack?

Generally, a pack of wolves is made up of an alpha pair, which are the breeding pair. The beta wolf is generally second in command, and in our pack the beta wolf was actually the puppy-sitter and peacemaker. Below the beta you have these mid-ranking wolves which are constantly squabbling amongst themselves for a better place within their mid-ranking group. They move up and down in status. Below all the other wolves are the omegas, and the poor omegas are usually the ones that are picked upon.

—Jamie Dutcher, American naturalist

OPPOSITE A lonesome howl at dusk

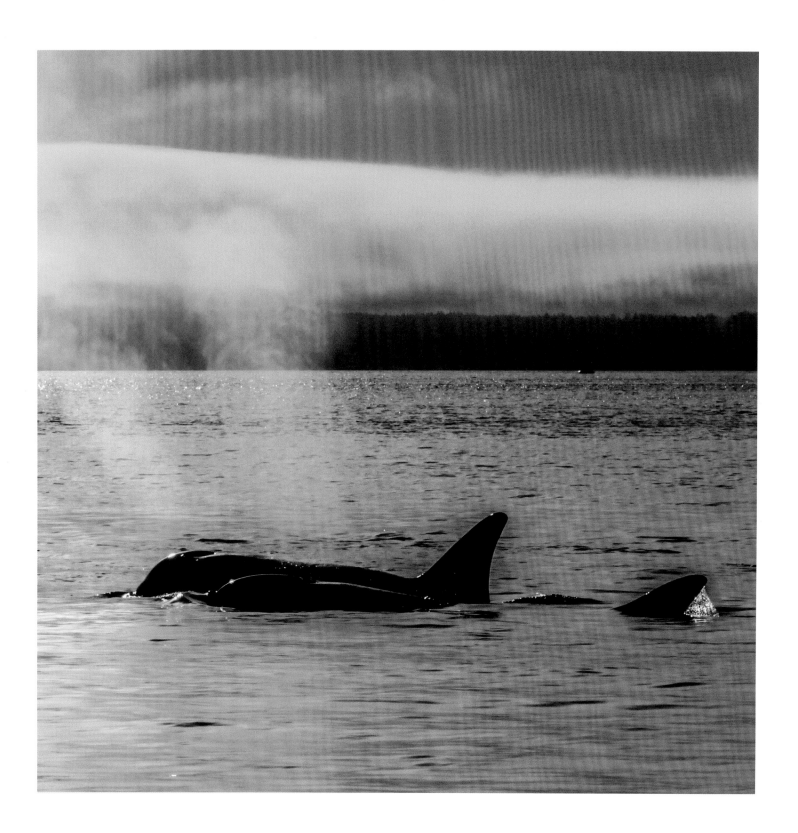

OCEAN

With every drop of water you drink, every breath you take,
you're connected to the sea. No matter where on Earth you live.
Most of the oxygen in the atmosphere is generated by the sea.

SYLVIA EARLE

In order to effectively patrol his territory and find ample prey to hunt, Takaya needed to move constantly between all the islands in the archipelago, which includes three large islands, five smaller islands and numerous rocky outcroppings.

This means swimming. And it means swimming across channels with extremely strong tidal currents that are constantly changing. Tides move in and out four times in each 24-hour cycle, changing always in direction, strength, timing and duration.

I soon learned through observation that Takaya's tracks and kills were scattered throughout the islands. He was definitely not living only on the larger island, Discovery, as was often assumed. I began to document his patterns of movement by setting up trail cameras at strategic places and then keeping an account of how often he passed, and in which direction he was moving. What the cameras revealed was fascinating. Takaya could move very quickly between one island and the next, and would often do a circuit of his islands on a daily basis.

OPPOSITE Orcas surface and exhale at dawn

One day I saw him on the south side of Discovery. A kayaker reported to me that they had observed him 20 minutes later on the north side of Chatham. He had travelled the length of his territory in under half an hour, including a swim!

My cameras also revealed that he swam at all hours of the day, including in the wee hours of the morning. He primarily visits some of the tinier islands between the hours of midnight and sunrise. Swimming in darkness is not a problem for Takaya.

I decided that I wanted to see if I could photograph Takaya swimming. I initially developed a theory that he would swim at low / slack tidal levels, when the distances between the islands were shorter and the sea calmer. Much of the time, strong currents rush between the islands like a raging river, often creating rapids and eddies. I figured that Takaya would choose easy swimming conditions.

I was absolutely wrong. The first time I actually observed him swim between the two larger islands, he chose to swim across the widest part of the channel — and during a very strong ebb. I was fascinated to see that he knew how to "ferry"

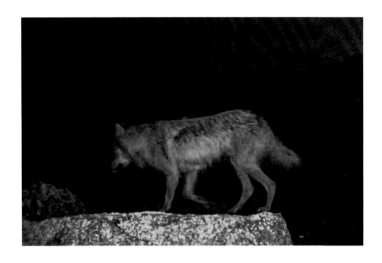

across, making use of the current by swimming diagonally against it, facing upstream, thereby crossing to the opposite side without being swept down. This is a technique that people have used throughout history to cross rivers without being swept away. Takaya is very powerful and fast — an intelligent and fearless swimmer.

I soon realized that one of the biggest dangers for Takaya as a swimmer isn't the sea and tidal state, it is the sporadic presence of humans in the islands. While in the water, Takaya is probably at his most vulnerable, so he is very careful to avoid swimming when people or boats are in the area. I have watched him wait on a bluff for just the right time to swim. Once I saw him begin to swim from one island to another and then, partway across, he turned around. I wondered why, and then saw a crab boat enter the area. With his acute hearing, he'd been alerted to the danger.

ABOVE Takaya emerges from a night swim

BELOW Takaya swims at low tide through his island archipelago

OPPOSITE Takaya leaving Discovery Island to swim to Chatham Island

My good friend Anna often accompanies me on early-morning explorations of the islands and has come to know and love Takaya too. Early one morning we found Takaya on one of the smaller islands, something that hardly ever happens. I have come to believe that he usually visits these islands in the night because he feels more vulnerable and at night there is less chance he will encounter humans. But this particular morning, he had not yet made it back to a larger island. Although we were right beside him in our boat, he made the decision to swim. We were then able to observe him swimming between a series of small islands. At each island, he got out and ran across it, then went back into the water to swim to the next island. It was obvious he felt very exposed and wanted to get to safety as quickly as possible, even though he knew it was us. Once he reached the larger island, he relaxed. He shook himself off, then lay down above us on a favourite bluff. Safe. Comfortable.

Takaya moves as easily and effortlessly in the sea as he does on land. He is at home in the ocean. One day I realized that this may offer another benefit for him besides being able to cover his territory. I have noticed that Takaya's coat is very

That wolf can move

A number of locals paddle amongst the islands and will often send me reports about Takaya's behaviour. I think of them as the *Islands Web.*

Did you see the wolf at 7am yesterday? It was 9:30am when I saw him on the west shore of Discovery. That means he doesn't mind swimming in the current. Max ebb was around 8:30am. He didn't wait for low tide either to cross the channel. On April 9th, it must have swum in a fairly strong current as well, but the tide was lower. I'd love to see the wolf swimming!

—email communication from the *Islands Web*

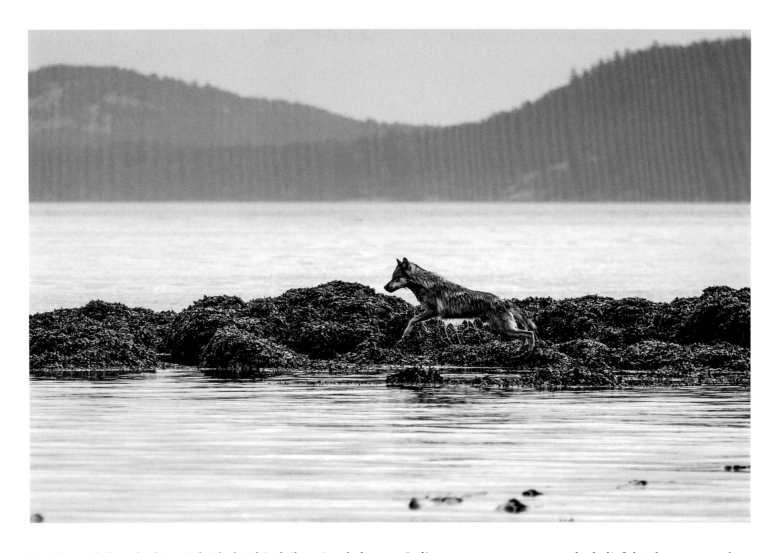

healthy and clean-looking. I think that his daily swims help him to stay well groomed.

As well, when I have observed Takaya with a cut on his nose — presumably from a tussle with prey during a kill — it seems to heal remarkably quickly, within only a couple of days. This may be due to his frequent immersion in salt water.

In a sense, Takaya himself has become a marine mammal. He spends a lot of time swimming in the sea, eats primarily marine food and is kept company mainly by other sea life. This is an interesting thought when considered in the context of a legend of the Haida people. This BC coastal Indigenous group expresses the belief that long ago, wolves became orcas, often referred to as sea wolves. Wolves are considered the land manifestation of the orcas because they mate for life, are intensely family-oriented, hunt and travel in packs, and are the apex carnivores in their ecosystems.

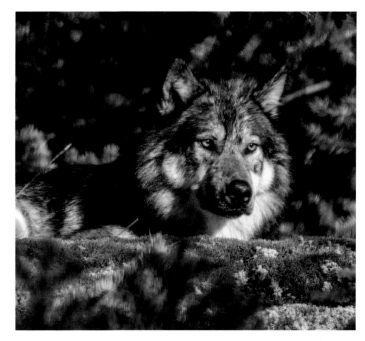

Whale to Wolf

The *kak-whan-u-ghat kig-u-lu'-nik* or *akh'lut* is an orca-like composite animal that takes the form of a wolf when on land. The killer whale is credited with the power of changing at will to a wolf. After roaming about over the land, it may return to the sea and again become a whale.

—Inuit folklore

OPPOSITE Using rocky outcroppings, Takaya moves amongst the islands

ABOVE Anna elegantly boards my boat during one of our early morning adventures

ABOVE RIGHT Takaya with an injured nose (likely from hunting a seal or river otter)

Wolf to Whale

Once a man found two pups on the beach. He took them to his home and raised them. When the pups had grown, they would swim out into the ocean, kill a whale, and bring it back to shore for the man to eat.

Each day, they did this. Soon there was too much meat to eat and it began to spoil. When the Great Above Person saw this waste he made a fog, and the wolves could not find whales to kill nor find their way back to shore. They had to remain at sea.

Those wolves became sea wolves (orcas): *wasco*, the sea wolf.

—*Wolf and the Sea*, Haida legend

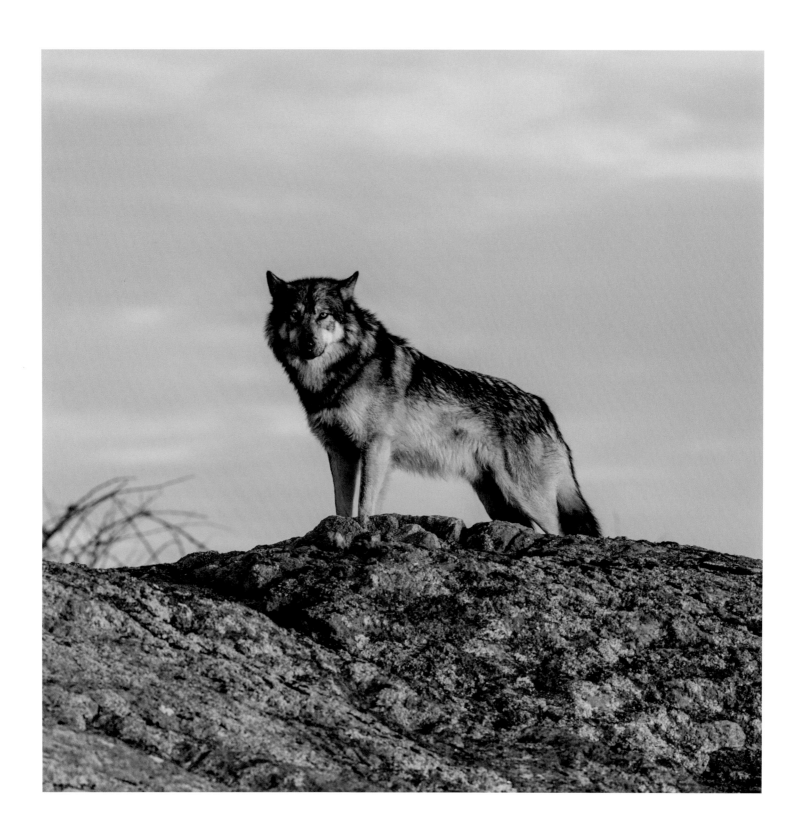

WONDER

And only then, when I have learned enough, I will go to watch the animals and let something in their composure slowly glide into my limbs; will see my own existence deep in their eyes.

RAINER MARIA RILKE

I have always been drawn to mysteries, to the unknowns, to the intangibles of life. Perhaps this was what thrilled and intrigued me about this wolf: he was the epitome of wild, his life largely unknown.

My second close encounter with Takaya occurred later in 2014. He crossed in front of me as I was hiking along one of the island paths. He stopped. Our eyes connected. There, in the intensity of his gaze, I saw wonder. At the same time, I sensed a completely relaxed attitude, a curiosity, an acceptance of my presence in his territory.

It was in that moment of looking deeply into the wolf's eyes that I was truly enthralled. I felt like I was in contact with something very ancient, elemental and somehow connected to the deeply buried wild part of what it is to be a human animal.

Looking into the eyes of a wolf is a very powerful and moving experience — indescribable, really. It stirred in me a longing for a deep connection with the wild world, a world I knew I wanted to be in and to understand more fully. Throughout my life it is in wilderness that I have always felt most alive and connected to the Earth. Most at peace with myself.

A classic story from Aldo Leopold, in an essay called "Thinking Like a Mountain" from his book *A Sand County Almanac*, describes an experience he had looking into the eyes of a dying wolf that he and fellow foresters had shot. It was an experience that eventually came to symbolize his awakening to nature, and his shift to understanding the significant role of wolves and predators in ecosystems. He moved from his role as a forester seeking to eradicate wolves to an advocate for wildlands, wildlife and apex carnivores.

I was curious about why the presence of a wolf in wilderness conjures up feelings that are difficult to describe. There is a sort of magic, and somehow the islands felt different after this wolf arrived. Even though visitors to the islands may not see Takaya, they express a satisfaction and joy at just knowing he is there. I know that when Takaya is no longer living in the islands, it will feel empty, somehow bereft of its vitality.

OPPOSITE Takaya on a bluff, looking into my eyes

I photographed a lone wolf for about six months in Northern Ontario over 40 years ago. She was apparently estranged from her pack and was in pretty rough shape when we first met. You could see her ribs and she was suffering from mange. She favoured one paw and seemed nervous, at least when she was at my camp. I had noticed her tracks following the trails I snowshoed every day for several weeks before I first saw her in person. It seemed I was breaking trail for her explorations.

I remember the day our eyes first met. I was out chopping wood. At first, she stood in a stand of trees about 150 yards from my cabin, apparently watching me and the activity at my bird feeder. I put suet out and my feeder had attracted mink, marten and a rare fisher but never a wolf before. There was something in her eyes that spoke to me. A sense that she knew she was in trouble without her pack and probably not going to make it without a little help.

My heart went out to this wolf. I would see her come by every few days so I started putting meat scraps out for her. First on the edge of the forest, then halfway to the cabin, then eventually right beside my bird feeder, which was outside my picture window. Within a few weeks she stopped limping and she looked more relaxed when she stopped by. By the spring she had turned into a magnificent specimen of a healthy wolf. Strong, alert and so beautiful.

As I prepared to leave camp for an extended period, I weaned her off my supply of fresh meat, but she still came by once a week to check on me and to watch my feeder. Over the years, I imagined that she would kick *** if she ever rejoined her pack. I know I had changed her life and before long it is clear she had also changed mine.

—Garnet McPherson,
posted on CBC's *The Nature of Things* website

Jim Brandenburg, in his book *Brother Wolf*, paraphrases Sigurd F. Olson to express the magic of wolves:

If a country is wild enough for wolves, then it is wild enough for the human spirit. If it is big enough for wolves, it is big enough to accommodate our primordial needs. Wolves make a country alive and complete, for without wolves ... the country becomes merely countryside, tamed because, though it may retain its beauty, it has lost its vitality ... Without wolves and their wildness, the country lacks the very electricity of life. (page 150)

Undoubtedly there is something in the eyes of the wolf, in the spirit of the wolf, that resonates deeply with us. Some have described that it seems as if the wolf looks right into your soul, while others say that the wolf looks through or past you — that as a human, you are rather insignificant in the life of a wolf.

For me, the essential feeling of locking gazes with a wolf — with Takaya — is one of absolute wonder.

OPPOSITE Moving silently along beside me in the woods, Takaya cautiously peers out

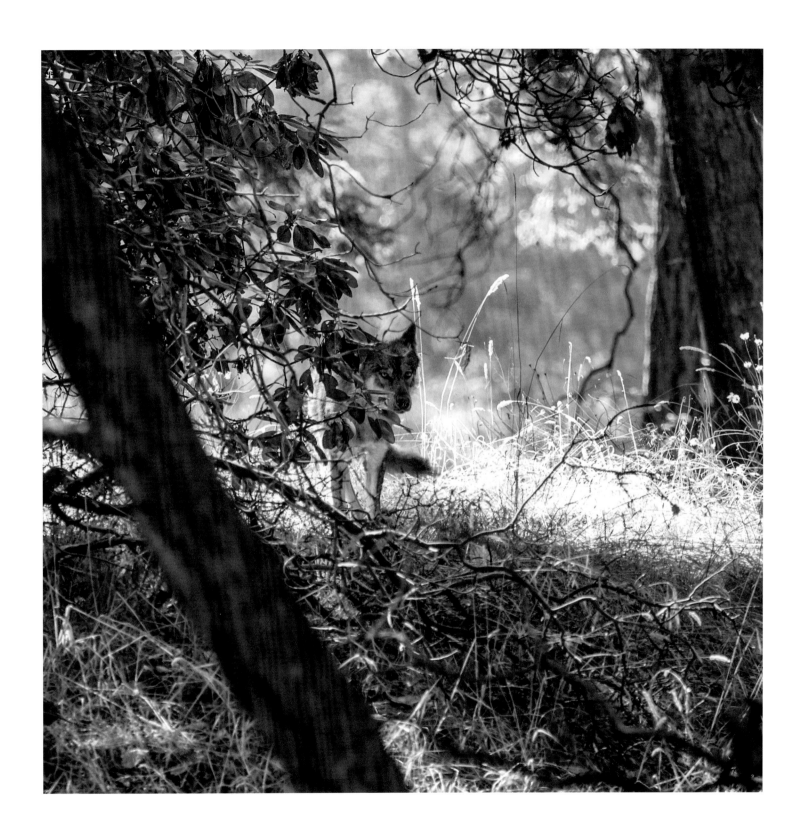

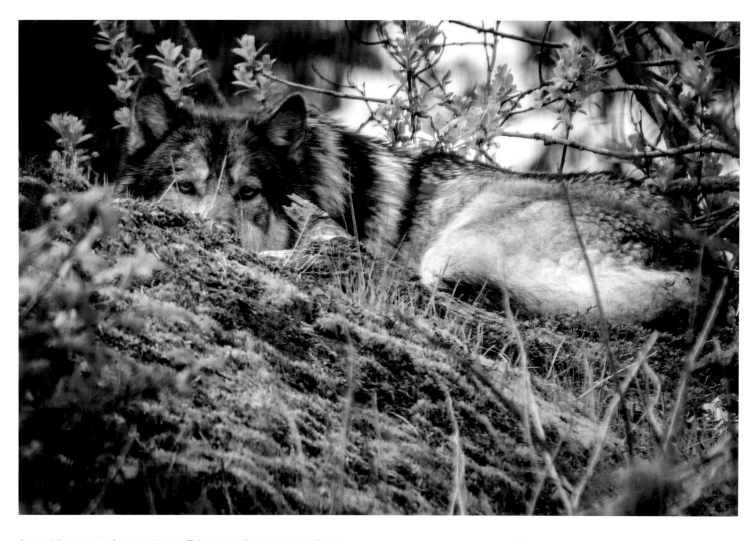

A special moment of connection as Takaya quietly gazes at me from a
favourite resting spot

Look into My Eyes

We reached the old wolf in time to watch a fierce green fire dying in her eyes. I realized then, and have known ever since, that there was something new to me in those eyes — something known only to her and to the mountain.

—*A Sand County Almanac*,
Aldo Leopold, page 138

Although a much briefer encounter, I too once looked into the golden eyes of a lone male alpha wolf who approached me while I was painting in Tremblant National Park. It was a moment that transformed my whole life. This is partly why I resonate so profoundly with your relationship to Takaya. I also feel your profound connection to the natural world, and your talent at expressing this connection through stunning photos and words is a delight to behold.

—story provided by Holly Friesen, artist

The Wild in Me

A poem by Lorna Crozier, a local Victoria writer whom I had met at a friend's house around this time, captures some of what I felt in that moment of connection with this wolf.

Wolves

The wild in you has gone out
to meet the wolves who are hunting

on the other shore. You can't see
this wayward part of you

like you see your breath in winter,
but you feel the bite of canine teeth

as if you now live
in the throat of a panicked deer.

You've never understood before
what beauty means, how it

blasts the blood and leaves you
shaken, demanding more

than you can ever,
in this human body, be.

CHALLENGE

Life is not measured by the number of breaths we take,
but by the moments that take our breath away.

MAYA ANGELOU

As a photographer of wildlife and nature, I was excited to see if I could capture some of Takaya's life on camera. I felt inspired by the ability of this wolf to live his life with such resilience, strength and courage. The more I came to know about him, the more important it seemed to document his unusual life.

As I began to learn about Takaya, I realized I needed a new set of skills in order to properly study and document him. I wanted to develop my boating skills, my video talents, my knowledge of tracking and signs. I also needed to develop a better understanding of wildlife field research techniques, like using remote cameras that are triggered by movement to capture still or video images

My library of wolf books grew exponentially. Dave, a confirmed minimalist, wondered how many more books my office shelves could contain!

I've always loved kayaking, and have done lots of whitewater and ocean kayaking over my lifetime. It is a most wonderful way to journey on the sea and to travel amongst the

islands. It is, however, fairly difficult to take professional camera equipment out in a kayak. Additionally, the strong currents and large seas often meant that heading out in a kayak wasn't a reasonable option for me. I began to travel out to the islands in a small, 17-foot outboard fibreglass boat. The classic boat of choice for West Coast fishermen: an old Hourston. These boats were designed by Chuck Hourston and built locally in North Vancouver, with a stable hull designed for West Coast seas and solidly constructed to last for years. By around 2018 I had shifted to my current boat, a smaller inflatable that manoeuvres through the narrow, rocky passageways out in the isles without as much risk of hitting hidden rocks at low tidal levels.

Taking to the waterways by motorboat meant that I needed to become more experienced and confident in all kinds of conditions — and on my own. I had to get better at navigating the often treacherous waters around the islands. The water bristles with shoals, unmarked rocks and strong currents — sometimes even lethal deadheads. These make navigation challenging and at times downright dangerous. I began to mark the hazards I found on my GPS, which helped me to remember submerged dangers. I committed to memory the

OPPOSITE I scan for Takaya, carefully steering *Blenny*, my small inflatable, through the islands

flow of the sea and the movement of the currents through the islands.

I became acquainted with many of the hidden dangers, however I still stumbled into a few really scary situations. Once I hit a log while returning home in the dark and nearly capsized. Another time, I misjudged the location of a rock and got trapped against it by the rushing ebb current, just managing to get off without putting a hole in the fibreglass hull. And then there was the time I got the anchor chain wrapped around the prop while trying to reverse and avoid getting swept downstream. Ahhh, the currents will take you!

My research and documentation required that I be able to drive my boat, navigate and use my camera at the same time. Keeping the camera still while filming was a constant challenge. I did get better with experience, and gained confidence in being able to know what the seas would do, as well as navigating and steering with one hand while stabilizing the camera and filming with the other. My propeller, however, still shows the scars from encounters with rocks.

As Captain Beaumont, an early island settler and boater in the area, used to comment, "I know where all the rocks are. I've bumped into all of them. And every once in a while, I bump into them again, just to remind myself!"

In order to better understand the traces of Takaya that I found around the islands, I decided it would be helpful to develop a better understanding of signs and tracks. I travelled to Tofino to take a tracking course from David Moskowitz, a renowned wildlife tracker and researcher. We were very fortunate during the course, because it turned out there was a

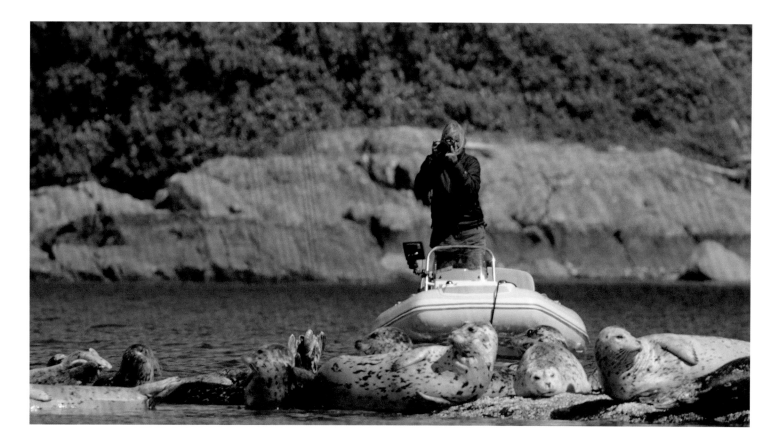

pack of wild wolves living in a sand-duned beach area and so we were able to learn a huge amount about tracking and understanding the movement of wolves, an animal normally extremely difficult to even find in the wild.

This knowledge really helped me to read information from Takaya's tracks and scat, to better understand his behaviour and analyze where he might be. How long before me had he passed by a certain spot? Was he walking, loping, running, leaping? Was he perhaps carrying or dragging something? Was he marking his territory? Scent rolling in a pungent odour as a way to disguise or camouflage his own odour and get closer to his prey?

Especially at first, Takaya was difficult for me to find. He also moved around a lot at night. Wolves tend to be crepuscular, meaning they move and hunt most often at dawn and dusk. I knew it would be helpful to use a motion-activated wildlife trail camera to try to observe some of Takaya's life, so I started down that road of learning.

I knew nothing about using trail cameras, and it turned out to be a pretty steep learning curve. Happily, I got lucky the very first time I set my rig up. When I reviewed the memory card, the very first video clips showed Takaya running along the bluff at sunrise and then sitting right in front of the camera and howling his thoughts seaward. I could hardly believe it! I was thrilled. This first success inspired me to try to capture more moments of this wolf's life.

Though sometimes breathless — either from inspiration or having had the wind knocked out of me — I met each challenge. And my confidence grew.

ABOVE Photographing seals from *Blenny*

OPPOSITE Kayaking towards the islands at first light

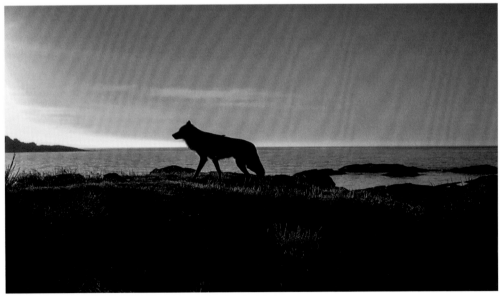

ABOVE Setting up my trail camera

LEFT Takaya patrols his shores at sunrise

OPPOSITE Takaya's prints indicate his movement along an intertidal mud flat

Ghosts on the Landscape

With a topic as complex as the relationship between wolves, the ecosystems they inhabit, and humans — their primary predator as well as their biggest admirer — the methods of a wildlife tracker come in handy ... Wildlife trackers are comfortable with ambiguity; it's the nature of their work — indeed, having a sound assessment of what can and cannot be determined from tracks and signs is as much a skill in wildlife tracking as is actually resolving any questions from the evidence ... While the tracker is comfortable living with ambiguity and with having to amend explanations of the unfolding story, he or she must also be comfortable stepping beyond where the trail disappears, anticipating where it might continue, and striking off in that direction.

—*Wolves in the Land of Salmon,*
David Moskowitz, page 18

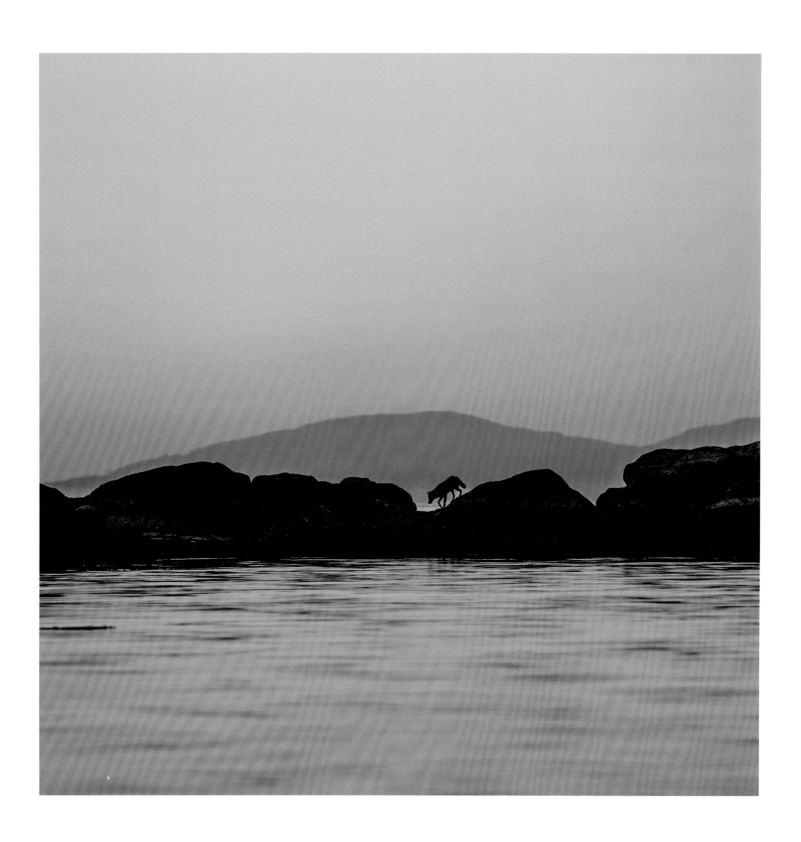

MYSTERY

If we can somehow retain places where we can always sense the mystery of the unknown, our lives will be richer. We will find strength and beauty.

SIGURD F. OLSON

After my initial encounter with Takaya in the spring of 2014, I had enthusiastically contacted a BC Parks supervisor to share the photos I'd taken and to ask questions about the wolf. It turned out that not much was really known about the life of this wolf. No one was really paying much attention to him.

As I knew almost nothing about wolves, my first questions were simple: *Where does he spend his time and where does he sleep? Does he have a den or home base? What does he eat? What does he do for a water source?*

I also had a few more-difficult questions: *How does he get along without a pack or family? Is he lonely? Why does he stay here?*

As an amateur detective, I had many questions. And I wanted answers.

After returning from Desolation Sound, I began to head out more frequently, often at dawn and dusk. Nothing quite compares with crossing a silky, rose-tinted sea toward a sliver of land outlined by the rising sun, and seeing a wolf silhouetted on a rocky isthmus.

I began my search for signs on Discovery Island, the largest in the archipelago. At that time, I believed the wolf to be living only on that one island. I followed trails through the grass and invasive ivy that covered the ground, hoping to find where and how the wolf was spending his time. Early newspaper reports had indicated that the wolf was a female and was believed to be building a den. I tried to locate a den site to find where the wolf slept.

OPPOSITE Takaya hunting at dawn

ABOVE Using my GPS, I navigate the channels and rocks just before first light

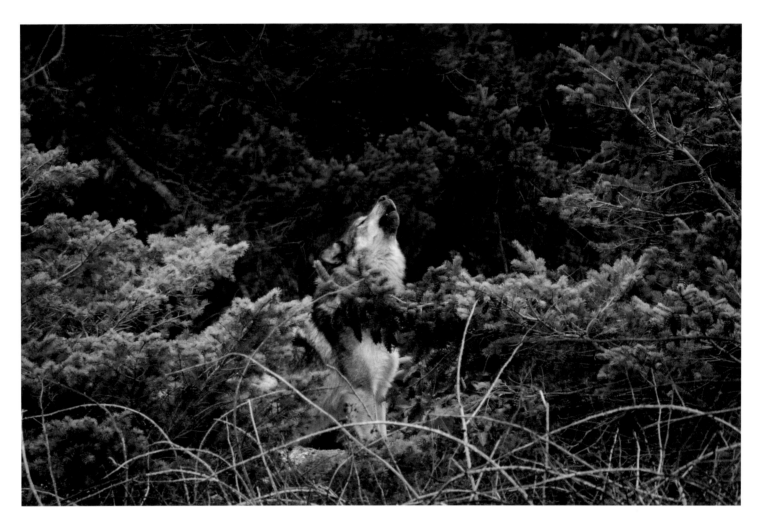

Takaya howling his feelings skyward

One of my main challenges was to actually find the wolf itself! The islands are forested with dense undergrowth. Unless the wolf was near the water, I really had no hope of figuring out where he was. Also, early on, I had not yet understood that Takaya actually travelled frequently between the many islands and so could be on any of them.

It wasn't until the fall of 2014 that I again actually saw Takaya. During this encounter, I saw the wolf disappear into the woods and then it began howling. Some of these howls sounded really strange. What started out as long melodious howls shifted more toward a rough, deep, growling kind of howl, likely in response to a couple of campers who were hiking along the trail in the wolf's vicinity. Later I would learn what kind of howls these were.

And then, a week later, another sighting of the wolf. All very thrilling.

At that point, I had the idea to set up a trail camera near where I'd seen him. I had found a seal kill in the middle of a nearby field, so I knew this was a spot where he was active.

From the data collected on this trail camera, I began to

Howls – Speaking as a Wolf

Wolves howl to communicate with their family members and with other wolves nearby. Howling is the glue that keeps the pack together. Wolves often roam over large distances and become separated from each other, so the howl is a way to communicate with pack members. Each wolf's howl is unique, and thus they are able to identify each other. Fred Harrington is a Canadian specialist in behavioural ecology and an expert on the vocal behaviour of canids. According to him, wolves bark, woof, whine, whimper, yelp, growl, snarl and moan more often than they howl — yet it is the solo or chorus howl that captivates us. Many of the sounds that wolves make, such as soft sounds like clicks and whines, I don't hear from Takaya because they are communication among pack members. Fred Harrington identifies three main types of howls:

Lonesome howl. This is the typical solo howl we most often associate with wolves. It is long, mournful and mysterious-sounding. It typically lasts between 3 and 14 seconds, and can rise and fall like the sound of a melodious saxophone. It may be used to attract a mate, communicate with the pack over long distances of up to 15 kilometres or simply to express a feeling.

Bark howl. The bark is a harsh-sounding howl often used to assert dominance, during a threat or an attack, and as a warning or a defence. Often combined with the bark is a woof, which is a soft, low sound that originates in the abdomen rather than the vocal cords. Wolves often bark and woof when humans or other large animals approach a den site. The bark may also be used to warn the pack of danger, or to warn away intruders without actually being confrontational.

Chorus howl. This usually begins with a solo howl and then one or more wolves will join in. The sound may be harmonious or more modulated and wavering, and often sounds complex and chaotic. When the sounds are modulated rapidly enough it will sound like many wolves howling, rather than just the few. The functions of this type of howl appear to be communicative, between and among packs, and it may strengthen social bonds.

keep track of how often he passed through this area and which direction he was heading. Did he travel more in one direction than another? What times of day and night was he active?

Each time I enter the islands, I feel an intense anticipation and excitement about unravelling the mysteries of the wolf's activities. My first question always is *Where is Takaya?* Then: *What happened during the night? Did he make a kill? What is he doing now? Is he hunting? Is he sleeping? Is he watching the sunrise or sunset? Is he monitoring and marking his territory? Will I be lucky enough to see him?*

It took a lot of sleuthing, but gradually I got better at figuring out the movements of Takaya's life. This meant that I could find him more easily. And as I did, I began to understand more about how he was living out there.

Sometimes I would be able to find Takaya via reports from kayakers who had seen or heard him, indicating which island he was on. Mostly, however, I developed certain patterns

and strategies to help me determine where he might be. As I entered the islands, I would check at a tiny beach that I had named Paw Print Beach due to its firm sand that keeps clear tracks. The prints, in relation to the tidal line on the beach, would indicate if Takaya had recently been there; sometimes the prints would indicate the time he most likely passed by. I could often tell if he had just swum over from a nearby island or vice versa.

I found that I loved the process of tracking. There was something magical about following the path that a wild animal had recently made. I once had an experience where I realized that I was travelling across the ground only minutes behind Takaya. I had checked a beach, found no prints, decided to hike around the island, and returned a few hours later to the same beach. There, I found very fresh prints. I followed them, excited by the evidence that he was just

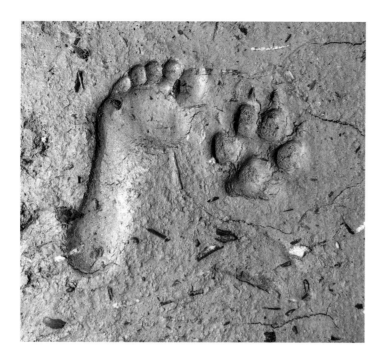

OPPOSITE Takaya's tracks along an island beach

ABOVE Tracking barefoot, I leave my prints alongside Takaya's

moments ahead of me. And then, elation: I spotted him walking around the shore. In awe, I sat down and watched. In full knowledge of my presence, he lay down a little distance away, on a rocky point, as though he were waiting for something.

But Takaya didn't wait long that day. He was on a mission. He decided to go for it, wading into the sea and setting out for another island. It struck me that he was likely returning to the site of a large seal kill that he'd left on a beach across the sound. I had found it earlier that day and, assuming he would eventually return to feed, I had set up a cam. That day, the cam captured his return and subsequent retrieval of his prize — a very exciting discovery for me.

Another time, I took out a member of the local media who had wanted to interview me about the wolf. I had gone out earlier that morning to try to figure out which island Takaya was on. I found him on Chatham, resting high on a grassy bluff.

But by the time I'd returned with my companion, Takaya had vanished. We stopped at Paw Print Beach and found perfect evidence of his whereabouts: his tracks led straight into the water. A thrilling find. It was obvious that he had swum to the next island. Sure enough, we found him there.

Sometimes upon retrieving images from a trail camera, I would see that Takaya had followed exactly the same path I had travelled earlier the same day. I knew he would catch my scent and be aware that I had passed that way. We had occupied the same space moments — perhaps dimensions — apart.

When I follow his trails, I imagine the pattern of his movements and his gait, the experience of his paws making indentations in the long grass or on the beach. I feel his wild presence in the islands. It is a profound experience for me to share the landscape with a wild wolf.

Early one day while out hiking, I spotted Takaya's paw prints in the early morning dew that had formed on a log overnight. He was nearby, likely moving just ahead of me. I could strongly feel his presence but I could not see him. Over the years, I experienced many times this feeling that he was watching me, unseen himself. Only if he chose to would he reveal himself to me while in the forest.

Takaya sometimes did choose to approach me while I was in the forest. It was always a completely silent approach. Cautious, yet curious. I would only have a sense that he was close, and then catch a glimpse. Typically, he would circle around and then lie down nearby, yet far enough away that he maintained a safe zone. On rare occasions, he even let his head fall onto his outstretched paws as he drifted into a doze. Those moments felt like an incredible gift.

As well as following tracks, I became an avid observer of scat, and could glean lots of useful information from Takaya's digested material. His scat indicated what he may have recently killed, how recently he had passed by the scat spot, and how and where he marked his territory. I found it hilarious to witness Takaya stopping in the middle of a large log and

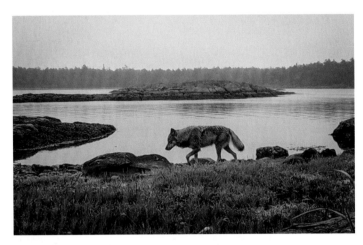

making a "deposit." A hiker on the island once reported to me that Takaya had backed his rear end up to a newly cut log and claimed it as his by careful placement of his scat.

I have collected many samples of Takaya's scat, recording the location, time and date. If I am lucky, I will actually see him make a deposit and be able to retrieve a really fresh sample. These end up in ziplock bags in my freezer (Dave has been very patient with all the scat, hair and carcasses I have brought home to freeze over the years) and have been used for genetic analysis, as well as to determine the specifics of Takaya's diet. Amazingly, often his scat turns out to be almost 100% hair, bone and claws — evidence that his system is very efficient at extracting the nutrients from his food.

It seems a little strange, but I have also developed a pretty good sense of which island Takaya might be on. It's really just a feeling, but over time, I have realized that my intuition is often right. I can't explain this rationally — it's just something that has grown as I've gotten to know Takaya better. Sometimes I'll even have a strong feeling about the exact spot or rock he might be on. And sure enough, there he will be.

Slowly I began to develop a somewhat fuller picture of the life of this wolf. I was humbled to realize that many things I had initially believed to be true were actually false.

One such thing was that I had originally thought the wolf was a female, because this is what had been reported in the news accounts. I had heard that the wolf was building a den and might have pups. Once I realized that the wolf was in fact a male, I became certain that the wolf was not building a den, despite what the news reported. I stopped looking for a den or spot where the wolf "lived." Through my readings and research, I'd learned that only breeding females of a pack will build a den. They will occupy the den for giving birth and during the first few weeks of the pups' lives. Otherwise, wolves do not sleep in a den. They may have favourite or preferred daybed areas but they don't have a specific home spot.

Takaya definitely sleeps around: his beds are scattered throughout the isles.

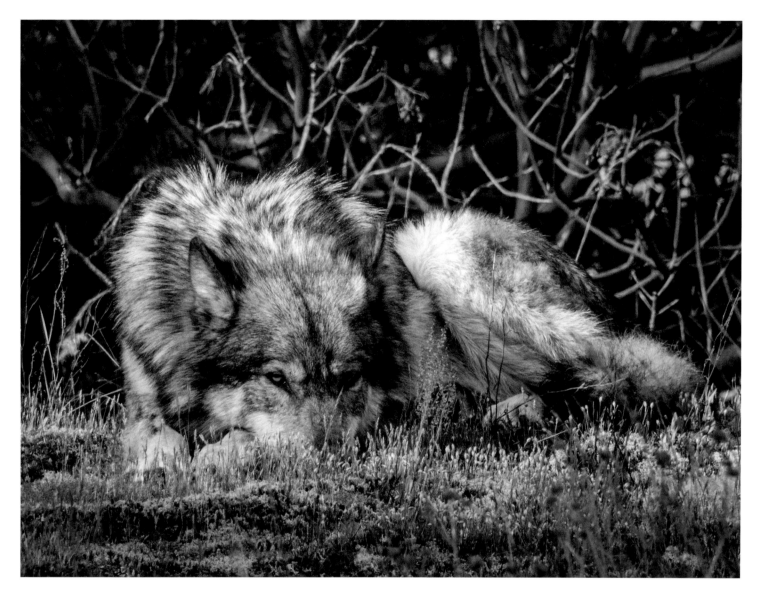

ABOVE Takaya watches me from one of his many daybeds

OPPOSITE TOP I walk along the shore after setting up a trail camera

OPPOSITE MIDDLE Later that day the camera records Takaya following my path

OPPOSITE BOTTOM Tracks in the dew on a log are evidence that Takaya has recently passed by

Peter Steinhart, in his book *The Company of Wolves*, speaks about an early American wolf scientist, Diane Boyd, who experienced moments of inexplicable communication with wolves:

> For two of the early summers while she was trapping wolves, she would occasionally dream at night of trapping one. "When I woke up in the morning, I knew I had caught a wolf. I knew the color of the animal I'd caught, because I'd seen it in a dream." She would tell Mike Fairchild that she had had the dream, and they would go out to the trap line and find that she had indeed caught a wolf.
>
> —*The Company of Wolves*, Peter Steinhart, page 26

OPPOSITE TOP A large seal claw in Takaya's scat is evidence of a recent meal

OPPOSITE BOTTOM I found a really long scat mainly composed of seal hair

ABOVE Takaya sound asleep in a daybed

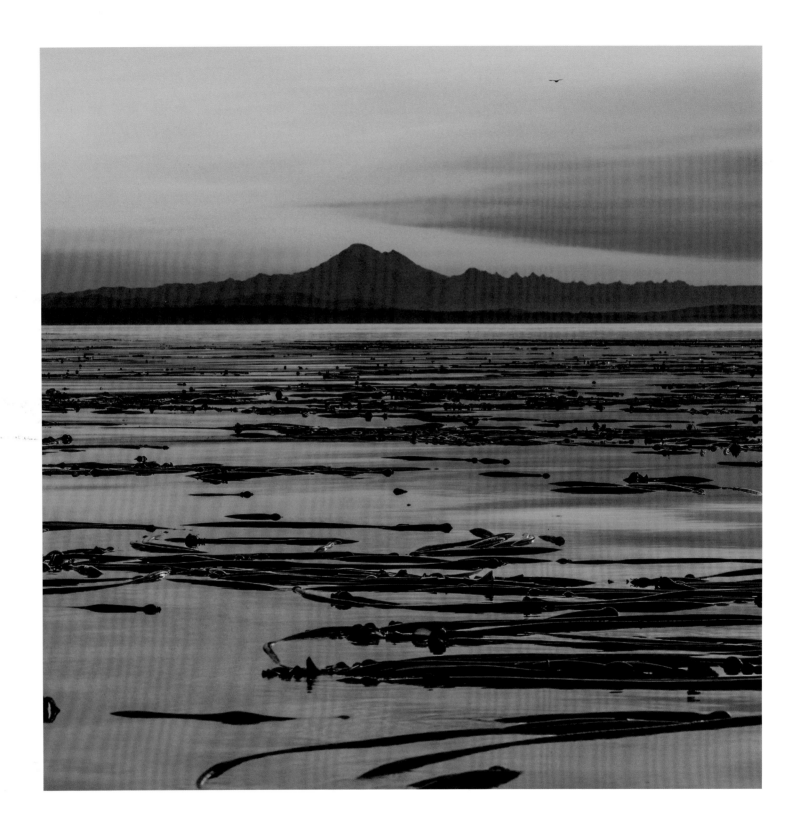

MEDITATION

All the time I was getting closer to animals and nature, and as a result, closer to myself and more and more in tune with the spiritual power that I felt all around. For those who have experienced the joy of being alone with nature there is really little need for me to say much more; for those who have not, no words of mine can even describe the powerful, almost mystical knowledge of beauty and eternity that come, suddenly, and all unexpected.

JANE GOODALL

On the days when I don't find Takaya, I am content to just wander through the islands and drift with the wind and currents, absorbing the intricate web of life in the islands. Often an intense sense of calm will come over me and I feel that this is where I belong, this is where my deep roots are, this is where I will find myself.

I like thinking of the way Takaya experiences his world, through the sights and sounds of creatures going about the business of living and hunting, just like he must. Perhaps he has learned something by watching these animals as well?

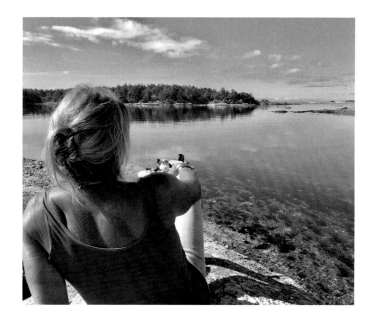

OPPOSITE Kelp bed in the glow of the rising sun, Mount Baker silhouetted

RIGHT Perched on Sedum island, I enjoy a moment of quiet in the islands

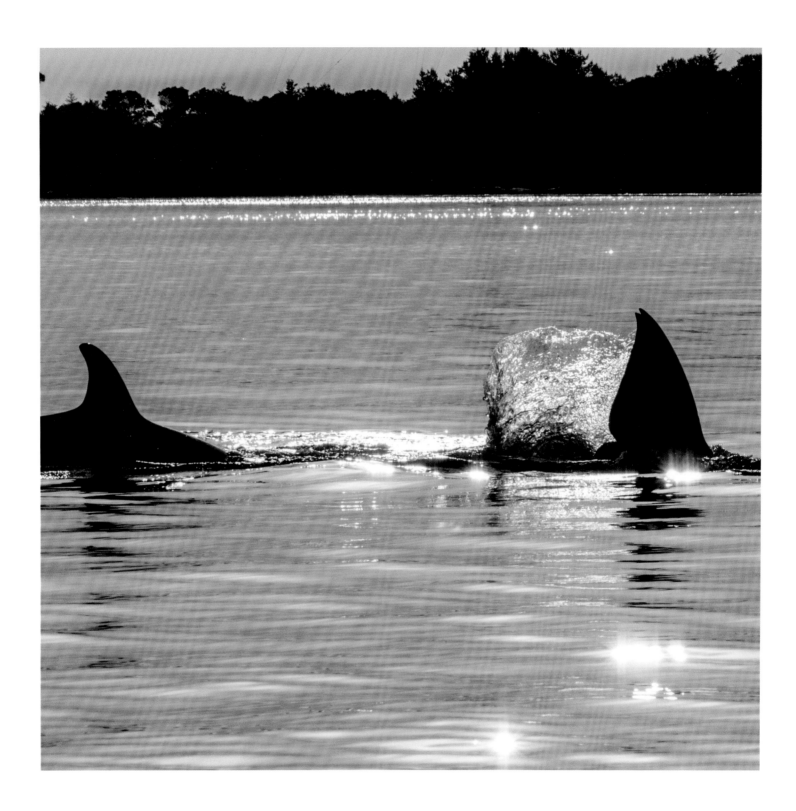

OPPOSITE A pod of transient orcas hunt near the islands

ABOVE Sea lions cluster on Brinn Rock off Discovery island

RIGHT Seals seek protection on intertidal rocks as a large orca enters the shallows

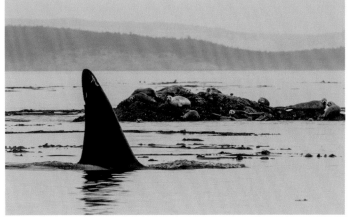

Takaya will often lie still on a rocky outcrop or small sandy area, only his eyes, ears and nose engaged, moving, absorbing everything. He watches, constantly alert.

I love learning about the intricate island ecosystem and the many layers of life on both land and sea.

A breath, a blow — and I know that whales are about. Most

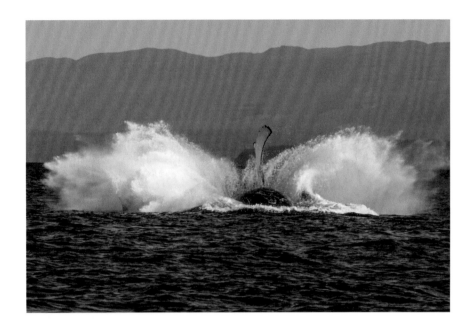

TOP Humpback whale splashes down after an aerial breach

BOTTOM Harlequin ducks gather during their mating season

OPPOSITE Cormorants socialize on an exposed intertidal rock

times it will be transient orcas cruising the islands hunting for seals, sea lions or sea birds. I have watched them swim so close to the rocky shore that I'm sure their bellies are touching the barnacles. The seals, on alert, cower on rocks or try to hide in kelp beds.

I have seen the orcas teaching their young how to hunt seals, circling and swatting at the unlucky individual caught in the middle of their pod. Once, I watched as a juvenile orca caught a seal, and then, the seal's tail firmly in its jaws, pushed its prize through the waves like a macabre Rose Dewitt Bukater (Kate Winslet's character) on the bow of the RMS *Titanic*.

Does Takaya lie on the rocks above and observe all this with a removed curiosity? Perhaps the orcas and other sea life provide him with something interesting to watch, relieving, for a moment, his isolation.

In the past couple of years, the Steller sea lions have moved back into the area, possibly because their population has more than doubled in BC waters since the early 1970s. They haul out on rocks, clustering so tightly together that the rock disappears and all that is visible is a lumbering, snorting, growling mass of huge bodies draped over each other. When the orcas go by, the cacophony of the sea lions' roars can be heard for miles.

Takaya lopes past these giants of the sea and completely ignores them. Perhaps he senses that their immense size means they aren't possible prey for him without the backup of a pack.

One year, a grey whale moved into the islands and stayed for a few months, foraging for tiny creatures on the rich seafloor of the inland waters, filtering the morsels of food through its

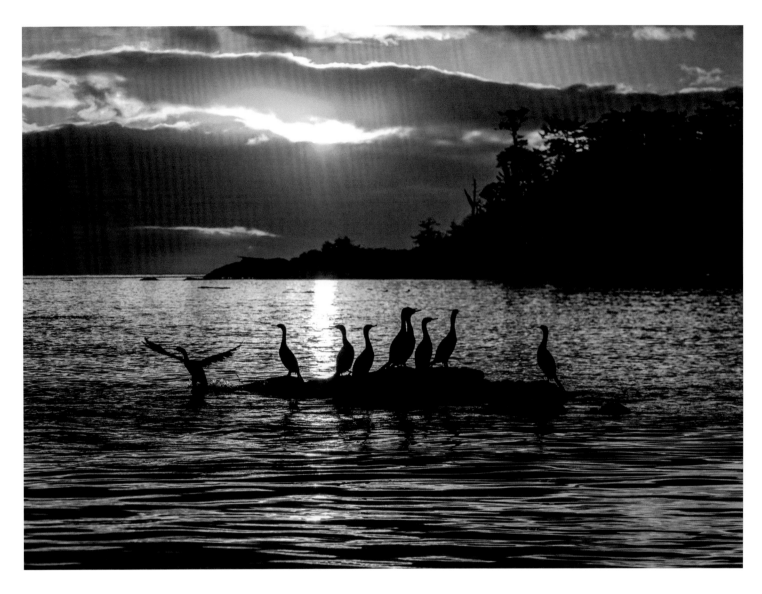

baleen plates. A lone whale in the inner waterways of the archipelago; a lone wolf on the nearby shore.

In recent years, after decades of being overhunted, humpback whales have begun to return to the Salish Sea, and can often be seen and heard in the waters just off the island shores. Surely the songs and splashes of the whales provide exquisite company for Takaya as he lies on the rocky bluffs looking out across the straits.

Bird life is abundant in these islands; part of the area is actually encompassed within the Victoria Harbour Bird Sanctuary, the oldest migratory bird sanctuary along the Pacific Coast. I find myself transfixed when vast numbers of birds obliterate the sky in sudden flight as an eagle soars threateningly overhead. The light glinting off the wings of the sanderling as they fly in tight, fluid formations (murmurations) creates a sense of aerial fireworks.

In winter, sea birds migrate through the area in huge numbers, rafting together in protected waterways around the

islands. Each type of seabird seems to have its favoured spot and will cluster there with hundreds of others.

Large groups of long-tailed ducks gather along the eastern edge of the islands, slightly offshore, often with flocks of surf scoters nearby or intermingled. Harlequin ducks choose the west shores. Buffleheads and mergansers prefer the more protected, lagoon-like areas. Auklets ply the straits where the larger tidal flows are found.

Ancient and marbled murrelets are more solitary, however, and are often found in pairs scattered around the islands, as are the Pacific loons. Occasionally I'll see a Pacific black brant perched on a rock.

The cormorants huddle together on exposed tidal rocks, moving only when necessary when the sea covers their perch. They are sometimes joined by black oystercatchers, which scour the rocks for molluscs and fly low in small groups or pairs, their high-pitched, piping call echoing into the distance.

Mallards congregate in the island marshes and wetlands, foraging for insects and seeds, and feeding on aquatic vegetation. They frighten easily and will all take off en masse if alarmed by an eagle flying over — or if the figure of a wolf is spotted moving along the edge of the pond.

I have only occasionally found evidence that Takaya preys on seabirds. They must be very difficult to catch. Sometimes he lies on the shore watching them go by and I have seen him lunge, ineffectively, toward them. I did find the carcasses of a few mallards that he had somehow caught and dragged up into the bush.

One day the shrill cry of the killdeer alerted me to its presence on a nest of four eggs. But ... can we call this a nest? The bird had simply scratched a tiny depression in the soil on a beach berm. With its "broken wing" display, the killdeer lures predators away from its (quite obvious) eggs by appearing to be injured, and therefore perhaps a little nicer eating.

The marshes of the islands provide a fabulous habitat for songbirds. My favourites are the red-winged blackbirds that

ABOVE A kildeer sits on her nest

OPPOSITE An eagle kills a newborn seal pup as its mother watches helplessly from the water nearby

nest in the reeds and the Anna's and rufous hummingbirds that steal fluff from the bulrushes and fly away with it to make luxuriously soft nests.

The larger birds are always so fascinating to watch. Great blue herons will hang out in the trees surrounding an inner lagoon and hunt fish in the intertidal areas. The way they perch in the treetops seems impossible for such a large, ungainly bird. When a heron is wading in the shallows and Takaya passes by on the shore, each completely ignores the other.

Raptors like red-tailed hawks, rough-shinned hawks, peregrine falcons and osprey also take advantage of the profusion of life, waiting in trees for the perfect opportunity to dive into the sea or a marsh area in pursuit of fish, voles or small birds. I have even seen hawks dive sometimes at Takaya, although I'm not sure why.

Eagles are frequent hunters in the islands, and a few pairs make their nests and raise their young in the tall fir trees. In the spring they can be seen performing incredible aerial mating ballets. Their hunting behaviours are fascinating. As well as fish, they frequently catch gulls, herons, and even newly born seal pups. I have never seen any evidence of interaction

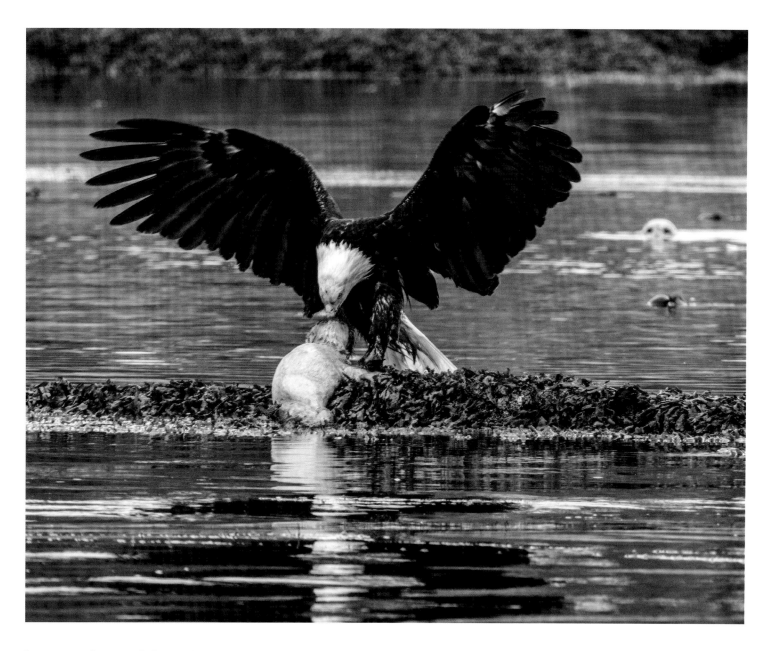

between Takaya and the eagles, outside of him picking up any bird or fish morsels that are accidentally dropped from nests when feeding the young eaglets. I imagine that they each respectfully coexist.

Sometimes — as when orcas encircle a seal that has become separated from its group — the world of the wild is difficult to watch; the cycle of death feeding life becomes more obvious and inescapable. One morning, I had just entered one of the island channels and spotted two eagles on an intertidal rock, barely above the water. I could see they were fighting over something. Stunned, I realized it was a newly born seal pup, still alive. One of the eagles flew off, leaving

the victor to peck at the head of this little writing creature, its mother watching from the water nearby. I could barely keep my eyes on the scene. Although intellectually I understand and lack judgment, I am human. Watching this eagle kill and eat a live seal pup was emotionally painful.

Yet, something dies so that another might live. Life and death are therefore inseparable. It's a human reality as well. This is the immense drama of nature — a drama we would often prefer not to acknowledge. We, in our human world, are so sheltered and out of touch with the life-and-death struggle that happens daily in nature. It is a recycling of life's energy and an expression of the interdependence of all life. Predator / prey relationships are an integral part of all natural ecosystems. These relationships are vital to maintaining the health of an ecosystem and are fundamental in creating biological diversity. Apex predators like wolves are particularly significant in this cycle.

The shallow seabeds around the islands are full of life as well. I love to watch the tiny nudibranchs and anemones floating around in the eelgrass, the plate-sized Dungeness crabs scouring the sea floor, the massive mussels and gooseneck barnacles that get exposed at extremely low tides, and even small beds of oysters struggling to latch on to the rocky intertidal. Jellyfish glide mysteriously, riding to somewhere on the currents. And the bull kelp — stunning arrays of it twisting and glistening in the currents, vast beds surrounding much of the island's shores. These creatures are all part of Takaya's ecosystem, and even

TOP Nudibranch swimming through eel grass

BOTTOM Anemone feeding

though they don't seem to be consumed by him, they are all intrinsically interconnected. Teasing out the strands of these connections would take a lifetime.

The days where the sky, land and sea are perfectly reflected like a Rorschach inkblot and it is impossible to tell what is up and down — these are the most meditative, and bring a sense of peace and calm to my soul. On these days, there isn't a ripple on the ocean, nor a breath of wind in the trees. The creatures seem quieted too, moving slowly and delicately in the air and water. The still life of the heron fits perfectly on days like this. In my boat I seem to drift in a dream world, floating on that fine line between earth and sky. These are days of contemplation and intense awareness of nature's exquisite beauty.

Stormy days, in contrast, deliver a special kind of experience. Perhaps this is when I feel most alive and exhilarated by the awesome power of Earth's natural systems. The winds can whip up in a few minutes; the glassy waters become a tumble of whitecaps, foam and spray; logs become projectiles; the trees bend in deference to the storm's force. One of my favourite things is to be out in the electric air of a thunderstorm.

On these days I think of Takaya, fur wet yet still warm, curled with his tail near his nose under a fir tree in a small round bed of needles. He has many places like this scattered around the islands where he chooses to wait out the storms.

It's not often that snow will blanket the islands, as our marine climate stays relatively mild through winter. When snow does fall, though, it creates an otherworldly silence. And for a short while, Takaya experiences a climate more like what his northerly relatives live in through much of the year.

What's So Great about an Apex Predator?

Wolves are a keystone predator at the top of the food chain. Predator behaviour and eating habits result in a trophic cascade of effects to the rest of the ecosystem. Prior to the 1995 reintroduction of wolves into Yellowstone National Park, deer and elk numbers had greatly increased due to the lack of predators. This resulted in overgrazing, causing defoliation of trees and vegetation, and erosion of soil and riverbanks. With the return of the wolves, the ecosystem began to regain balance. Elk populations were reduced and they began to leave the lower elevations to avoid the wolves. This had the effect of allowing riparian areas to recover from overgrazing by elk. This, in turn, increased the biodiversity in the park. With more aspens and willows flourishing in riparian areas, other species like beavers, birds, fish, mice and plants began to recover. Animals like vultures, crows and foxes, which depended upon carrion left by the wolves, also made a comeback. As George Monbiot expresses in the short film *How Wolves Change Rivers*, "We all know that wolves kill many animals, but perhaps we're slightly less aware that they give life to many others."

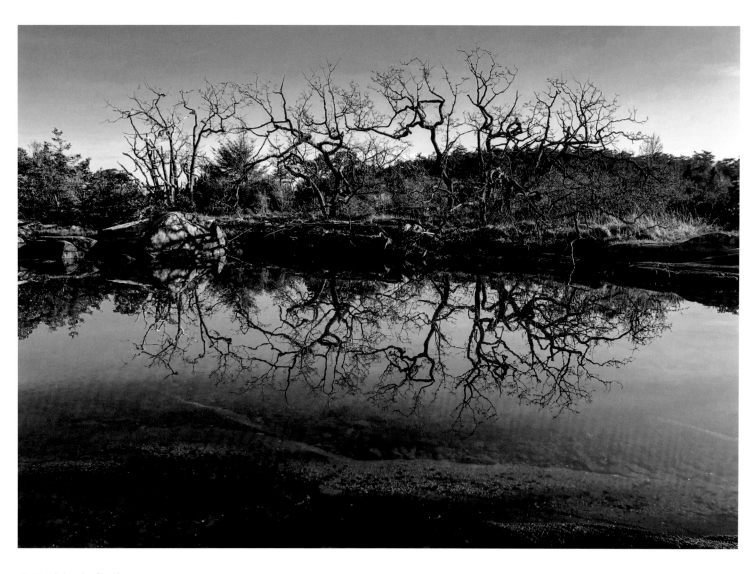

ABOVE Island reflections

OPPOSITE A lonesome winter howl

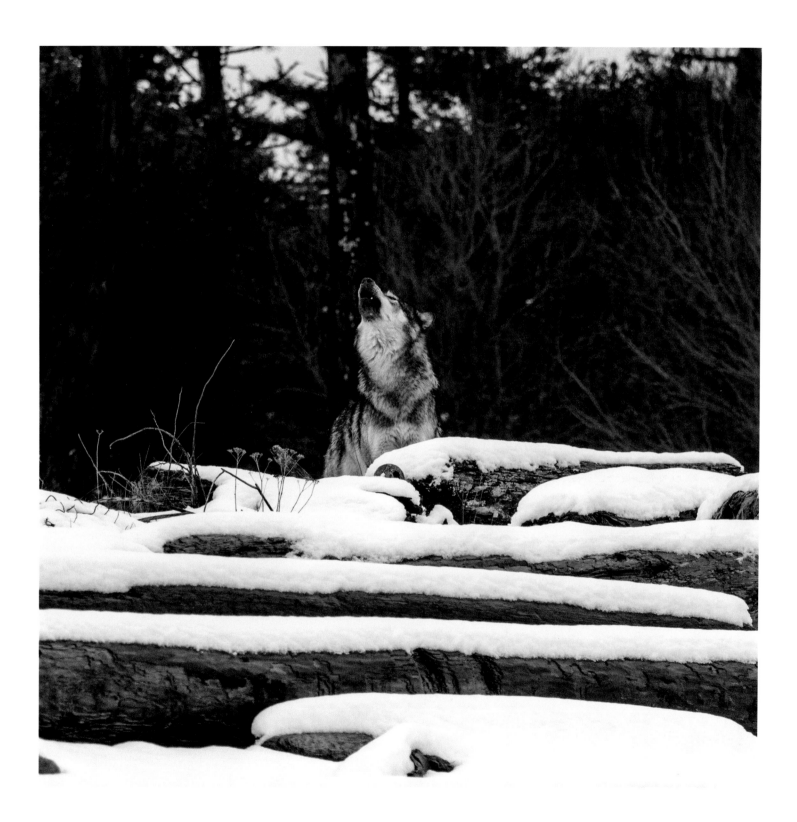

Spiderweb delicately suspended from marsh grass

WEBS

All things are connected like the blood that unites us. We did not weave the web of life. We are merely a strand in it. Whatever we do to the web, we do to ourselves.

CHIEF SEATTLE, A SUQUAMISH CHIEF WHO LIVED
ON THE ISLANDS OF THE SALISH SEA

The web of life in these islands comprises many different strands. As well as the plants and animals, the ecology of the islands includes the people who temporarily visit.

With Takaya as the connecting link, a community sprang up within the isles.

It was during this time that I became acquainted with a small group of men who frequented the islands. Informally known as the Island Protectors, these kayakers and sailors had, like me, been visiting the islands for many years. They had been given special permission by Songhees Chief Robert Sam to be on the Nation's reserve lands in the islands. The men looked after the islands, removed garbage from the beaches and ensured that no one was doing potentially destructive things like lighting fires in dangerous places. Mike Sheehan was the first Island Protector that I met, under rather humorous circumstances.

I had been sitting up on a bluff overlooking the channel between Discovery and Chatham islands, waiting at low tide to perhaps catch the wolf swimming between the isles. Mike Sheehan paddled toward where I was sitting, then announced, "Do you know that there is a wolf right behind you? But don't worry, she isn't aggressive and won't harm you."

Wow! Instead of being worried, I was thrilled. This was just what I'd been waiting for! I had felt a presence but hadn't quite believed it. After Mike paddled away, I sat still and listened in awe as the wolf sent up a howl in the woods right beside me. A short while later, a nearby bush rustled, and out walked Takaya. He regarded me calmly and then, keeping his distance, climbed up onto the bluff above me. This was my first of many close encounters with the wolf. I felt no fear whatsoever, just a calm wonder at being in the presence of such a magnificent creature.

Eventually I would come to know Mike well, and to share many island experiences, observations and stories with him. He is an avid and skilled kayaker who paddles out to the islands throughout the year. After each foray, he

compiles brilliantly phrased observations and insightful, beautiful photographs of island elements not often noted. I also learned that he was one of the first people to have actually seen Takaya in the early years. Mike had grown very fond of the wolf, documenting him in photographs whenever he could.

The only difficult thing between us was that for the two years preceding our acquaintance, Mike had thought of the wolf as *Staqeya*, a female, as reported in the media and by the Songhees. This was based on the fact that "she" often had been observed squatting to pee. One of our first intense discussions was about whether the wolf was a male or female.

In the first few images I had taken of the wolf, it was obvious to me that it was male. I showed these photos to Mike, and when finally confronted with photographic evidence, he reluctantly accepted it. He mourned the loss of the "female" he'd come to know — and became newly acquainted with the island alpha male!

In order to confirm that the wolf was a male, I checked with Harriet Allen — now my wolf science advisor — about why a male wolf would squat. She provided a reference to a study by American wolf expert David Mech that indicated it wasn't

Takaya's Introduction to a Kayak

Mike Sheehan was paddling his kayak along the east side of Discovery Island in September, 2012 when he first saw Takaya.

Mike reports that "...he [Takaya] had his back towards me while he was scrutinizing a family of six river otters, perhaps developing some sort of strategy to capture one. Due to his age I suspect this wasn't the first time he had encountered river otters, but of course we will never know. To get his attention I tapped on the deck of my kayak, resulting in a dramatic reaction that went from a reclined position to a full-out burst of energy with exceptional stride length, which lasted all of about five seconds. His curiosity slammed on the brakes and he immediately came to the ledge edge and peered down at me. He moved back and forth over about fifteen minutes along the ledges showing only curiosity and absolutely no aggression. He must have wondered what manner of creature was below him, as I suspect I may have been his first encounter with such a strange looking water beast. He soon tired of the back and forth and retired to the hillside and laid down. I feel we have been incredibly lucky to have such a creature so close and so easily seen. His presence has raised my awareness and appreciation of wolves through my close encounters."

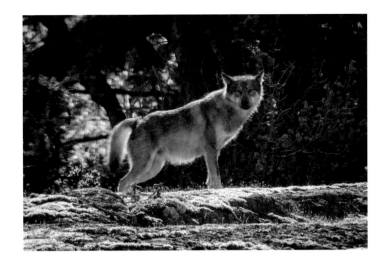

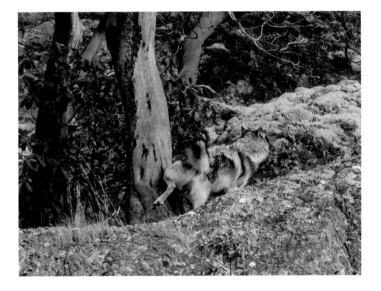

OPPOSITE Mike Sheehan explores the isles by kayak

TOP LEFT Takaya squat urinating

TOP RIGHT DIPO envelope left by Mike Sheehan

BOTTOM Takaya marking his territory with a raised-leg urination

unusual for a male wolf to not use raised-leg urination. Raised-leg urination is done primarily by an alpha male and female, while all other subordinate wolves squat. As well, the researchers found that lone wolves rarely perform raised-leg urinations for marking.

Harriet's conclusion: "I think that this wolf is a male; that he squat urinates because he is a subordinate, lone wolf; and that the pictures confirm the presence of male apparatus!!"

As Mike and I got to know one another, I discovered that he has a delightful, wry sense of humour. One of the first indications of this was when he sent me an alert that I had mail waiting at the "Discovery Island Postal Outlet" (DIPO). It was a CD sharing some of the images he had taken of Takaya in the first couple of years. I had to locate the DIPO using the address #37, Big Fat Flat Log, Discovery Island, BC. The mail had been delivered by a Wolf Courier.

Mike Sheehan and I continued to use the DIPO over the course of a couple of years, whenever we wanted to share relevant island information, materials and gifts.

Later on, I also had the privilege of coming to know well some of the other island characters who spent time in and loved the islands and the surrounding sea. Amongst those that I became closest to were Michael Blades, a designated island protector, and his wife Ann; retired librarian and avid

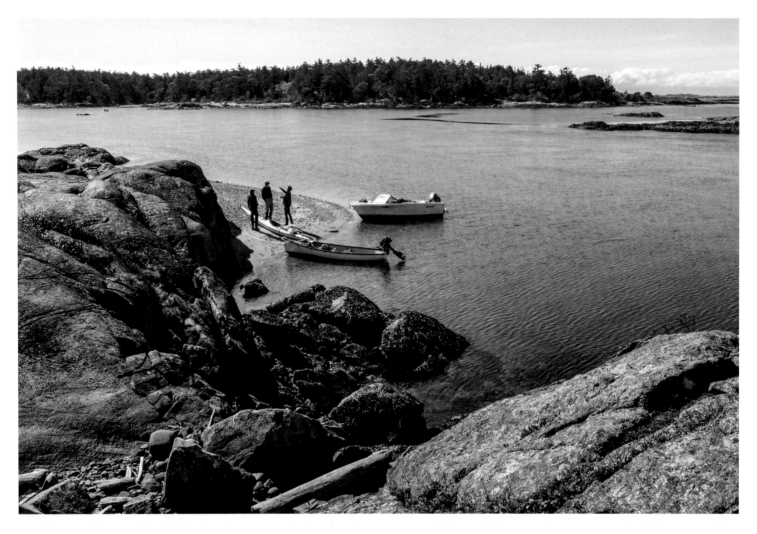

sailor Philip Teece, also an island protector; and Tom Reimchen and his wife Sheila Douglas, both talented scientists. Each of these people shared a love of the islands and provided information and perspectives that enriched and enlarged my understanding of the wolf and his world.

Michael Blades had actually been taught how to kayak by Mike Sheehan, but was now visiting the islands in *Moonsnail*, a beautiful old white dory. I would often see Michael and Ann drift by on the currents, looking like a couple from a different era — Ann at the bow wearing an elegant, wide-brimmed hat, with Michael standing on rock lookout in the stern.

On warm sunny days, we would all gather on a beach and engage in wonderful philosophical chats over lunch. We of course talked about the wolf and his activities, but we also shared thoughts about the importance of a sense of place, of quiet contemplation while observing nature, and of the challenges of navigating and understanding boats and the sea. Michael is an avid observer of nature, and after each island

outing would write about what he had seen, illustrated by photographs and insightful musings about life both wild and human.

Philip Teece had sailed his tiny boat *Galadriel* around the area for many years, and had written a couple of beautiful books about these experiences. I loved seeing Phil's red sails in the distance as he rode the currents and winds. Whenever we would meet up, we'd share stories of the island flora and fauna, as well as seasonal changes and encounters with and observations about the island wolf. He drew exquisite pen-and-ink illustrations to accompany his writings, and gave me a beautiful tiny drawing of Takaya that he had painted in his logbook in 2015. His death in the fall of 2018 was a big loss for our community of island folk.

I first met Tom Reimchen and Sheila Douglas on one of the island beaches in early September 2015. Mike Sheehan

Wolf of the Fog

Michael Blades remembers an early encounter with Takaya:

Probably my first real "magical" moment was in October of 2013 ... I had gone out in *Moonsnail* ... when the fog rolled in to zero visibility. I cut the motor and sat gently drifting in slim *Moonsnail*, and decided to pull out lunch and some hot tea ... it was cool and damp, and I was pondering how I might make my way home if the fog did not lift. All of a sudden, directly ahead of me, say 30 yards away, a portion of the fog dissolved, and there, on a raised rock, was the wolf, just looking at me. Not aggressive, just — or so I thought — equally as captivated as I was, interested, curious. Then he was gone, wrapped in fog again. This went on for about an hour ... he would appear, then dissolve ... eventually he moved southward back into the island, and in the very very thick fog I heard him howling, maybe for as long 45 minutes.

The howling is/was amazing ... there is the part of me of course that wants to anthropomorphise, he must be lonely, must be seeking a mate, and maybe so ... but as time passed, I would often just pause wherever I was and just try to stop, sit, listen. More and more I thought of it as just a real gift that I could experience something like this, so wild in so many ways ... and so I would say I feel that the howl is the song of the wild, something most folks have lost touch with and it simply broadens my horizons, adds an amazing dimension to the day.

joined us, and we all shared stories and drank plum champagne that Tom and Sheila had made. It was a delightful and stimulating island connection that has led to a long-term island friendship. In a strange coincidence, they had a dog named Mukpi, named after a 4-year-old Inuit girl who had journeyed on the MV *Karluk*, which had been piloted up the coast by my great-grandfather.

Tom is a virtual legend on the Pacific coast. An evolutionary biologist who advanced the theory that spawning salmon "feed" forests, Tom showed that their decaying bodies import vast stores of nitrogen to the ecosystem via food webs. So not only do salmon need forest habitats as part of their ecosystems, but forests need salmon. This elegant idea added to our understanding of coastal ecosystems and our ability to see the interconnections of ecosystem components.

One of the fascinating aspects of our first

OPPOSITE Philip Teece sailed the Strait of Juan de Fuca in SV *Galadriel*

ABOVE Tom and Sheila bird (and wolf) watch from their inflatable

When I first encountered him, soon after his initial appearance on The Islands, he was starting out pretty lean and bony, but that changed very quickly when he settled in.

—Philip Teece

beach conversation was when Tom shared the concept of humans as super-predators. In his early research on the tiny stickleback fish, he had noticed that while many predators ate the fish, the stickleback population remained relatively stable because it was the young who were mostly consumed, leaving the older, reproductive fish to continue producing. These observations led to recognizing that humans often prey mostly on the most mature and largest of a species, thereby weakening it over time.

Tom's knowledge about evolutionary biology and predators was a perfect fit with my work of observing and documenting the life of the island wolf. He understood well the

TOP A member of the *Islands Web* paddles along the southern shore of Discovery

BOTTOM Island paddlers Paolo Pouellet, Dan Gedosch and Mike Jackson pause to share stories of Takaya

OPPOSITE An international group of wolf scientists visit the islands with me (Adrian Treves, Guillaume Chapron and Bob Crabtree)

significance of an apex predator living in the islands. Tom shares my delight in Takaya's presence in the islands. He has generously shared with me not only his biological knowledge but also his night vision goggles!

Sheila Douglas, Tom's wife, is a botanist and plant specialist and has similarly been a great source of knowledge, specifically about plant identification. Recently she helped me identify some plants I'd found with exotic names like *Montia parvifolia* and western coralroot.

When I was away from Victoria and the islands for any length of time, I would often receive emails from other visitors to the islands. I thought of them as the *Islands Web*. They would periodically send me information and observations about Takaya and island wildlife: what he had killed, when, where, any sightings that had occurred. All of these island protectors are strong advocates for the preservation of the islands, of wild areas and, most importantly, of the wolf. We created a kind of safety net, and within that we share information aimed at protecting this area of great beauty and magic.

As well as the various locals I met out in the islands, a web of international scientists developed an interest in Takaya and began sharing their knowledge through visits with me to the islands.

Chris Darimont, an interdisciplinary conservation scientist who teaches at University of Victoria in the Environmental Studies Program (the same program that I had taught in almost 40 years previously), was one of those who visited the islands and was able to observe the wolf with me. Although Chris is one of the best-known scientific researchers on BC's coastal sea

wolves, when I contacted him in 2015 I was surprised that he had never been out to the islands, nor seen Takaya. He keeps himself busy with scientific projects focused on the Great Bear Rainforest, a swath of the coast that runs along mainland BC from north-central Vancouver Island to Alaska. I learned much about coastal wolves from Chris's scientific writings and from various discussions that we've had.

At Chris's request, I introduced visiting wolf scientists from the U.S. and Sweden (Adrian Treves, Bob Crabtree, Guillaume Chapron and Kyle Artelle) to Takaya and his unique life in the islands. As we toured around the isles, we discussed the unusual fact that Takaya has remained in the islands without any other wolves for so long. They didn't seem to think it likely that another wolf would find its way over to these islands, and wondered if Takaya might still consider leaving. There was some light, joking discussion about how

VOLUME 100 • NUMBER 1 • JANUARY 2019

ECOLOGY
ECOLOGICAL SOCIETY OF AMERICA

esa

ECOLOGICAL SOCIETY OF AMERICA

REPORTS Experimental habitat fragmentation disrupts nematode infections in Australian skinks

THE SCIENTIFIC NATURALIST Staqeya: the lone wolf at the edge of its ecological niche

Cover of the scientific journal *Ecology*

Takaya Enters the Domain of the Scientist

Abstract: *Staqeya: the lone wolf at the edge of its ecological niche.* Dylan Collins, Cheryl Alexander and Chris T. Darimont. In their contribution to the Scientific Naturalist section in the journal *Ecology*, Collins et al. document the ecology of the lone wolf (*Canis lupus*) Staqeya. Named by the Songhees Nation, this wolf inhabits a tiny archipelago adjacent to a major city in coastal British Columbia. Employing non-invasive research techniques, they report on range, foraging habits, and social biology. The unique ecological and socio-cultural context prompted the authors to reconsider the spatial ecology, dietary niche, and sociality of wolves, as well as to reflect on human coexistence with carnivores.

—*Ecology*, Volume 100, No. 1, January 2019

to perhaps smuggle a female wolf over.

I was able to show them a freshly killed, full-sized adult seal carcass but unfortunately wasn't able to find Takaya. They discussed what an unusual opportunity this was to observe and study a lone wolf's life in the wild, and gave me lots of encouragement to continue my efforts. Like Tom, they were incredibly supportive and suggested that I consider publishing my findings in a scientific journal.

It was very satisfying when my work was eventually able to form the basis for a project with Chris and one of his undergraduate students, Dylan Collins. In January 2019, we published an article about Takaya in the highly regarded scientific journal *Ecology*. I was honoured that one of the most iconic images I've taken of Takaya was chosen for the cover that month, commemorating their 100th edition.

Reports from the *Islands Web*

A sampling of email reports received when I've had to be away from the islands:

Cheryl, the seal carcass that Peter found in the grass above the landing area has been moved by the Takaya Cartage Company to an unknown area.

—MS

From the top of the beach trail it looked very shiny and white, almost like metal. I was surprised to see it was a seal, a very light grey with a few little black spots. The seal was about 3 feet long and very fat and pristine, meaning whole with very small bite markings just below the head … No blood anywhere, and no flies either. At first glance I thought it was sunning itself because of its natural position. I left shortly after, presuming that the wolf wasn't far off and that he would be back to haul it into the shade. I think the wolf would not be hauling it too far away … I would guess, from catching large salmon, that it weighs about 25 pounds.

—PN

We paddled over to Chatham on October 9. While there we heard the wolf howling, long and mournful. We paddled into the second bay, from the west, on Discovery's north shore. The wolf was lying on a small wooded point in the bay. When he saw us he bark/ howled, raised his tail to a 60 deg. angle and moved into the woods but we could still see each other. He continued to bark/howl. We left after 14–20 minutes without any attempts to further our contact. On October 16 we again paddled to Chatham and Discovery. We did not see or hear the wolf but we did spot a possible wolf kill above the high tide line on one of the outer rocks beside the westernmost Chatham Island at approx. 48.43 deg N ; 123.25 W. The possible kill was a baby seal. I say "kill" because I could see blood on the rock beside the upper thoracic, neck area … I will pass on to you any information we gather on the behaviour and whereabouts of the wolf.

—CD

I saw him last weekend. Dan and I also heard him howling the weekend before but did not see him. I think he is lonely! Recently, we saw the wolf just north of Puget Cove. It got up, climbed higher and then sat down to watch us in the morning light. As we paddled around the NE corner of Chatham, he got up and followed us so that he could sit down again and watch us paddle over to Cadboro Point! I think he does like "company." I also wonder if he recognizes people and/or boats. He must be pretty used to you and your boat and might be getting familiar with Dan and me.

—MJ

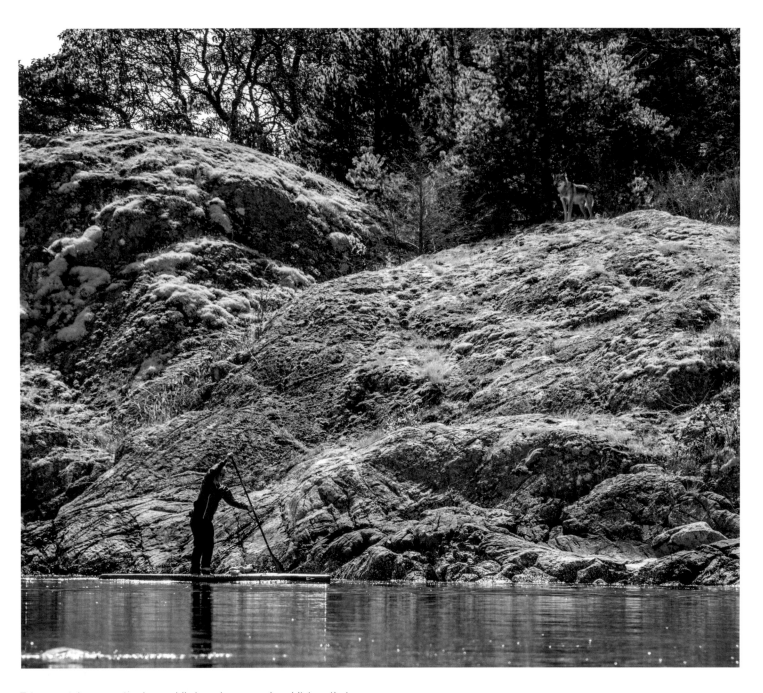

Takaya watches as a standup paddle boarder passes by, oblivious that a wolf is watching from above

TRUST

To have a relationship with a wild creature has a lot to do with respect, understanding the living being that's in front of you and that it is alive, so it has all the rights that it needs to exist. It doesn't need a manifesto so that humans can prove that it has some sort of benefit to humans so we can keep this animal alive.

CHRIS AGNOS

Gordon Haber studied wild wolves in Alaska's Denali Park for 43 years before he was killed in a plane crash while doing his research. After many observations concerning wolves and their interactions with people, he concluded that "...the fear wolves show toward people is a realized fear, not a natural fear — one born of persecution. In the absence of persecution, as in the wilderness areas of Denali National Park, wolves show a non-threatening fearlessness, and perhaps even some mild curiosity, toward people."

For the most part, Takaya seems to exhibit this same fearless yet accepting behaviour toward the presence of people in his territory. He is habituated, or socialized, to the presence of people, but not in a negative sense. It is food habituation that is most potentially problematic and may result in aggressive interactions between wolves and humans. Takaya is definitely not food-habituated and has more than adequate prey to consume.

Takaya will generally avoid people if possible. In a curious manner, he will also sometimes follow a kayaker around the shore. And he will warn people if they get too close.

After I had seen Takaya a number of times, almost always from my boat, an event occurred that really touched me. I was anchored very near to where he was lying on a small beach, very relaxed, head on paws stretched across the sand. We had been there quite a while in this companionable state when Takaya stood abruptly, alert to danger. He then turned and loped back into the long grass, whereupon he lay down, eyes and ears just evident over the top of the grass. I looked around and saw what he had heard long before me: a group of kayakers was approaching. Takaya stayed hidden, peeping over the grass, until they paddled off. I later described this behaviour to Dr. David Mech. He told me that he'd labelled this "peeking behaviour."

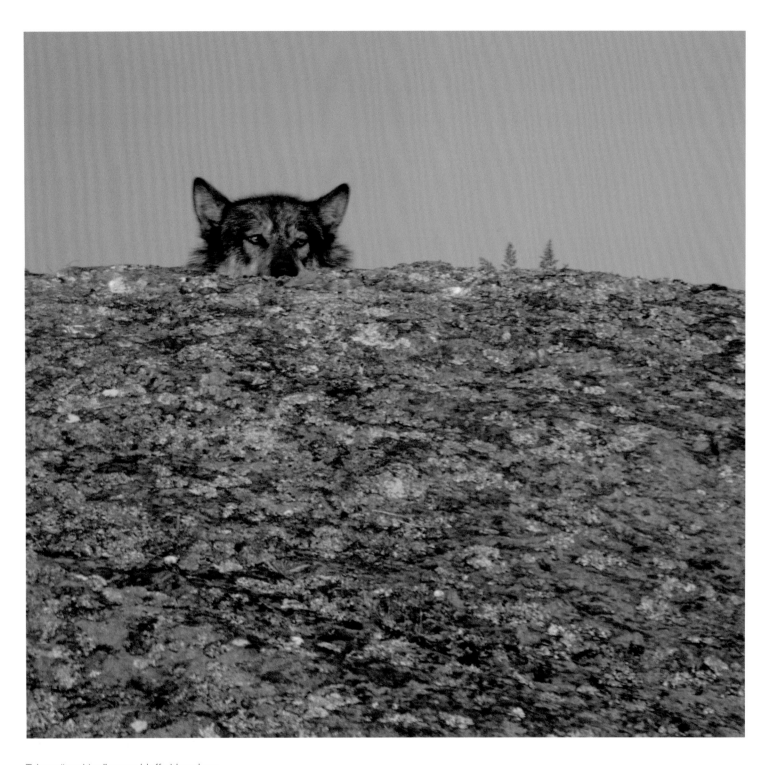

Takaya "peeking" over a bluff at kayakers

After the kayakers left, Takaya got up, came back and lay down near me once again, and proceeded to roll over onto his back, legs flailing in the air, scratching and rubbing. I realized with delight that by exposing himself to me in this very vulnerable way, he was demonstrating a high degree of trust. My discussions with David Mech confirmed that most likely Takaya had come to trust me and realize that I was not a threat to him, so he just carried on with what he would naturally do. I was reassured that my company wasn't habituating the wolf.

When I encounter Takaya in the islands, he will usually raise his nose high in the air and, by scent, confirm that it is me. He likely also recognizes me by sight and the sound of my boat as well, but it is by his highly developed sense of smell that he usually confirms my identity.

As I spent more time near Takaya, he became very accepting of my presence and would often choose to lie down on a nearby knoll. He understood that I meant no harm. I was almost always in my boat and not on land. When on land, Takaya has very clear physical boundaries and always moves away if a person comes too close. He is still a very cautious wild wolf.

What's in a Scent?

There have been a few times when Takaya has actually approached me while we were both on land. One notable time was when I watched him take a well-eaten carcass into the forest. I followed after a while and found the carcass, but no sign of him. Then, a small movement. I saw that he had circled around and lain down on a nearby knoll, eventually laying his head on his paws and sleeping. Another time, Takaya came toward me while I was sitting on a beach and lay down just behind the sand in some grass. He watched me for a while, then rested his head and closed his eyes.

According to Dr. Michael Fox, an American veterinarian and animal behaviour researcher, "the relaxed stretching of a wolf is a display in itself" and indicates *I feel relaxed in your presence*. He states that this behaviour may be related to the more exaggerated stretch and bow, which is a play-soliciting

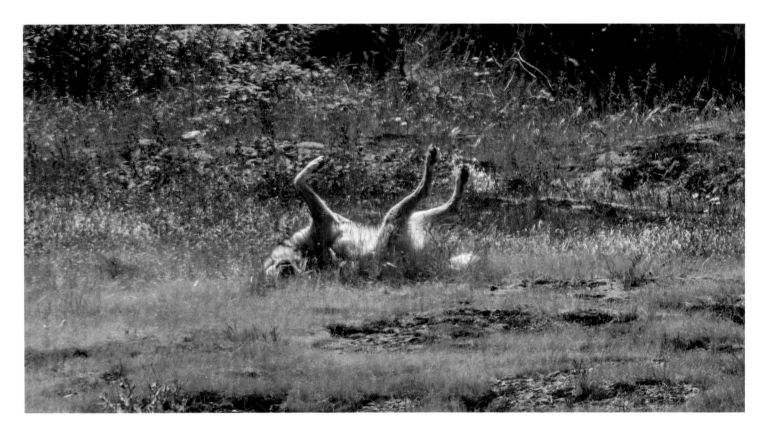

signal: "Wolves will often stretch in an exaggerated way in front of a companion and then approach and greet, or assume a deeper, more exaggerated stretch with a clear open-mouthed 'play face' and solicit play." (*The Soul of the Wolf*, Michael W. Fox, page 83)

Takaya will often do this after we have been hanging out for a while.

Takaya's trust and comfort with my presence has allowed me to really become an observer of his world. I am not an active participant in his life; I am a silent witness to his existence.

I am immensely honoured that this wolf has allowed me into his life — that he has given me his trust. He always confirms that it is me by extending his nose high into the air, sniffing, and catching my scent. Once he knows it is me, he relaxes and continues whatever he was doing.

When I am out in the islands with others in my boat, Takaya grows more cautious, and it is often more difficult to find him. People who frequently accompany me, like my family and my friend Anna, are now familiar to Takaya through their scent, and he accepts their presence with me.

Once, Anna and I were sitting on a high rocky spot eating lunch. We knew that Takaya was behind us in the bush because we had heard him howling. Suddenly, a huge number of crows began to cluster around us, dive-bombing through the trees. We then noticed a couple of hikers coming toward us along the shore. Turning, we saw that Takaya had come out of the bush and was just standing a few feet away behind us, also watching the people approaching. As they came nearer, he crept back into the trees, coming into sight again only after they had passed by.

Wolves Do Not Naturally Fear Humans

It is conventional wisdom that wolves and other creatures should inherently fear people, and if they do not, something must be wrong with them. This isn't, however, necessarily true ... for wolves in particular, it is more likely the other way around: fearless, bold, inquisitive behavior around people is much closer to "natural" and "wild" than are fear and wariness.

—Among Wolves: Gordon Haber's Insights into Alaska's Most Misunderstood Animal, Dr. Gordon Haber and Marybeth Holleman, page 174

OPPOSITE Takaya rolling and scratching

TOP Takaya stretching after a long rest

BOTTOM Takaya sniffing for my scent

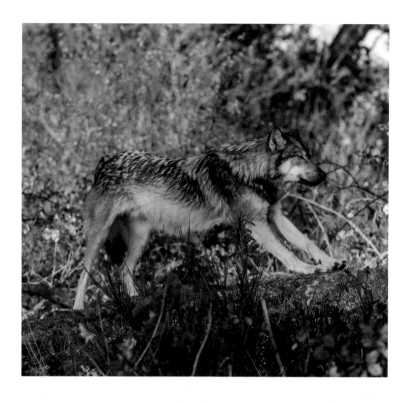

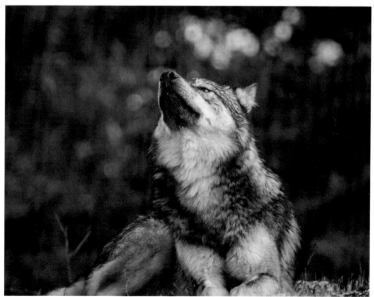

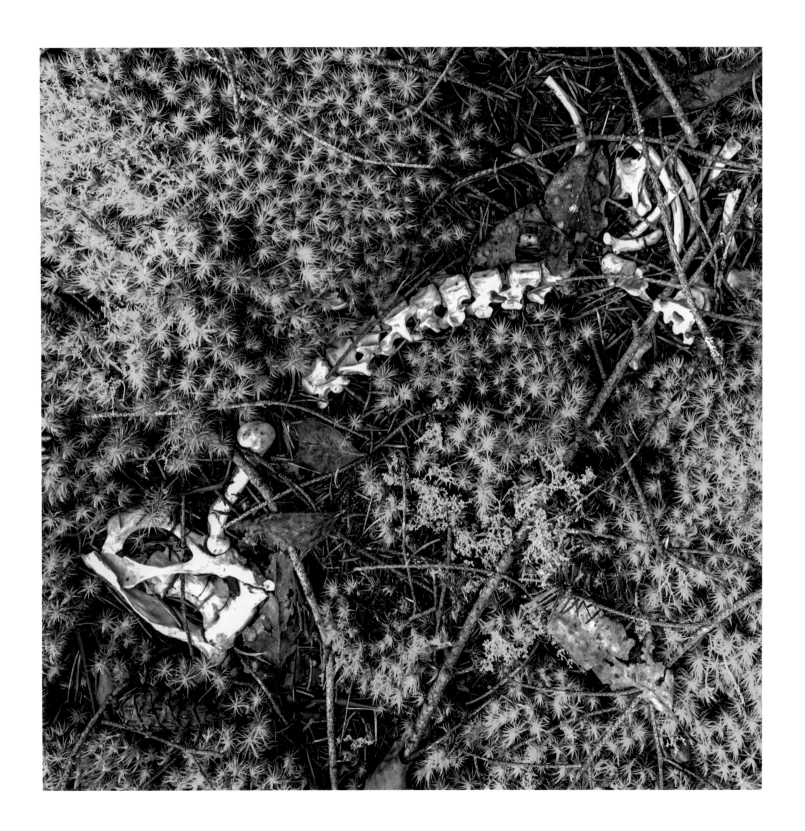

ADAPTATION

Adapt or perish, now as ever, is nature's inexorable imperative.

H.G. WELLS

One of the most intriguing questions about Takaya's life concerned his diet. How was he surviving on this island with no deer or other normal prey for a wolf? He certainly looked healthy. He was big and strong, with a thick, glossy coat ... so what was he feeding on?

I soon began to find evidence of what he was eating: seals! One of the first seal carcasses I found was very high up on a bluff. I was stunned that Takaya was taking his kill so far away from the sea. Over the years, I have found evidence of Takaya's seal kills scattered throughout all of the island ecosystems. I have found kills deep in the forest, weathered skeletons buried deep on mossy knolls in the very centre of the island, and freshly killed seals on bluffs and beaches around the island shores.

One of the likely reasons Takaya moves his kills away from the coast is to keep them away from scavengers. Sometimes, however, he will leave whole, uneaten carcasses for the vultures, eagles, crows and ravens to feast upon. During the late summer months, he will often have a surplus of food that coincides with the migration of vultures through the islands. By opening the seals' carcasses, he provides a good and easy source of food for these scavengers.

Pacific harbour seals can weigh up to 300 pounds and be

Does the Wolf Change the Islands' Ecosystem?

It is now understood that nutrients, in the form of migrating salmon, are moved from the ocean to freshwater streams and then into the forests when foraged by bears and wolves. The carcasses left by these carnivores are in turn consumed by other animals, insects and birds, ultimately distributing nutrients throughout the ecosystem.

In a small way, Takaya is doing this in his islands when he transports seal carcasses into the upland areas and distributes the remains of his kills throughout the grasslands and forests.

OPPOSITE I found this seal skeleton nestled in a mossy bed deep inside the forest

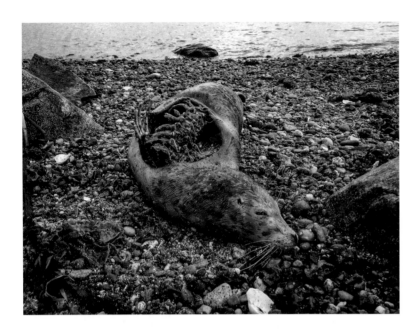

7 feet in length, but the largest of the carcasses I've found in Takaya's kill zones only weighed around 130 pounds. He mostly hunts and kills adult seals in the winter months, when small seals are scarce. One wintry January day, I found a large seal that he had dragged up into the park picnic area — evidence of this being a clear blood trail across the beach, up over some rocks and huge drift logs, and across the grass. His ability to move such a large body by dragging is remarkable.

During the next week, I returned each day and watched as he consumed the seal. It took him about ten days to completely finish it, meaning he ate about 10+ pounds every day. This is in line with the average wolf diet in winter: about 9–10 pounds daily.

As he ate each day, the carcass got a little lighter, and Takaya would drag it a little farther toward the woods. Planting his feet firmly, he grasped the tough seal skin in his jaws and tugged as hard as he could. The seal carcass would move a foot or so with each heave. Takaya would then pause and enjoy some of the blubber and innards. In between the times he feasted, the eagles and ravens claimed some of the food. When Takaya returned to feed, he would leap at the scavengers to scare them off.

Eventually the carcass was light enough for him to carry into the forest. The ravens and eagles followed, not at all happy with this development. They loudly shrieked their displeasure, aggressively swooping deep under the forest canopy to locate the supper that he had carted away.

During the seal pupping season, which in this area is from July to September, I often will find pup carcasses left on beaches, virtually intact. Sometimes only the head will have been removed, or only organs removed from gaping holes in the abdomen. One time I found five seal pups dead on a beach, largely uneaten. Was Takaya the wolf version of Jack the Ripper?

TOP Seal carcass on beach, partially eaten

BOTTOM Turkey vultures feeding on one of Takaya's seal kills

OPPOSITE LEFT Takaya feeding on a large seal in a campground

OPPOSITE RIGHT Takaya taking remnants of the large seal skeleton into forest

OPPOSITE BELOW Takaya dragging the seal carcass towards the woods as it gets lighter

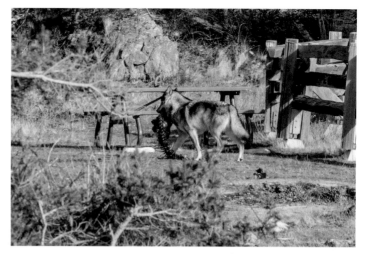
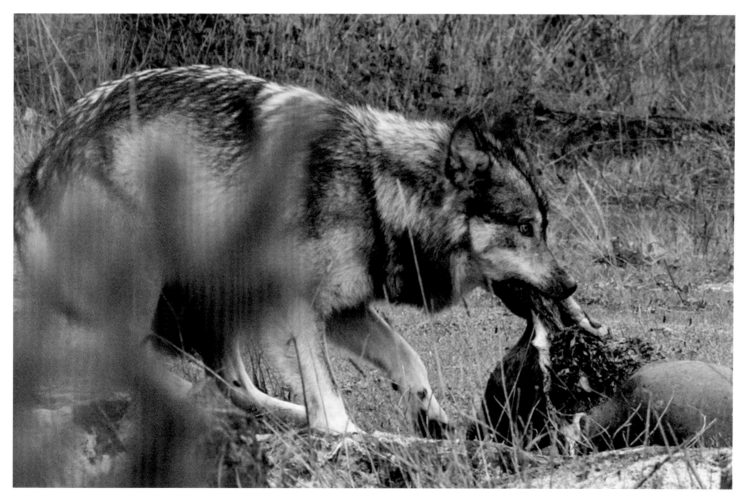

I didn't understand what such a number of dead pups meant, so I decided to call Dr. David Mech. He reassured me that this was normal wolf behaviour — something scientists call surplus killing. Takaya does this during the late summer months when seal pups are easy prey, often left alone on the beach or hauled out on the rocks while their mother goes off to hunt. During this time, Takaya takes advantage of this unusual opportunity, preying on pups when he can.

Takaya doesn't find all the seal pups left behind while their mother is off hunting, though. I once sat for hours with a newborn pup lying high on a beach, far away from the water during a low tide. Takaya didn't pass by, and eventually I had to leave, so I set up a cam to see what would happen. The tide came in, and the seal escaped with its life. Takaya missed this find by only a couple of hours. My cam caught him as he trotted along the beach a few hours later.

I also found evidence that he would cache or bury some of his excess seals. He buries carcasses in root wells where trees had been uprooted by wind, and under bushes with just a light covering of soil scratched on top. I've found old cache holes, now empty, scattered about the inland island areas. In this way, Takaya is also distributing nutrients throughout the island ecosystem.

One significant mystery remains that I've been unable to solve. How does Takaya actually kill the seals? I have tried but haven't yet succeeded in observing him in the act of killing one. I have come close, catching him running with a freshly caught seal in his mouth.

Trail cameras don't work well for this, as they are activated by the motion of the sea when positioned on the coastline. Takaya is largely an opportunistic hunter, so I will just have to luck out and be in the right place at the right time. It's a

Mother nursing her seal pup

ABOVE Seal pup left on shore while the mother is away hunting

Not Deviant Behaviour: Surplus Killing and Caching

Surplus killing is something that wolves will do when prey are abundant, highly vulnerable and easy to catch. They will kill often and may not completely consume the carcass. For wolves, hunting is hard and it is often difficult to find food, so they are programmed to kill whenever it becomes possible.

When wolves are able to kill more than they can eat, they will often bury some of the food for future use. This is called *caching* and is a way of protecting food from scavengers and saving it for later use. Wolves have been known to return months later to their caches.

job, for sure: there are many kilometres of shoreline where seals might possibly haul out.

I also have camped out on a small island in the centre of the archipelago and used night vision goggles, hoping to catch him in the act. This didn't work out all that well: on one of these nights I heard him howl, but couldn't see far enough to tell what he was doing.

One night around midnight, my trail camera did manage to capture a shot of Takaya heading toward the shore. Fifteen minutes later, he returned with the body of a good-sized seal clamped between his jaws. The seal almost touched the ground on either side of his mouth; the creature was nearly four feet long.

Being crepuscular, Takaya likely capitalizes on the cover of darkness to attack seals. I imagine that he stealthily creeps up on them as they are hauled out around the islands, especially at low tide. Seals can be vicious, however, and are able to defend themselves with teeth and claws. I have often found a carcass without a front flipper, leading me to hypothesize that perhaps he grabs one and rips it off, leaving the seal incapacitated or bleeding out in shock. But this is not always the case; sometimes there is no physical evidence on a carcass of how death has occurred.

I admit that it is difficult when I see a fluffy newborn seal pup hanging limply from Takaya's mighty jaws, its umbilical cord just newly detached. The fact that wolves kill in what seems like such a vicious way often negatively impacts people's perception of the wolf. The wolf is viewed as destructive, ruthless, a "crazed killer." I believe, however, that it is important to remember that life is really a succession of everything eating everything else. It's survival.

I learned that wolves will fail in a hunt more often than

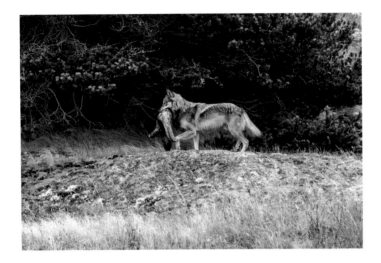

An ecological view states that things must die for life to flourish and evolve. Death provides the possibility of change. Although we mostly live unaware of the dramatic nature of the cycles of life and death around us, animals and plants continually adapt, change and die, feeding the cycle of nature. 'All meat is grass'. And in Takaya's case, 'all meat is phytoplankton – the grass of the sea.' Predator and prey are an integral part of all ecosystems. And we are part of this endless cycle in which all things are really everything else. We all return, in some way, to the soil systems of the Earth. It is easy for us to forget this in our state of isolation from wild ecosystems.

they succeed. Wolves are known to lead a feast-or-famine existence where most of their hunts will end in failure. It varies by prey species, season and circumstances, but more often than not, wolves do experience difficulty catching prey. If hunting is difficult for wolves living in a pack, then we are assured it must even harder for a lone wolf.

I have watched Takaya as he hunts river otters. River otters are large, semi-aquatic ocean-going animals that can weigh up to 35 pounds. They are known to be very vicious and can move extremely quickly. Although he knows exactly where to find otters in his territory, it is a challenge for Takaya to catch and kill one. I have observed him patiently waiting above the piles of driftwood on the shore under which otters make their dens.

Once I actually joined Takaya while he hunted an otter. He had trapped a large one in a freshwater pool at the base of an old lighthouse building. I watched from the sea for a few hours as he patiently alternated between lying and watching the otter, then rushing to catch it when it would emerge from under a rock. He hunts with an incredible degree of patience.

After several hours of watching, I decided to climb up above where Takaya was so that I could see better what he was actually doing. Sitting on a rock above the pond, I could see the dance of the hunt between wolf and otter.

Then, to my surprise, Takaya actually moved up the rocks and lay down a few feet away from me. We both continued to watch the otter below. I really felt like I should be helping him hunt! Takaya teetered precariously on the cliff a few times as he lunged for the otter each time it ventured out from under the rock. Eventually the otter made a successful break for it and ran into the sea, safe for now from the wolf. Takaya had spent all morning hunting this otter, ultimately without success. He would go hungry for a little while longer.

Another day, I watched as Takaya conducted a more successful hunt. He had cornered a full-sized, mature otter under a pile of drift logs. He patiently waited until the otter tried to escape back into the sea. Relying on some sense other than sight, Takaya demonstrated his skill and amazing speed as he sprang over the logs, catching the otter as it desperately lunged toward the water.

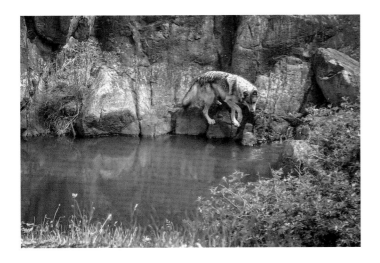

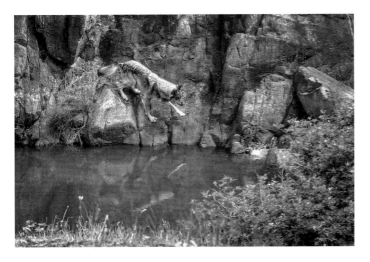

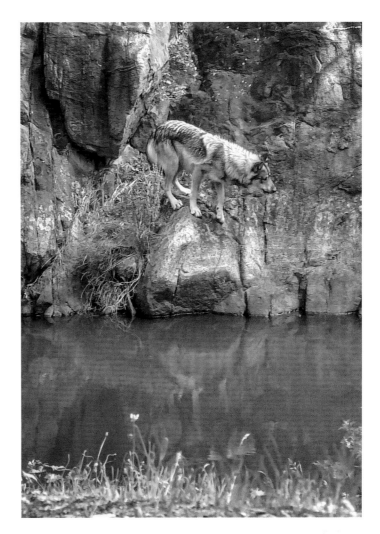

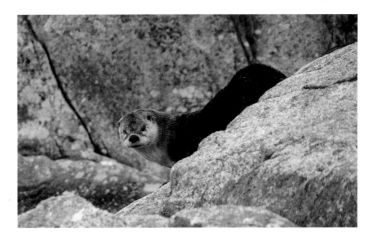

ABOVE Balanced on a steep, rocky wall, Takaya hunts a river otter but fails to catch it

RIGHT River otter

With difficulty, he grasped the otter in his mighty jaws and carried it precariously along the slippery, kelp-covered rocks to a small beach. There he laid it down, killing his quarry with a final twist of the neck. For some unknown reason, Takaya decided to carry it farther along the beach. The otter was huge, so he had to stop multiple times to rest. He would drop it carefully on the beach, giving his jaws a break, then

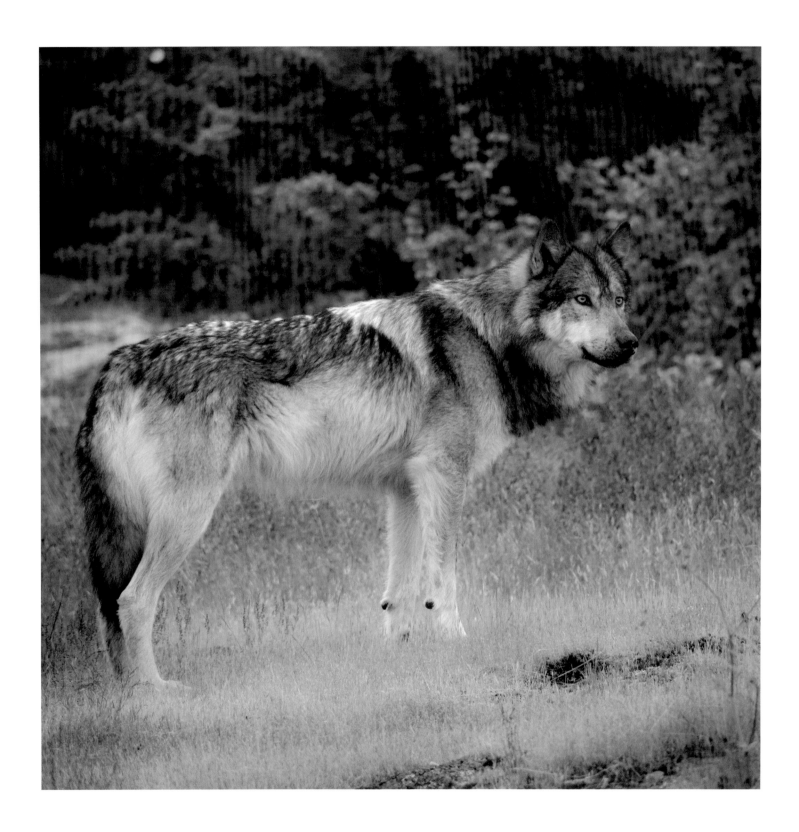

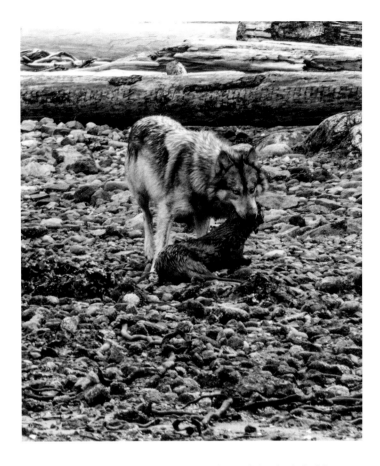

OPPOSITE Takaya, in his winter coat, stands stately in a bed of wild camas

ABOVE Takaya with a freshly killed river otter

pick it back up and trot further along. Eventually he leapt over a series of logs and up into the forest, disappearing with his prize.

Takaya, hunter extraordinaire, had made a kill. That day, he would eat well.

There are also many mink living along the island shores in the intertidal areas. I believe Takaya must eat mink as a small part of his diet, though when I have watched him try to hunt them, he's always been unsuccessful. Belonging to the same family as otters and weasels, mink are extremely fast and can easily hide under rocks and logs. I have never found a mink carcass, although I think not much would remain if Takaya actually managed to catch, kill and consume one.

Having a good territory with a stable food base is a necessity for a lone wolf. The island territory that he has chosen as his own provides a predictable source of food. It is clear that Takaya has no problem feeding himself. He is extremely healthy looking, with exceptionally thick, glossy fur. It is likely that the high degree of seal oil and omega 3s in his diet contributes to his "movie wolf" appearance. He looks much larger and stockier than many other coastal wolves, and this may be due to a difference in prey abundance. This ample supply of food is likely one of the main reasons that he has chosen to stay in such an unlikely place.

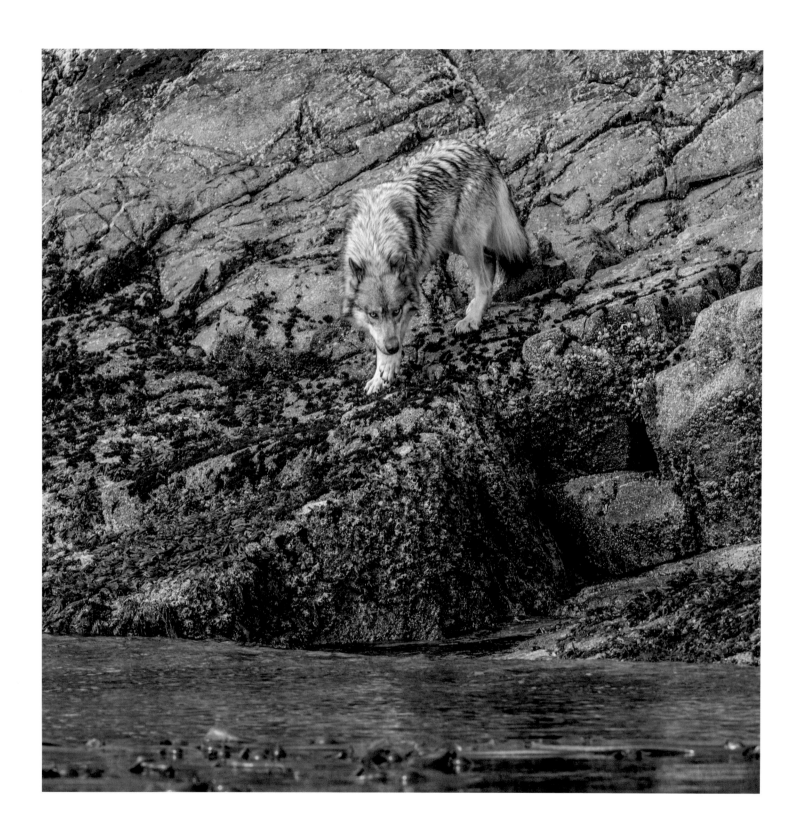

INTELLIGENCE

Intelligence is the ability to adapt to change.

STEPHEN HAWKING

You have only to look into the eyes of a wolf to grasp that an intelligent being is looking back at you. After watching Takaya for so many years, I have seen this intelligence exhibited frequently. According to David Mech, intelligent behaviour in wolves reflects ancestral knowledge stored in the genome, however individual experience can also result in novel insight and learned actions.

Takaya's developed hunting styles and use of marine resources seem to offer an example of learned behaviour. He diverges in resource use considerably from others of his species, even other coastal wolves. While coastal wolves do scavenge beaches, fish streams for salmon and feast on beached sea lion or whale carcasses, they also hunt deer and other large land mammals living along the coast.

The hunting and feeding behaviours I have observed in Takaya are, I believe, previously undocumented among wolves. He has adapted over time to his new environment and makes use of every resource possible. I wondered often whether he might have learned some of his survival skills before coming to the islands. Or did he learn these from observations of other creatures in his new environment? Or did he become creative out of necessity, simply figuring out on his own how to best use the food resources in his territory?

Canada geese use these islands as nesting areas in the spring. I wondered if Takaya hunted the geese and goslings, or if he ate their eggs. When I discovered a nest in a forested area, I set up a trail camera to see what I might learn. What I found was rather remarkable — again, an example of unusual wolf behaviour that hadn't been previously recorded.

A pair of geese had built a beautiful nest in a protected spot high on a rocky bluff under a large arbutus tree. In mid-April, the female began to lay her eggs. At first, there were just two eggs in the nest, however within a week, she had laid seven eggs. My trail cam showed that Takaya visited the nest three times over this period. The first couple of times, he merely sniffed the eggs. The third time, after all seven eggs had been laid, he actually urinated on the nest. I assume he was marking it as his.

A few days after claiming the nest as his, Takaya returned in the middle of the night when the geese were away foraging. They had covered their nest with feathers and leaf debris, a protective strategy when leaving the nest unattended. With his large paw, Takaya carefully scraped off this covering material. Ever so gently, he removed two of the eggs with

Takaya hunting at shoreline on Discovery island

his powerful jaws, one at a time. He trotted off with each egg to a nearby knoll. I later found the shells intact except for a small hole on top. Both eggs had been carefully opened — not crushed — and the contents drained without spilling a drop.

Following Takaya's raid, the geese returned and refurbished their nest. Four days later, Takaya returned and again raided the nest, this time taking three eggs in the same gentle manner. Takaya didn't visit the nest again for a week. When he returned, he took the remaining two eggs. A few days later,

he sniffed at the empty nest and looked under the leaves for more eggs, then urinated on the nest again before trotting off. Wolves will mark food caches with urine when they are empty in order not to waste time looking there again. Maybe this is why Takaya marked the nest for a last time.

Why did Takaya not take all of the eggs at once? It is possible that he wasn't really hungry, although this conflicts with the way wolves will often gorge on food when it is available. (Hence the term *wolfing it down*.) Perhaps he had learned, in previous encounters, that geese will sometimes re-lay if their

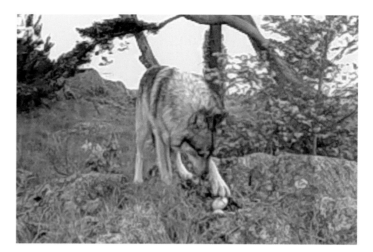

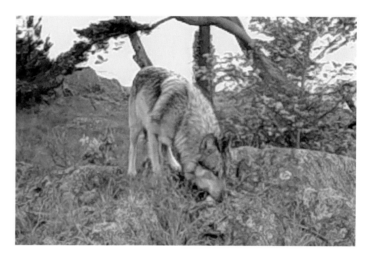

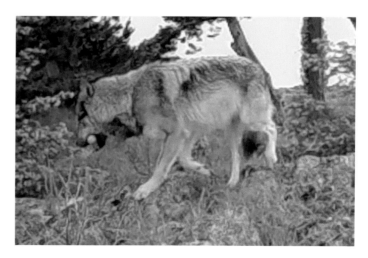

OPPOSITE Goose nest

ABOVE Egg delicately eaten by Takay

RIGHT Takaya stealing goose eggs (trail camera footage)

eggs are destroyed. That way, if he took a few at a time he was perhaps encouraging the geese to re-lay, thus ensuring an ongoing food source. Or maybe he was watching his cholesterol?! This seems something worthy of a longer-term study.

I spent some time observing killdeers nesting at around the same time in the spring. I wondered if Takaya would also eat their eggs, as the nests I watched were situated in two separate places where Takaya frequently rests and walks. He would have known that they were there. I watched the killdeers' eggs until they hatched, however Takaya didn't seem to pay any attention to them.

The same is true for the oyster catchers. They nest all over the islands and basically just find a convenient spot on the ground or in the beach pebbles to lay their eggs. I set a trail

camera up on one of their nests and 'someone' had eaten them by the time I returned. Sadly, the camera had malfunctioned and I had no proof of who it was. It could have been the wolf, an otter, a mink or even, perhaps, an eagle.

Another of Takaya's interesting adaptations concerns the use of resources in the intertidal area — the zone that's underwater during high tide and exposed at low tide. This is a seriously life-rich area. During my meanderings along the island shores, I had never seen any indication that Takaya ate crabs, clams or other intertidal creatures. I also didn't find any indication of this in his scat. However, one day I did observe something unique. He was methodically hunting and eating prickleback fish — a chosen food of herons and river otters.

I watched as Takaya combed a large intertidal flats area for a few hours. He seemed to be either smelling or listening for the presence of these long, dark, flat fish that hide in shallow water or under large rocks. Takaya moved in an almost grid-like pattern, stopping to turn over large rocks with his massive paws and then gulping down one of the flapping, eel-like fish he'd found underneath. It was interesting that he didn't turn over every rock, only select ones.

I returned to the same area the next day to mimic his process in an attempt to photograph the pricklebacks. I turned over many rocks and had trouble finding even one. Somehow, he always knew under which rock he would find a fish.

It seems possible that Takaya learned about these new kinds of food resources from observing other animals and their hunting behaviours. Perhaps he saw mink and otters raiding the nests of the geese to eat their eggs? Did he learn about the pricklebacks from observing herons and otters? Takaya would have had ample opportunity to observe their hunting behaviour as he stalked them for his own nourishment.

Following this logic, it's possible Takaya also learned his hunting techniques from observing the eagles attacking and stealing newborn seal pups during the summer months.

I talked about this with Jamie Dutcher, the woman who

had raised wolves in Idaho. "He seems to be keyed into this landscape and has learned to survive in it," she told me. "He has come here with no skill and is just trying to find what's available and how best to deal with it, how best to eat it, to kill it. I can easily see him watching other animals and taking his chance on seals. If it were too much of a struggle, I would imagine he would have made an effort to leave here ... which he hasn't. It's just an incredible story of survival."

Takaya has definitely shown how intelligent and adaptable wolves, and nature as a whole, can be. Fifty years after wolves went extinct on Vancouver Island, a major predator now lives alongside a city of over 400,000 people.

There is one more extremely unusual thing that Takaya has learned to do with the seals and otters he catches: he skins them. I have found many carcasses where the skin has been turned inside out and all of the meat, skeleton and organs taken out. The pelt of the animal is left intact, with only the head removed. Sometimes the skeleton remains attached to the other end of the skin.

Wolves have extremely powerful bites — much stronger than lions or tigers or grizzly bears. They can easily cut through bone. With his powerful bite, Takaya often decapitates his prey and then peels it like a banana. This allows him to eat the meat and fat without ingesting the skin or hair.

I haven't been able to figure out how he actually does this. Human hunters will sometimes "sock" a carcass in order to preserve the pelt whole. In order to do this, they rig up an elaborate mechanism in a tree to hold the pelt while pulling off the skin from top to bottom. Without hands or a tree rig, you can see that for Takaya, it's not an easy feat to hold the carcass down and then pull off the skin.

OPPOSITE TOP Oyster catcher near her nest in rain

OPPOSITE BOTTOM Eggs of the oyster catcher

TOP Takaya hunting prickleback fish on the tidal flats

MIDDLE Heron hunting prickleback fish

BOTTOM River otters hunting in the intertidal

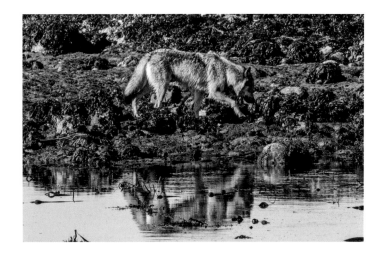

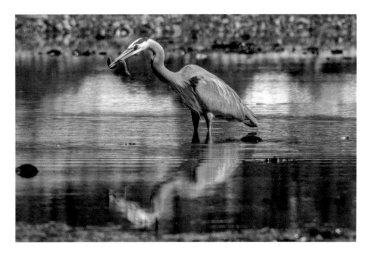

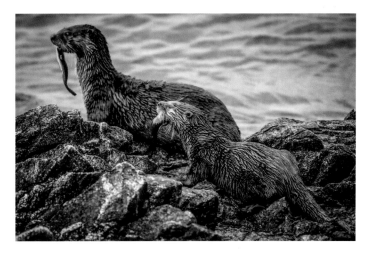

When one day I found a dead seal on a beach, undamaged, I decided to see how easy it would be to peel away the skin. A friend helped me to try to skin the animal. I was humbled to discover that even with a knife it proved difficult.

This skinning, or socking, behaviour isn't something that wolves are known for. It seems Takaya figured it out for himself.

Another area where I observed Takaya's intelligent innovation was in regard to water. The third summer that I watched Takaya was one of severe drought. The seasonal wetlands where he normally found water had completely dried up. How was he getting enough to drink?

What I discovered was astonishing. In times of drought, Takaya digs for moisture in the dried-out ponds and swamps. I found some holes that were four and five feet deep. I checked the scientific literature and could find nothing about wolves doing this, probably because their much larger territories would always have some source of year-round water, even if

Woman Tans Seal Skin ... Almost

One day I found the skin of a seal lying in a small intertidal pool. The skin was inside out and perfect, with no flesh remaining and only the head gone. I decided to try to preserve it as an example of what Takaya does. I took it home and put it in our freezer. (Poor Dave.) I googled how to clean and tan the hide, thinking it would be a good experience to do this myself. I didn't have to skin the seal or remove fat, bones, organs or muscle — Takaya had already done that for me. I got ready with a big bucket, salt and some potash alum powder, removed the skin from the freezer, and began the tanning process as described on a backcountry survival website. I soon realized, however, that the job was going to be a little too complicated for me when I turned the skin right-side-out and found that all of the flippers, claws and tail were still intact. If I wanted to keep them attached — which I did — I realized that I would need professional help. I sent the skin away to a tannery.

it meant the wolves had to travel long distances. Takaya's tiny territorial size meant he needed to be innovative.

It is known that other highly intelligent animals will dig for water in times of drought. A German study in 2015 of animals in central Tanzania found that animals like elephants, zebras, warthogs and baboons knew to dig waterholes and adapt to times of water shortage. They did this when existing rivers became low and contaminated with bacteria, thus finding water and avoiding disease. Kangaroos have also been spotted digging for water during drought conditions

in the South Australian outback, thus avoiding ingesting pathogens as well as finding drinking water.

I wondered if Takaya somehow knew that he needed to do this to avoid contaminants from the multitude of ducks using the island marshes and ponds where he typically gets his water.

It is also possible that Takaya was getting moisture from the many seal pups he was able to kill during this time. The seal pupping season coincided with times of drought. Another possibility is that he relies on dew deposits, which are quite frequent during the extremely dry time of year.

Takaya is perhaps the most extreme example of a sea wolf, and is certainly the epitome of adaptation. He is thriving and surviving at the very edge of his normal ecosystem, pushing the boundaries of his ecological niche. He may well be the only wolf in the world living on almost exclusively marine foods. I collected hair and scat for an analysis, which found that marine mammals make up over 95% of his diet. While there is no population of deer on the islands, a carcass will infrequently wash up, and when it does, Takaya consumes it.

Unlike the sea wolves of the Great Bear Rainforest or other coastal wolves on Vancouver Island who seem to primarily scavenge for seal and sea lion carcasses that wash up on beaches, Takaya actively hunts the seals that make up most of his diet. In contrast, while other coastal wolves do forage extensively from the sea and up to 75% of their diet can be marine-based, they still hunt terrestrial species as well. As Chris Darimont so eloquently states, these wolves live with "two paws in the ocean and two paws on land."

Takaya often lives with all four paws in the sea.

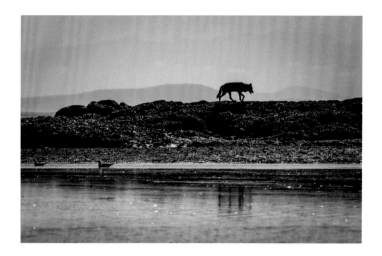

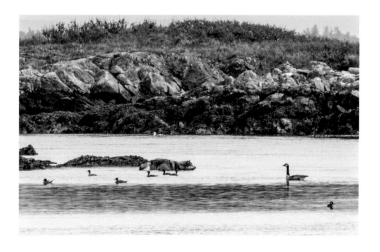

OPPOSITE Seal skin that Takaya has turned inside out (socked)

TOP Takaya during a period of intense drought

MIDDLE Holes that Takaya dug looking for water in the vernal ponds where he would typically drink

BOTTOM Takaya with four paws in the sea, surrounded by ducks and geese

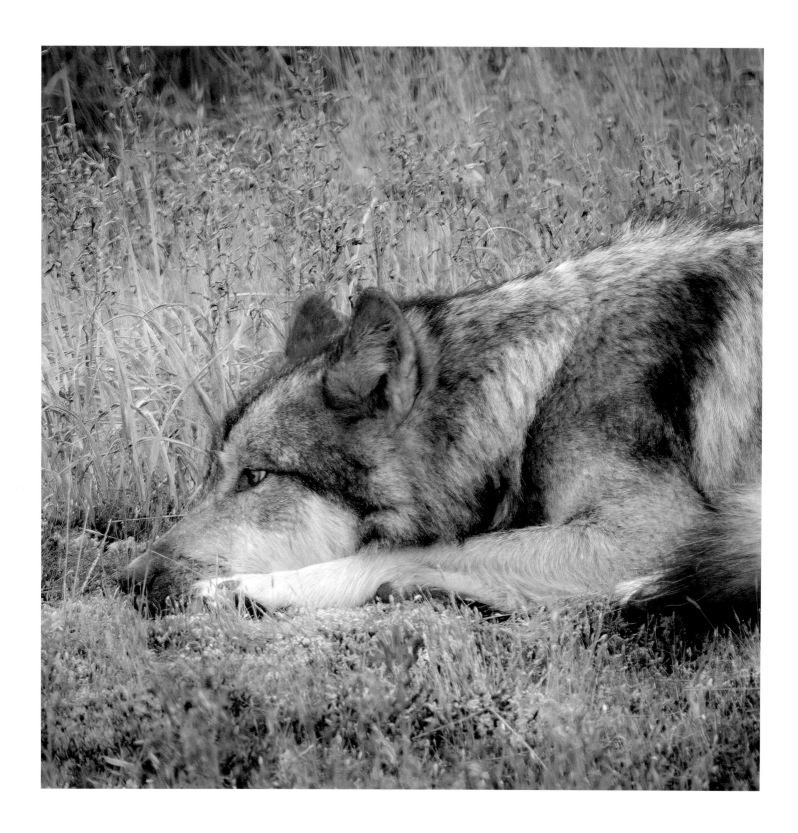

PERSECUTION

We are the ultimate losers from all this wolf killing, I am convinced, for the way it diminishes the ability of our surroundings to evoke the sense of wonder that helps us not just to live, but to be alive.

GORDON HABER, AMERICAN WOLF BIOLOGIST

Wolves and humans — two intelligent, social carnivores — have a long history of coevolution. Anthropologists propose, and Indigenous knowledge reflects, that our lives have long been intertwined with the wolf. It is increasingly understood that wolves and humans may have worked together and learned from each other, benefiting from sharing hunting and survival skills. In fact, many now believe the wolf may have had a large role in early hominid development. The view that relationships between wolves and humans involved cooperation and mutualism rather than competition and violence is eloquently outlined in a recent book by Raymond Pierotti and Brandy R. Fogg, *The First Domestication: How Wolves and Humans Coevolved* (2017). The two species seem to have established an early partnership where wolves perhaps taught humans to cooperatively hunt, changing the behaviour of humans and allowing dominance over other evolving species.

Takaya takes a midday nap in a bed of wildflowers on his favourite bluff

Wolves and humans are meant to be together ... If humans do not have contact with wolves, with the keepers of the wild, we forget that we are part of the world around us ... This bond goes back for as long as humans and wolves have lived in these lands.

—*Promise of the Wolves*, Dorothy Hearst, page 238

And some wolves eventually became our domesticated dogs. These dogs now live with us and often sleep on our beds. They are considered our "best friends."

Yet somewhere along the line, things changed. Wolves began to be perceived as evil, and were persecuted. In recent human history, driven by fear, competition and

misunderstanding, humans began to hunt them, trap them and try to wipe their species off the face of the Earth. The current rapid loss of ideal wolf habitat through human activity like agriculture, logging and mining drives them into closer contact with humans, often resulting in even more conflict.

In Canada, legal persecution of wolves currently occurs throughout British Columbia and Alberta. Wolves in many areas are targeted by government-sponsored culling programs in a misguided effort to protect other endangered species like woodland caribou. This culling is not always science-based and is often inhumanely done with poisons, snares, or by gunning the animals down from helicopters. Sometimes the "Judas wolf" technique (a practice of live-trapping, collaring and then releasing a wolf) is used to lead government shooters back to a pack.

On Vancouver Island, hunters are again pointing the finger at wolves as being responsible for a reduction in deer populations. Although ample research conducted over decades indicates that wolves aren't responsible for declines in prey species, the animals are often simply convenient scapegoats. A decline in prey species like deer, elk and caribou "is not because of wolves, but due to continued destruction and fragmentation of their habitat by logging, resource extraction and motorized recreation." (Pacific Wild, 2019)

These highly intelligent and social apex predators are also targeted by sporting goods stores and organizations that sponsor wolf-killing contests where killing is encouraged for the sport of it and prizes are awarded to the hunter killing the most wolves. These are called "wolf-whacking" contests by their participants.

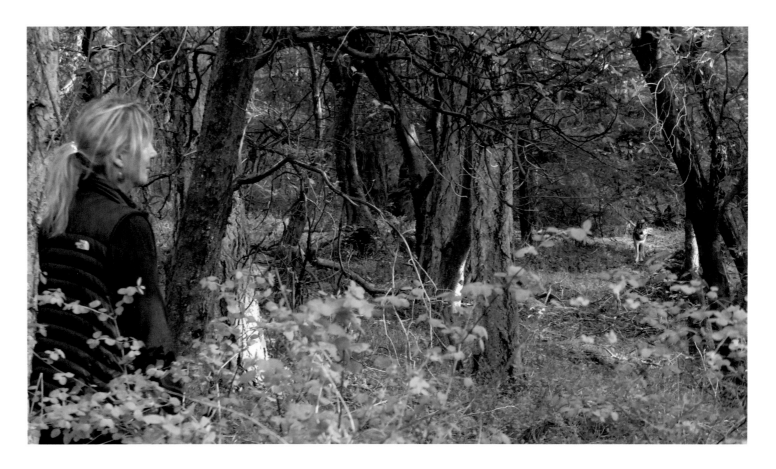

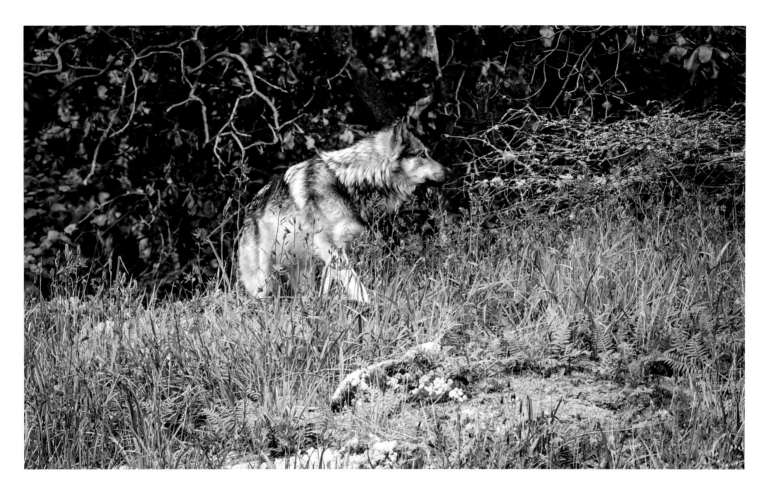

OPPOSITE Takaya approaches me in the forest

ABOVE Takaya strolling through a field of camas

We killed hundreds of thousands of wolves. Sometimes with cause, sometimes with none. In the end, I think we are going to have to go back and look at the stories we made up when we had no reason to kill, and find some way to look the animal in the face again.

—*Of Wolves and Men*, Barry Lopez, page 199

It is still legal to hunt wolves in 97% of Canada's wild spaces. On Vancouver Island, where Takaya likely originates, hunters can hunt wolves for ten months of the year without any special licence.

Thankfully, Takaya is fully protected from being legally hunted, because all of his territory lies in protected areas. However, our long ingrained human attitudes toward predators like Takaya can still affect people's attitude toward his presence in the islands. To some, a wild wolf remains terrifying — an unknown threat.

Historically, our human attitude toward wolves has been conflicted. Some, like many Indigenous cultures, venerate wolves and admire their qualities of strength, intelligence, dedication to family and hunting prowess. Stories from

Indigenous peoples around the world frequently report positive interactions between wolves and people, and hunters would often leave parts of their kills for the wolves and ravens who acted as guides.

Conservationists value the role the wolf plays in maintaining healthy ecosystems. Outdoor enthusiasts love the mystique of the wolf in the wilderness. Sometimes, though, the admirers of wolves stray into an unrealistic attitude of putting the wolf up on a spiritual pedestal. Like us, however, the wolf is very much an animal. An intelligent, social animal.

While urban populations are more likely to admire the wolf, rural people often dislike the wolf. Ranchers often want to get rid of the wolf to protect their livestock, forgetting that we humans have taken over much of the wolves' available land.

Others hate and fear wolves and will take any opportunity to destroy them. These people vilify wolves and consider them vermin to be eradicated. Some hunters think of them as competitors for prey. In the words of a local trapper that I spoke with: "I gotta tell ya, I ain't got no love for wolves. They are vermin. I'd kill as many as I could."

Whenever large carnivores move into an area of human habitation, often pushed by a dwindling supply of wild prey, it is the animal who most often suffers and is destroyed.

Still, for some, it is the wild wolf, the undomesticated version of the dog, who still excites our imaginations and awe, and epitomizes our sense of what it is to be wild. A significant aspect of our human psyche is that quality of wild that connects us to our past as hunter, survivor, and part of the evolution of life on Earth.

Humans and Wolves: A Conflicted and Emotionally Laden Relationship

There seems to be no neutrality when people think about wolves; they either love or hate them. As Paula Wild so eloquently puts it:

> Mystical and mysterious, the wolf has influenced culture, art and legends of human societies since early times. Perhaps more than any other animal, it has become embedded in the human psyche, even affecting our language. A *wolfish grin*, *wolfed down his food* and *keep the wolf from the door* are common phrases, joined in more modern times by *lone wolf* to indicate a solitary terrorist. But there is no single vision of the carnivore. Depending on the time and place, it has been portrayed as ruthless and evil or a majestic icon of the wilderness. And, although few people ever see this elusive creature in the wild, its photograph has graced countless calendars … And yet, its essence remains shrouded in a mist of speculation, fairy tales, rumours, righteousness and sometimes, truth.
>
> —*Return of the Wolf*, Paula Wild, page 4

From the beginning, humans and wolves were much alike. Both are apex predators. Both human tribes and wolf packs consist largely of familial units. Both rely on a strong social structure to govern society and the hunt (which in turn ensures survival of the society). Both elect, in their own ways, leaders possessing great craft or physical prowess. And in both societies, elaborate rituals reinforce relationships, maintain order, and enforce discipline ... We adopted the wolf, or the wolf adopted us, because the two of us are so very similar. That is very significant. Thousands of years ago, we brought a powerful, intelligent predator into our caves and our lodges, and today it sleeps at our feet. While we were learning to love the wolf that became the dog, we somehow learned to hate the wolf that stayed the wolf. I hope this will change. If we despise the wolf, we despise the true nature of the world in which we live. And our planet's health depends upon recognizing that we face the same biological constraints as the wolf and all other life.

—*Brother Wolf*, Jim Brandenburg, pp. 67, 150

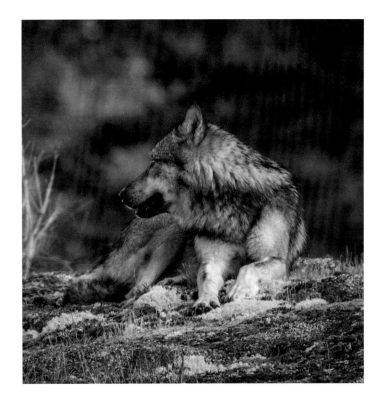

Takaya at rest but alert

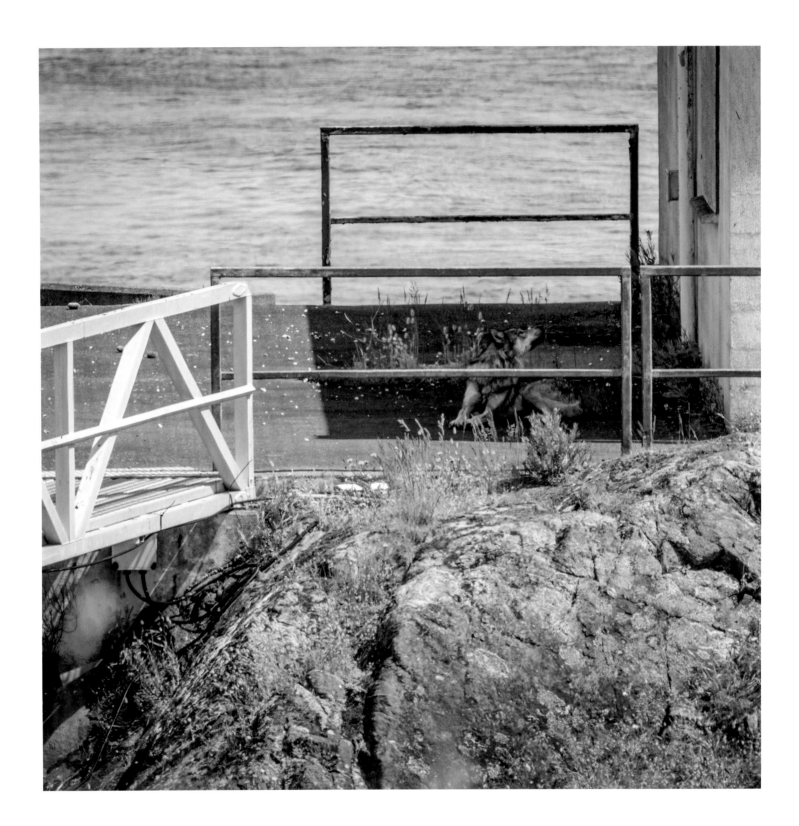

CRISIS

The Chinese use two brush strokes to write the word "crisis."
One brush stroke stands for danger; the other for opportunity.
In a crisis, be aware of the danger – but recognize the opportunity.

JOHN F. KENNEDY

The wolf has just cornered and attacked a family at the lighthouse.

I received this message on my cell from my friend Michael, one of the Island Protectors, just as I was returning from the islands late one afternoon. "What?!!" I thought. "Oh no!"

For the first three years of observing Takaya, I had worked cautiously and quietly in the islands. I had intentionally not publicized my study of the wolf for fear that publicity would jeopardize his safety. But in September 2016, after four years living on the islands without incident, Takaya was involved in an event that would highlight his precarious life so close to humans.

I immediately turned around and headed for the Discovery Island Park campground. What had Takaya done?

Two men and two children around 8–10 years old had visited the islands in a small boat. They had brought their dog (some reports indicate it was two dogs) with them — but dogs had been banned from the island ever since Takaya's presence became known to conservation and parks authorities. During a hike, these visitors encountered the wolf. They were afraid, uneducated about wild wolves, and weren't sure

what the wolf would do, so they retreated to the abandoned lighthouse on the island and climbed on top of an old foghorn building using a vertical ladder they'd found on the wall. They would have had to carry the dog up, too. Takaya remained in the area, so they were afraid to come down. Using a VHF radio, they called the Coast Guard for help.

I can just picture a perplexed Takaya below the lighthouse building, gazing up and wondering why a dog was now on top.

Staff of the Joint Rescue Coordination Centre reported that the people issuing the distress call claimed they were "stalked by a wolf and made their way to the lighthouse, and climbed on top of the foghorn building of the lighthouse to escape it."

The Coast Guard sent the nearby MV *Charles*, a large vessel, to assist. It was a rather dramatic rescue conducted by armed fisheries officers who went ashore in a large Zodiac.

Takaya lies on the porch of the foghorn building, looking up at the roof where the hikers waited for rescue

Mike Sheehan, one of the Island Protectors' Description of a Head-On Collision

I have been really lucky in having several close encounters with Takaya and although there is an initial feeling of apprehension, that feeling quickly subsides within seconds as it becomes immediately obvious that there isn't any aggression in his demeanour. The most interesting close encounter was on the campground path. The wind was blowing towards me, I rounded a corner and Takaya did so about thirty feet away ... he reacted by switching ends quite quickly, looked back at me and then switched ends again and immediately crashed into the bushes and disappeared going in front of me. I didn't react at all, as it happened so quickly, I didn't feel any apprehension whatsoever.

Of the "rescue," the Victoria Rescue Coordination Centre said, "It seemed to go down without incident. The wolf just kind of scurried away."

I've now spoken with two groups of campers who had kayaked to the islands for the weekend and were present when the people with the dog were dropped off at the campground by the Coast Guard after being rescued from the lighthouse. Those rescued were tasked with telling the campers about the incident to warn them about the wolf. They admitted that the wolf had not behaved aggressively toward them; they had simply become fearful because it was a wolf and they had children. Apparently, the park ranger visited the campers that evening, informing the group that this would likely mean a park closure and perhaps a requirement to shoot the wolf.

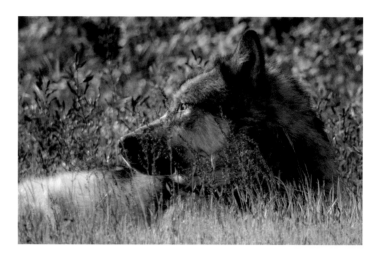

ABOVE Takaya in a bed of wildflowers

OPPOSITE Takaya peering out from bushes watching people pass by

Very quickly, print and television news sources reported this incident. Words used by the press to report on the incident illustrate our ingrained human biases when reporting on a wild wolf, and the need to sensationalize. Phrases like *wolf terrorizes family, people forced onto top of lighthouse, local family rescued after being cornered by wolf* and *threatened by wolf* were accompanied by stock photos of a wolf snarling and growling ferociously. The media didn't show images of the actual wolf, Takaya, or present him as he often is: lying peacefully in the grass or wildflowers.

This was a tipping point for me. For the first time ever, I decided to speak out about the wolf, and about what I'd been doing and learning. Takaya needed an advocate. And he needed the general public to know about him and value him.

I was contacted by CBC and CTV for interviews. I spoke with Chris Darimont at UVic, who agreed that it was time for him to speak out as well.

I took Gregor Craigie, from CBC's radio show *On the Island*, out to the islands. We did the interview in my boat, with Takaya lying peacefully above us on a bluff.

As a result of this incident, conservation officers recommended that BC Parks close Discovery Island and initiate an

assessment of Takaya to determine whether he was a danger to people. The authorities closed the park for a number of months and conducted a wolf-habituation monitoring study to collect information about the wolf's behaviour toward park visitors. It is significant to note that the wolf was observed by BC Parks researchers only once during the two-month monitoring period, even though signs and trail camera data indicated that he was often present in their monitoring area.

I spoke with the BC Conservation Officer Service and was told that the results of the study would determine one of two courses of action: either they would determine Takaya didn't pose a danger and they would leave him alone, or they would use lethal control. In other words, they would shoot him.

Hearing this, I was very fearful, and also angry that our human relationship with wolves is so delicately balanced — that we presume we have a right to interfere in nature, especially based on such limited information and on uneducated human behaviour that had created the situation in the first place.

I have no illusions or romantic notions about Takaya. He is a wild wolf and definitely needs to be treated as such. He is capable of doing harm to humans or dogs given the right set of circumstances. However, to date, his life in the islands has been devoid of any evidence of such aggression. I have observed many instances where the possibility of negative interactions existed, i.e., when humans or dogs came into close proximity to Takaya. His response has always been one of curiosity, watchfulness or hiding.

Takaya's life hung in the balance.

In the end, the study suggested that Takaya did not represent a danger. Once again, the authorities elected to let him be.

I finally was able to take a breath.

To me, it seems that the biggest ongoing risk for Takaya is that uneducated people will habituate him in some way, either by feeling the need to feed him or doing so to attract him in order to see and photograph him. It's also possible that people might once again defy park guidelines by taking dogs to the island, resulting in a territorial attack of some kind. The authorities would then likely decide to destroy him. It is certainly people who pose the biggest threat to Takaya, not the reverse.

It was because of this incident that you are reading this book today, and that CBC's *The Nature of Things* created a documentary film in 2019 about his incredible, improbable

CREATIVE CONSULTANT & EXECUTIVE PRODUCER CHERYL ALEXANDER CO-DIRECTOR & EXECUTIVE PRODUCER MARTIN WILLIAMS WRITER & CO-DIRECTOR MARY MARGARET FRYMIRE
EDITOR BRYAN SULLIVAN DIRECTOR OF PHOTOGRAPHY & ADDITIONAL FIELD DIRECTING MIKE MCKINLAY SOUND RECORDIST GILLES MAILLET MUSIC COMPOSER CATO HOEBEN
EXECUTIVE PRODUCER ANDRÉ BARRO FOR THE CBC EXECUTIVE IN CHARGE OF PRODUCTION SUE DANDO SENIOR PRODUCER GABY BASTYRA PRODUCERS BRUCE WHITTY & KIM BONDI

PRODUCED BY: cineflix TALESMITH mbm IN ASSOCIATION WITH: BBC CBC arte WITH THE PARTICIPATION OF: CMF FMC ONTARIO CREATES creativebc Canada

ABOVE Film poster

OPPOSITE Takaya standing on Camas Bluff with the Olympic Mountains as a backdrop, one of his favourite morning outlooks

A Dissolving Wolf

Michael Blades, one of the island protectors, reflects on some of the encounters he has had with Takaya:

I have been very lucky and had some wonderful close encounters, the most memorable are those on land, although from the boat is also amazing. For me the on land has a dual aspect … I don't have a Walt Disney concept of the wolf … part of me would like to believe that he recognizes me by sight, smell, sound and that I am not a threat nor a meal. On the other hand, I recognize he is a wild animal, and examining his kills makes me appreciate that all the more. So, when I am walking by myself, I always carry my walking stick, have a knife handy, and carry the small air-horn I have for the boat. However, when I have, on occasion, turned and there he is, just behind the trees, say, 15 feet away, fear has never entered my mind … It has always been wonder. Those few very close encounters have never lasted long. Usually we make eye contact and then he ever so slowly turns and dissolves. I'm left with a sense of amazement at the moments of no thought, just being there. A privilege to have the uncontaminated experience, alone.

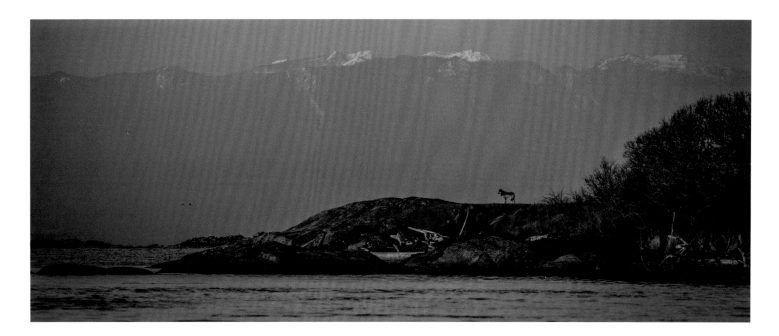

existence. I decided to tell his story in the hope that the more people who know about him and value him, the more protected he will be.

Takaya's continued safe existence on the islands is reliant on the compassion, acceptance and understanding of people to accommodate the coexistence of a wild predator amongst us. People must value him — and leave him alone.

I reflected on the lighthouse incident for many weeks afterward. Why had Takaya followed this group of people to the lighthouse? Is it possible he was just lonely? Had he simply been curious about these new visitors?

I had just found Takaya with a large seal kill the day before. It didn't seem likely that he was wanting to attack out of hunger. Could it be that he was inquisitive as to the dogs' presence? It is highly likely that he was either acting territorially or was simply curious and maybe interested in the presence of something resembling his own kind. After all, by this time he had been alone without the company of another wolf for over four years.

If one day we have to choose between keeping the park closed or killing the wolf, obviously we should all push to keep the park closed. Even kayakers and SISKA [South Island Sea Kayak Association] members seem happy with the current situation, as it's still okay to stay on the beaches.

—email communication from a member of the *Islands Web*

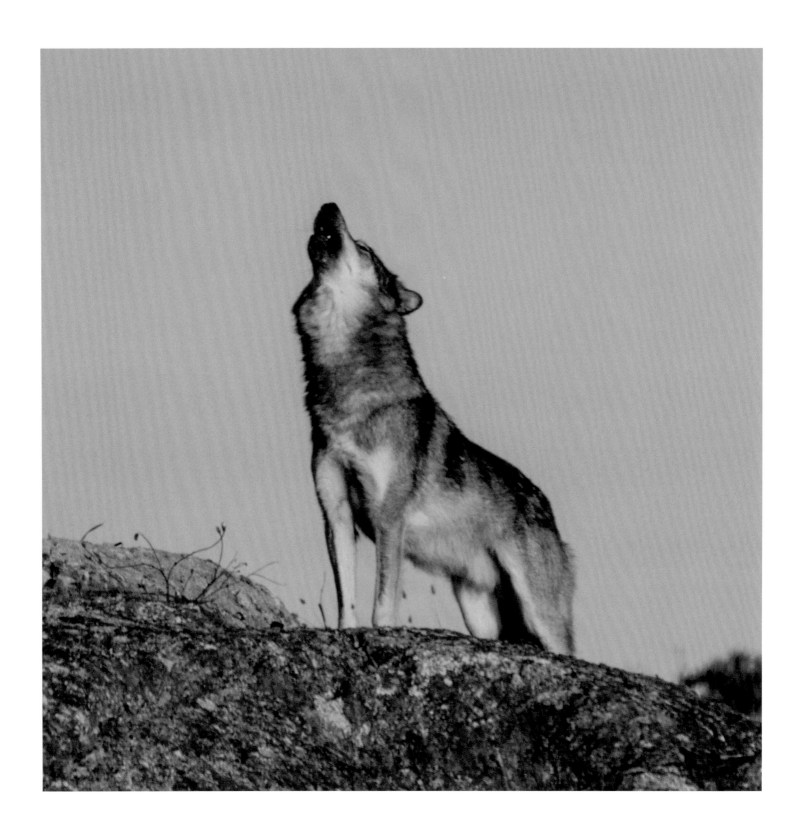

COMMUNICATION

I wonder how much of the day I spend just callin' after you.

HARPER LEE

Takaya's howls tell me that he is trying to communicate with someone out there, but who?

I had often heard Takaya howling, so I was determined to figure out what it meant. Sometimes it seemed that he howled after he had caught and killed a seal. At other times, his howls sounded lonely and mournful, perhaps an expression of what he was feeling.

In order to understand more about Takaya's howls, I invited the leading expert on wolf vocalizations out to the islands. Fred Harrington, an animal behaviorist from Mount Saint Vincent University in Halifax, has studied wolf howls for many years. Over time I had recorded many of Takaya's howls, and asked Fred to help me translate them.

Fred explained that howling is a long-distance means of communication and that it serves to hold the wolf pack together. But Takaya doesn't have a pack, so why howl?

Typically, Fred explained, lone wolves will not howl. Instead, they try to keep a low profile as they move across the landscape, as they're potentially in the territory of other wolf packs. By howling, they would draw attention to themselves and this might be dangerous. Therefore, they move quietly.

Takaya, though, has found his own territory and his howling demonstrates that he is confident and feels in control of his area. It belongs to him.

Takaya most often issues what Fred calls a "lonesome howl." This long, plaintive-sounding howl is very powerful, and when I hear it, I am often moved to tears.

Takaya is unmated, and it seems he's calling for someone. Fred Harrington hypothesizes that after all these years of being alone, Takaya is likely still hopeful that another wolf will hear him. Perhaps, like other animals, he doesn't really have

OPPOSITE Takaya howling

ABOVE Recording Takaya's howls from my boat

Everyone who first hears wolves howling in the wilderness is deeply moved. Many people cry. The sound seems to touch our soul, something deep within us. A mixture of awe, joy and fear. I'm grateful that I can share this sound with other people. I look into the eyes of those hearing a wild wolf for the first time and know that we are all still connected with nature, however dependent our lives are on technology.

—*The Wisdom of Wolves: How Wolves Can Teach Us To Be More Human*, Elli H. Radinger, page 73

Fred howling to see if Takaya would respond

I imagine OR7's howls might have been the loneliest sound in the world. After all, he'd been without family or mate or even companion for well over a year.

—*Wolf Nation*, Brenda Peterson, page 184

a sense of the passage of time, and just wakes up each day with renewed hope and desire.

I hear Takaya howling throughout the year, but he seems to be especially vocal during the winter months. Typically, the period between December to March is a wolf's mating season. During these months, his long howling sessions can go on for up to three quarters of an hour or more, with at least ten separate howls. Sometimes he howls standing, sometimes sitting, and sometimes even lying down with his head slightly raised. And Takaya howls at all times of the day and night, in sun, rain and fog.

It is certain that the howl of a wolf evokes a longing and a deep connection with the primal spirit of our past, and reminds us of our connection with nature and the Earth.

The lonesome howl is the most common one I hear from Takaya, but one day I heard something very different. Dave and I were picnicking in the park and Takaya was nearby but unseen, in the forest. Lonesome howls drifted over toward us on the wind. Suddenly, the howls became deep and growl-like. They were rough sounding, punctuated by low woofs at the end. It sounded like there was a lion growling in the woods!

A couple of hikers, oblivious to the presence of a wolf nearby, were walking toward the area where Takaya was hiding. This was the first time I'd heard what I later came to understand was a warning howl. He may have been warning the hikers to stay away, as perhaps he had a fresh kill nearby, or

The day is done, and the darkness
Falls from the wings of Night,
As a feather is wafted downward
From an eagle in his flight.

I see the lights of the village
Gleam through the rain and the mist,
And a feeling of sadness comes o'er me
That my soul cannot resist:

A feeling of sadness and longing,
That is not akin to pain,
And resembles sorrow only
As the mist resembles the rain.

—*The Day is Done*, Henry Wadsworth Longfellow

he may have been warning us that they were approaching.

Wolves rarely use woofs or bark-howling, but when they do so, it is primarily as an alarm signal. Woofs are similar to human whispers, and are often used in warning or defense. A wolf will use a warning howl to warn pups and pack members that humans or some other threat is approaching a den or rendezvous site. They will also bark-howl to show aggression in defense of the pack or territory.

The next time I heard Takaya do this was rather remarkable. Over time, Takaya had become very comfortable with my presence and would often lie peacefully nearby. If kayakers approached, however, he would get up and hide either in the long grass or in the woods nearby. Upon their departure, he would return to the open and lie back down again.

This one particular time, however, he did something very different and very startling. I had anchored for a happy-hour picnic with friend Anna, two of my daughters (Maia and Alexa) and my 6-month-old granddaughter Dana. Takaya lay relaxed on a low ledge just above us. Suddenly, responding to something that we humans couldn't yet hear, Takaya leapt up and darted behind a nearby bush. Before long, we could hear and see a group of seven paddlers coming around a far-off point.

Then Takaya did something unusual. As the kayakers neared my boat, he lunged out from behind the bush and began loud bark-howling and woofing. He was obviously not happy with their presence. As they surrounded my anchored boat, his alarm and warnings became even stronger. He continued this for several minutes, until the paddlers left. As they paddled away, Takaya followed them out onto the point, delivering a final woof as they paddled past. Then he returned to the ledge above us and lay calmly back down.

It seemed as if he was warning us ... or perhaps protecting us. Was he reacting due to the presence of our small baby, which perhaps fuelled his protective instinct? Wolves are known to be very protective and sensitive to young.

I have now experienced Takaya doing this same thing a number of times. It has occurred both when I've had my grandchildren in the boat when we are approached by kayakers, and it has happened when I've just been alone.

Although I am unsure about his motivation, it is a very moving experience. Wolves bark-howl to alert their pack to danger — and sometimes he seems to be alerting me.

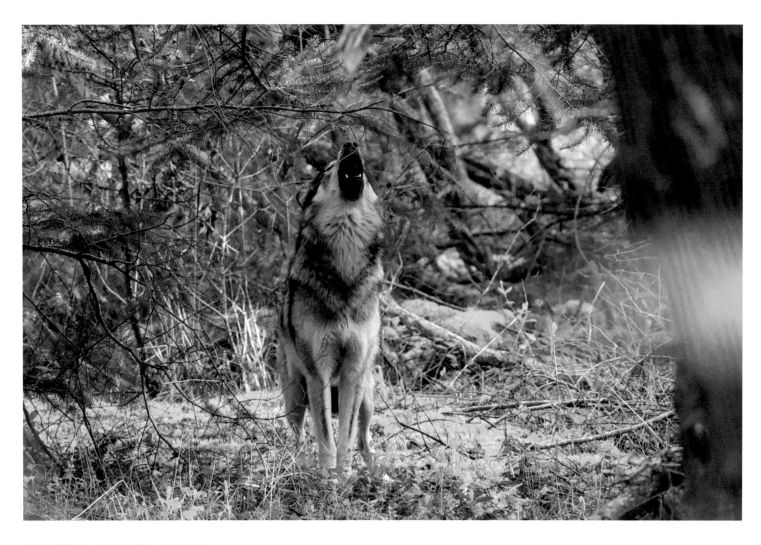

ABOVE Takaya bark-howling a warning

OPPOSITE Robert Bateman, Birgitte Freybe, and Bristol and Libby Foster look for Takaya with me

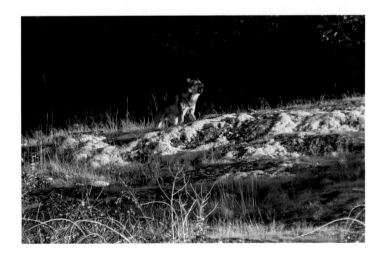

A Silent Witness

In the mid-1980s I co-taught environmental studies with Bristol Foster, a world-renowned scientist. He was head of the Royal BC Museum at the time, and founded the Ecological Reserves Program of BC. Through Foster, I have recently met his best friend, Robert Bateman, one of Canada's pre-eminent naturalist painters. In his art, Bateman often highlights the conservation issues related to humans and wildlife. Of wolves, he says:

> In spite of all the stories and research about vocalization in wolves, they are almost always completely silent. This is, of course, essential for their way of life. They move very quietly through the forest so that their prey would not be aware of the danger in the vicinity. Wolves face dangers as well from their only serious predator, man. Wolves who are not normally silent would be either very hungry or very dead.

I wondered if Robert Bateman might be interested to paint Takaya. This resulted in a trip out to the islands with him and Foster, as well as their wives, Libby and Birgitte. Unfortunately, Takaya did not appear for us, and because Robert Bateman likes to photograph each animal he paints, he hasn't yet created a portrait of Takaya. I remain hopeful that one day he may immortalize Takaya in one of his stunning paintings.

OPPOSITE TOP Takaya bark-howling at kayaker

OPPOSITE MIDDLE My granddaughter Dana greeting Takaya

OPPOSITE BOTTOM Takaya bark-howling at the group of kayakers who had surrounded my boat

ABOVE After successfully warning the kayakers away, Takaya lies down above us again

SURVIVAL

Survival, in the cool economics of biology, means simply the persistence of one's own genes in the generations to follow.

LEWIS THOMAS, AMERICAN PHYSICIAN AND AUTHOR

For me, one of the most poignant aspects of Takaya's situation is his state of aloneness. I feel sad that he doesn't have a mate and the company of other wolves. I also really regret that his seemingly excellent, adaptive genes won't be passed on through any offspring. Mixed in with this sadness is a deep admiration of his ability to survive alone. I've watched Takaya live his life without a single other creature to count on, and he is brilliant. But he also is getting older, and I worry that survival will become more challenging.

He's been alone already for almost nine years, and there is very little likelihood of Takaya ever having a companion. The chances of another wolf repeating Takaya's journey through the city are tiny. I wanted to understand why Takaya is alone, what that means for him on a daily basis, and what it might mean as he ages without a pack to support him.

During the last couple of years, I have begun to notice small changes in Takaya. They are perhaps indicative that he is indeed getting older. I began to worry that he seemed to be getting injured a little more frequently. Nothing big, but sometimes evidence of the risky nature of killing a seal or otter appeared as cuts on his nose. Once or twice I've seen him limping. Sometimes now, when he arises from sleep, he seems to have a degree of stiffness in his movements. Arthritis?

And one day I noticed that he was having some trouble howling. He would start and then break off mid-howl, looking like he was having trouble swallowing, his throat convulsing. This got me really worried, so I consulted with a vet I know who works with wolves. Her opinion was that it may be an irritation or a bone stuck in his throat. Alternatively, she said, it could be throat cancer. Fortunately, over the next month, the irritation in his throat resolved, so I assume it was a temporary occurrence, likely from a seal bone.

What does Takaya's future hold without a pack to support him? This question had begun to haunt me.

In order to better understand what may lay ahead for Takaya as an aging lone wolf, I made a trip to Yellowstone Park in the U.S. Yellowstone is legendary as the home of many highly studied wolf packs.

Across America, wolves had been almost completely wiped out by the 1900s. Then, in 1995, they were reintroduced to Yellowstone, using wild wolves from packs in British Columbia.

Wolf watchers in Yellowstone Park

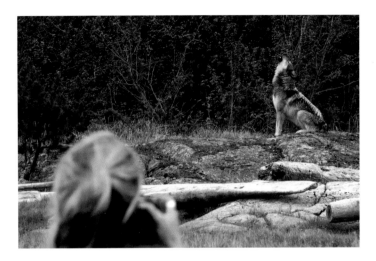

Now there are more than 100 wolves in Yellowstone, in at least nine packs. It is believed that the reappearance of an apex carnivore in this ecosystem has had a positive impact. Before their reintroduction, deer and elk numbers ran out of control, negatively affecting the flora and fauna in the park. With the presence of wolves, the ungulate numbers are more naturally controlled, allowing other species to flourish.

I connected with Kira Cassidy, a research associate with the Yellowstone Wolf Project. Kira has studied the Yellowstone packs for over 13 years, specializing in wolf pack dynamics and aging. It seemed likely that she would be able to help me understand what might lie in store for Takaya based on her observations of how older wolves are treated in packs and the benefits of being part of a pack. This was reassuring to me.

Kira emphasized that pack life is highly significant to the wolf, and an important factor in pretty much everything that wolves do. It's particularly important in the ability of the wolf to hunt large prey like elk, deer and bison, as pack members must cooperate and coordinate their efforts. Takaya, on the other hand, is compelled by his situation to hunt large and aggressive seals without assistance.

Much like us, wolves as they age rely more on their pack. Old wolves lose muscle mass and stamina, and they move more slowly. Their reflexes also change. As Takaya ages he

Getting Old Is Never Easy

While in Yellowstone, I was able to observe a number of different wolf packs and interactions. One particularly poignant event occurred while I was watching the wolves of the Lamar Valley pack. This small group was positioned at the east end of the Lamar Valley, attempting to cross the river there. Only three wolves remained in this pack due to illness and deaths over a difficult few years.

A very famous wolf, 926F (aka Spitfire), the daughter of perhaps the most famous Yellowstone wolf, 06, was leading the two remaining members of her pack (Little T and Dot). She crossed over first. The two younger wolves remained behind, unsure and howling. Looking back frequently and howling encouragement, the older wolf waited for them to cross the river, as well as the nearby road. Even though she had an injured leg, her confidence and wisdom allowed her still to be a competent member of the pack.

In December 2019, Spitfire was shot and killed by a trophy hunter after she roamed beyond the boundary of the park. Her famous mother, 06, had suffered the same fate in December 2012.

LEFT Takaya howling while I listen and document

OPPOSITE Yellowstone's famous wolf Spitfire approaches close during my visit to the park

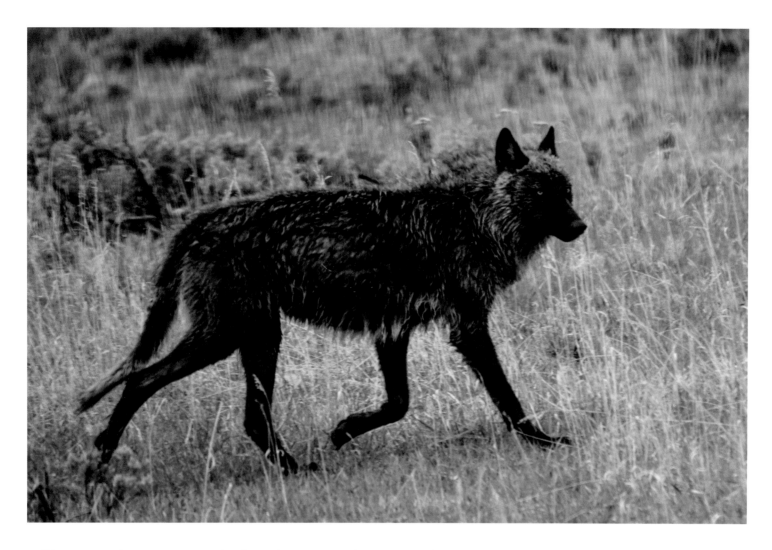

will have no pack to count on, and will need to maintain his physical health and abilities to hunt.

I was stunned to learn from Kira that the average age of wolves in Yellowstone is 3½ years. Physiologically, wolves can live to be as old as a large dog — typically 10–12 years. Wild wolves, however, will rarely live that long. One out of every 100 wolves in Yellowstone will live to 10 years of age.

One of the main causes of death in wild wolves is inter-pack fighting. The second cause of death is being kicked and in-jured or killed by large prey like elk. As well, wolves living in the wild will frequently get hit by cars or shot by hunters.

Takaya has been in the islands for almost nine years and likely left his pack to disperse when he was between 2 and 3 years old, so he's definitely getting up there in age. He may be 11 or 12 years old now. In a way, Takaya's solitary existence has allowed him to live longer than he might have if he was living with a pack and defending a territory somewhere else. Kira thought that Takaya's age was exceptional. The oldest wolf in Yellowstone right now is the 9-year-old alpha female of the Wapiti Lake pack.

Takaya has ended up in a really good place. It's a safe place — a place where he has been able to grow old and more

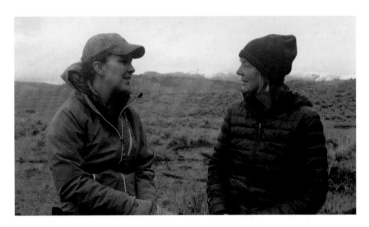

easily survive long term. In his territory there are no cars to hit him, he's safe from hunters, as all lands are protected areas, and his prey cannot easily kick or injure him. At least for now, Takaya still is able to kill full-sized seals and feed well.

And Kira confirmed that older wolves don't necessarily lose the ability to hunt as they age, unless diseased or injured. They will work hard at surviving, right up until death.

One of the things I often reflect on is the fact that wolves have a very rich life of communication in a pack that includes close physical contact. Touch, smell, warmth, company and play are all very much a part of the lives of most wolves living in packs. What must it be like to never have this?

Takaya has lived for many years without any physical contact. I have seen him play with sticks and other items he finds discarded on the island by humans, but he has no one to interact with. I've found old water containers with myriad teeth holes; bite marks on an island poly water line; and a cord connected to a hydrophone for government research completely chewed in two. Perhaps this provides some play-like entertainment for him.

Wolves usually engage in some type of play every day. Takaya sometimes runs and leaps along the beaches, perhaps just for the pure joy of moving, as if in play. But for the most part, play and touch are absent from his life.

Recently I had an experience where it seemed as if Takaya was actually playing with me. I was alone in the islands and the sun had set. I had been hanging out with Takaya for a couple of hours as he lay on a bluff above me. It was getting dark, so I packed up and headed home in my boat. I looked back and saw that Takaya had gotten up and was actually running along the shore after me. I stopped. He ran down to a rock and it seemed as if he would leap into my boat! I kept well back. When I turned to leave again, Takaya repeated his run, keeping up with me as I motored along. I stopped. He stopped and lay down just above me. We kept up this pattern for about a kilometre along the shore. It was getting dark,

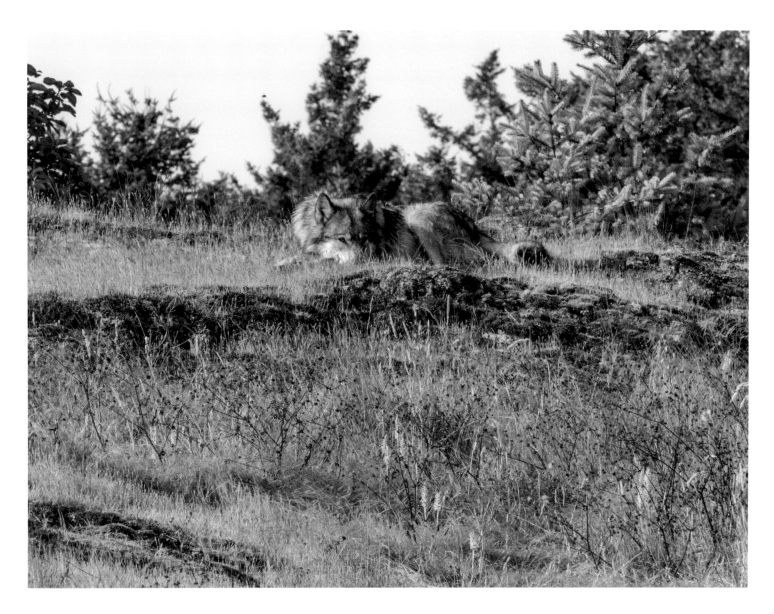

but each time I moved to leave, I would look back and there he would be, running along and following me, zigzagging in and out of trees, lunging up and over rocks along the water. In the end, I couldn't stop laughing at the craziness of it all.

OPPOSITE TOP Kira explaining to me how they use telemetry gear in the Yellowstone Wolf Project

OPPOSITE BOTTOM Kira and I discussing Takaya and wolves aging in the wild

ABOVE Takaya lying on a grassy bluff, ready to 'play'

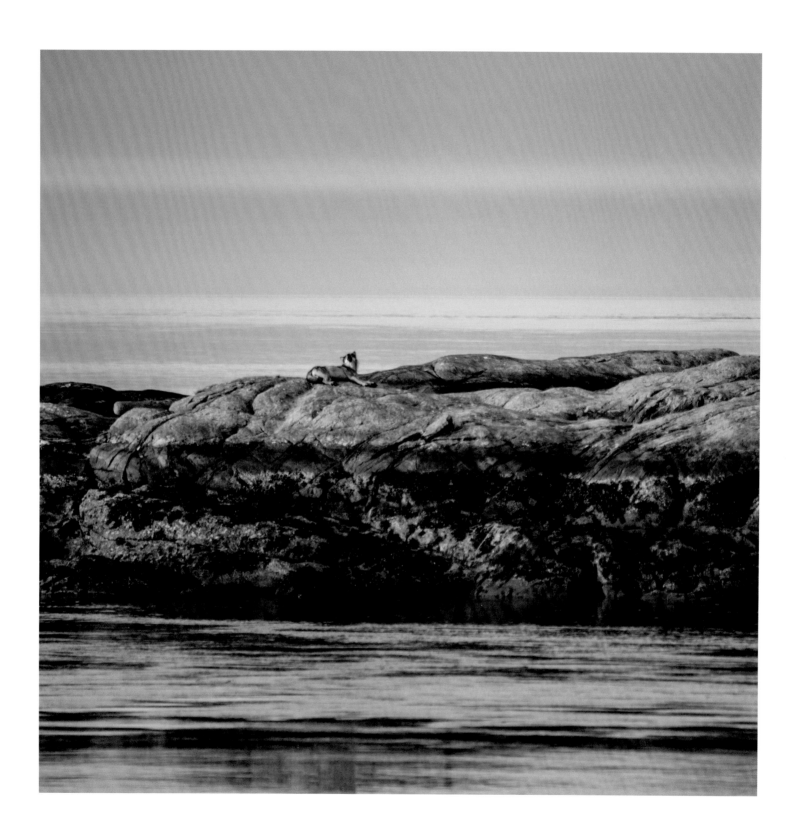

LONELINESS

*Only a mountain has lived long enough to listen
objectively to the howling of a wolf.*

ALDO LEOPOLD

I have spent hundreds of hours in the company of Takaya. There is no doubt in my mind that, after all this time, he has come to recognize and trust me. This is what has allowed me to observe him as he goes about his life. I know that if he were to become habituated, it could put his life in danger, so I always respect his boundaries. If he approaches, it's always by his choice.

I am a passive observer rather than an active participant in his life, and am honoured that he has allowed me in and has given me his trust. Any close contact has always been initiated by him. I sit quietly, simply grateful.

Perhaps, as Kira Cassidy has suggested, I provide, in a way, a little of the social interaction he needs. When I asked her if she thought that he was lonely, Kira replied, "Maybe he's doing exactly what he wants to do. So maybe it's a choice. We should value the fact that he's alone."

For many, the lone wolf conjures up strength beyond measure. The lone wolf is the embodiment of the wild spirit, with the courage and ability to survive alone. The lone wolf is the epitome of freedom: to roam, to seek and find one's place in

Takaya slowly raises his head to howl into the still morning air

the world, ultimately finding a family — a pack of his own.

Animals have deeply emotional lives and display wide-ranging feelings, including joy, happiness and grief. This view has been strengthened and supported in recent years by the work of people like bioethicist Marc Bekoff and ecologist Carl Safina. These two researchers clearly show that wolves have emotional lives, much like us. Sound can carry emotion across species and we can often understand and perceive meaning from tone and frequency. It is clear that words are not necessary to carry emotional meaning. Perhaps this is why the howl of a wolf stirs such emotion in us. So, when I hear Takaya howl and he sounds lonely, it is likely that is what he is feeling.

I hear Takaya howl frequently — long, modulating, mournful sounds. Sounds of longing. Sounds meant for ears other than mine. Sometimes he seems despondent as he barely raises his head from his lying-down position. It is winter now as I write this, and this would be his time of mating. Although my feeling may not be scientifically based, I know for certain that Takaya still waits for — still longs for — a mate.

As Jamie Dutcher said, "What does a lone wolf want? It wants to stop being a lone wolf. It wants togetherness, to be a

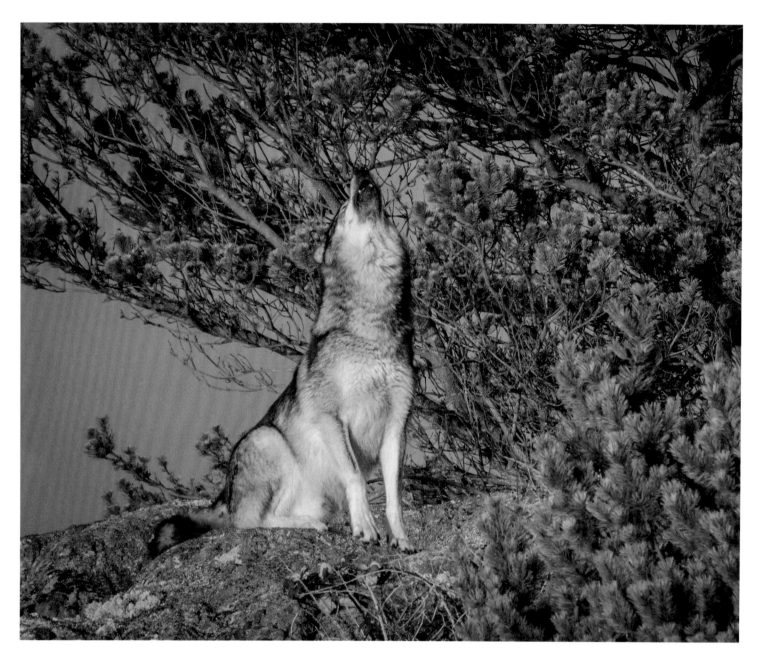

ABOVE Takaya howls into the sunset from a West Chatham bluff

OPPOSITE Another lonesome howl echoes through the isles

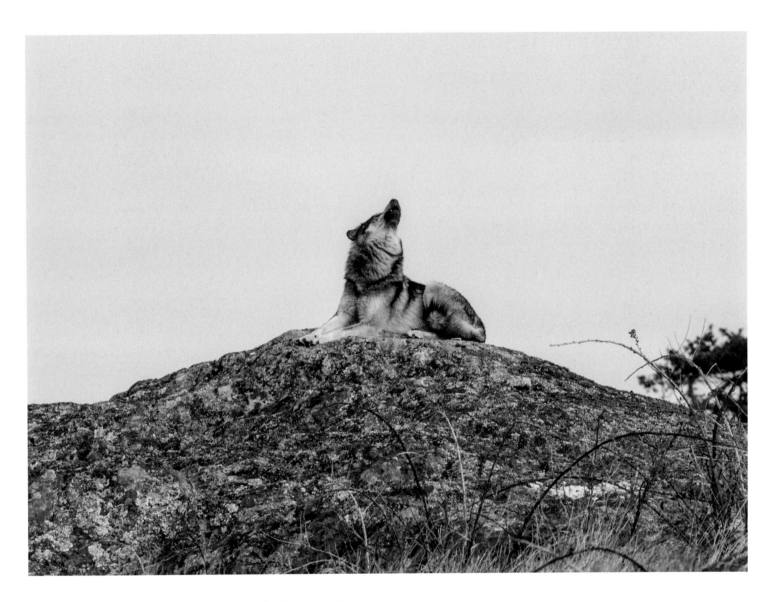

part of something bigger." (*The Wisdom of Wolves*, p. 93)

We'll never know for sure if Takaya feels loneliness, but his lonesome howls tell us that he is still seeking a mate.

As easy as it is to feel sorry for Takaya in his life without a family, though, we shouldn't. He is a wild animal that has lived a long, rich life. And he has given us such a unique opportunity to watch him and to learn from him. To be inspired by him.

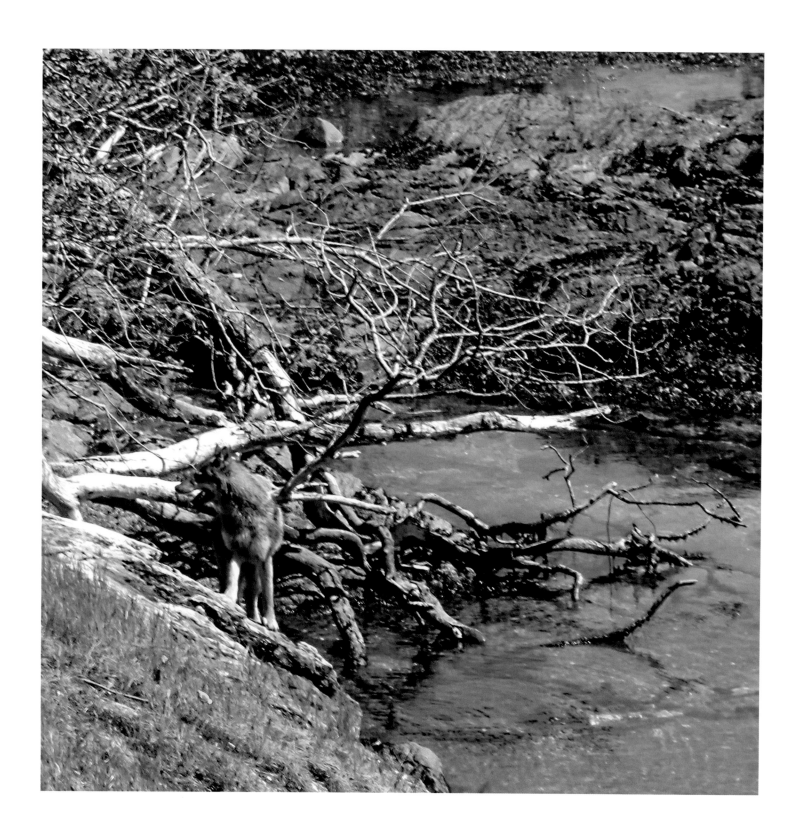

HOPE

*I am ready now. I howl to the new wolf. I put all my strength and all my
hopes into the howl. The echo of it rings from the mountaintops.*

ROSANNE PARRY, AMERICAN FICTION AUTHOR

In the spring of 2019, something quite unimaginable happened. A woman named Lesley Wolfe-Milner, living at the end of the Ten Mile Point neighbourhood just across the channel from Takaya's islands, contacted me by email to report that she had seen Takaya on the shore in front of her house. I was stunned. It seemed that, after seven years alone, Takaya may have decided to leave his island home. Had he finally swum back to the city? It didn't even occur to me that it might not be Takaya.

I spent a restless, sleepless night wondering what Takaya was doing and worrying that he had put himself in danger. I arose at dawn and went to the shore to look for any sign of him. I found nothing. Then, driving home, a wolf crossed the road right in front of me, stopped and looked at me, and then turned and loped down a driveway and into a garden, disappearing from view.

I couldn't believe it. What were the chances of that?

Upon returning home, I opened Lesley's email to look closely at the photo she had attached. After enlarging it I

New Wolf along the southern shore of Ten-Mile Point, just across the channel from where Takaya waits

could clearly tell that it was not Takaya. It was a new wolf.

Against all odds, was it possible that a wolf had finally heard Takaya's howls? And, importantly, could the new wolf be a female?

Based on educational material from the Yellowstone Wolf Project that identifies the difference between a male and a female wolf, it seemed most likely that the wolf was a female. New Wolf was more slender than Takaya overall and had a thinner snout. She also had a smoother forehead, with her nose coming straight down from the forehead, whereas Takaya's forehead is more prominently sloped, with his nose dipping more sharply down. It was primarily this difference in muzzle size and shape that indicated the new wolf was a female. I checked with some of the wolf experts that I'd gotten to know and they confirmed that the wolf was most likely a female — probably a young dispersing wolf.

A second call came from the Hosie family living on Cadboro Bay. While eating breakfast the same day that Lesley had seen the wolf, they spotted a wolf swimming in the bay. Their young adult son, Caleb, knew immediately it was a wolf in the water and not a dog or some other animal. Remarkably, he had loved wolves since childhood and had read lots

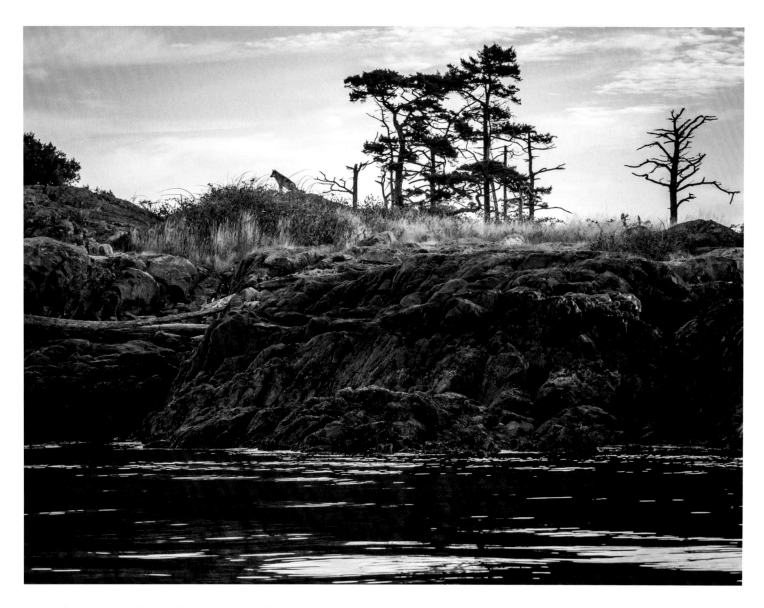

about them. Rob and Brenda Hosie were able to take a video of the wolf getting out of the water on the rocks at their shore and moving rapidly eastward along the point. The wolf was on a mission and didn't even stop to shake off.

This confirmed that New Wolf was in the immediate vicinity of Ten Mile Point for at least a few days. She had also been spotted and filmed a few days earlier while crossing a heavily subdivided area on her way to the southern end of the point.

Serendipity again — a friend of mine was out for dinner and his host mentioned that he'd seen a wolf in his backyard and had taken a video. This video footage showed the new wolf in a tiny, fenced suburban backyard, struggling to get out. After a couple of unsuccessful leaps through the bushes surrounding the yard, she jumped on top of a very high fence, moving like a cat along it.

Somehow, against all odds, a new dispersing wolf had

Male vs. Female Wolves*

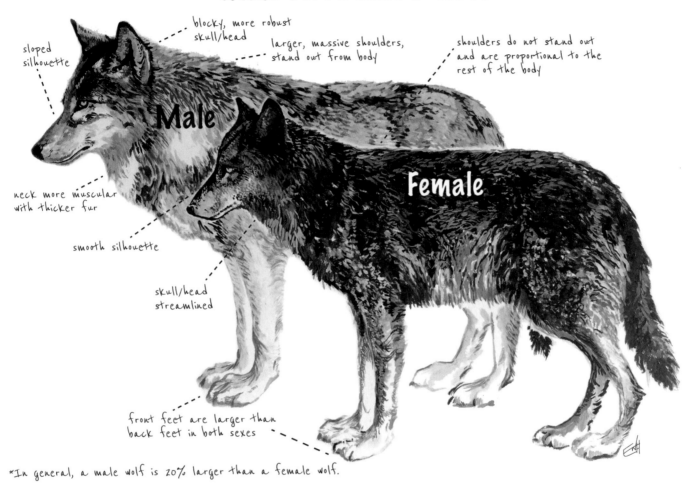

sloped silhouette

blocky, more robust skull/head

larger, massive shoulders, stand out from body

shoulders do not stand out and are proportional to the rest of the body

Male

Female

neck more muscular with thicker fur

smooth silhouette

skull/head streamlined

front feet are larger than back feet in both sexes

*In general, a male wolf is 20% larger than a female wolf.

OPPOSITE Takaya on Camas Bluff, waiting

ABOVE Illustration from Yellowstone Wolf Project showing the differences between male and female wolves. Illustration by Emily Harrington

LEFT New Wolf travels through a backyard in a suburban area of Victoria

arrived, and had very nearly made it to Takaya's islands. How did she know he was there? Why did she, like Takaya, travel through a densely built-up area of human habitation and improbably arrive at the same spot Takaya must have almost nine years ago?

Little is known about how dispersing wolves find each other. They often range over immense areas and yet somehow seem able to connect with other dispersing wolves.

Did New Wolf hear Takaya? Surely the scent marks he had left behind seven years ago would be long gone?

According to Fred Harrington, a wolf's howl can be heard over a distance of 15 kilometres in quiet conditions. If New Wolf was on the outskirts of Victoria, it is highly possible that she might have heard Takaya howl. Perhaps this is what drew her onward.

From the reports of her movements, it feels obvious that she was trying to find him. But what has stopped her from making the final swim across to join him?

Perhaps she became scared by the wide channel crossing necessary to get to the islands. Perhaps Takaya hadn't howled loudly enough or at the right time to guide her across.

After realizing that a new wolf was in the area and might swim across, I went as frequently as possible to the islands. I didn't want to miss it if Takaya was joined by another wolf. Each time I saw him, I kept expecting to perhaps see a smaller wolf at his side.

I even hunted through the surrounding suburban area for signs of New Wolf, thinking that she might be living in the many wooded areas near the point.

Two months went by with no sign at all.

Then, in May 2019, two months after New Wolf had been spotted, I received an intriguing and concerning email from a friend. He'd heard that a wolf had killed a lamb on a small hobby farm in Blenkinsop Valley, a semi-rural area about 10 kilometres away from where New Wolf had first been seen.

This was not good news. There was every likelihood that the wolf that killed the sheep was New Wolf.

I contacted the hobby farmer and received a trail camera video that he'd taken of the wolf returning to feed on the carcass of the lamb. Confirmed: it was the same wolf.

She had travelled away from the point nearest the islands and was now living in a small agricultural area of the city, 10 kilometres away from Takaya. And worse, she was killing sheep. A lone wolf especially will resort to killing livestock to survive. And sheep make particularly good, easy targets. Unfortunately, a wolf killing sheep will often be shot.

New Wolf stayed in the Blenkinsop Valley area for about three months. The farmer sensibly protected his sheep by fencing them, so that source of food was gone. However, the many rabbits and young fawns in the area would have allowed her to continue feeding herself. New Wolf was last seen on the trail cam footage at the beginning of August 2019.

Toward the end of August, a hiker encountered a wolf just a short distance from the Blenkinsop Valley, in the Elk Lake area. A headless rabbit kill was found on the trail nearby. I have received no other reports since then. It was most likely the work of New Wolf.

It would seem that New Wolf is moving farther away from Takaya and his territory. But she may still return. It would not take long for a wolf to travel the 15 kilometres back to the coast. And because it is now the mating season for wolves, and because Takaya continues to howl, perhaps she will hear.

If a young female wolf did join Takaya, I realize that it might prove problematic for a number of reasons. If Takaya and his mate had pups, their tiny territory might not easily sustain an entire pack. Certainly, in the long term, even if the island food resources could sustain a pack, the wolves would need to leave the islands to avoid inbreeding. The authorities might also not be as willing to allow more than one wolf to live there.

In my heart, I hope that eventually New Wolf finds the old wolf. And if this should happen, I believe that nature should be allowed to take its course.

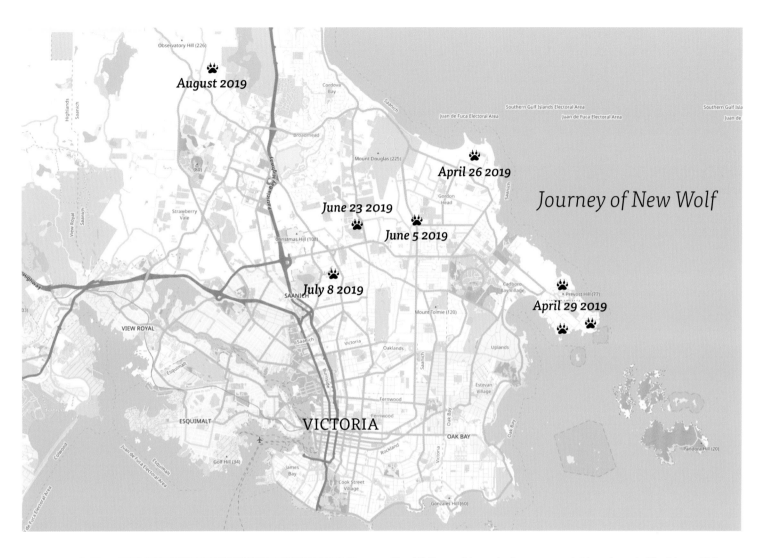

August 2019

April 26 2019

Journey of New Wolf

June 23 2019

June 5 2019

July 8 2019

April 29 2019

VICTORIA

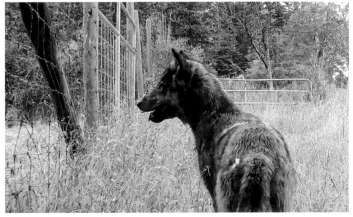

New Wolf, caught on a trail camera, watching sheep in Blenkinsop Valley (a semi-rural area near downtown Victoria)

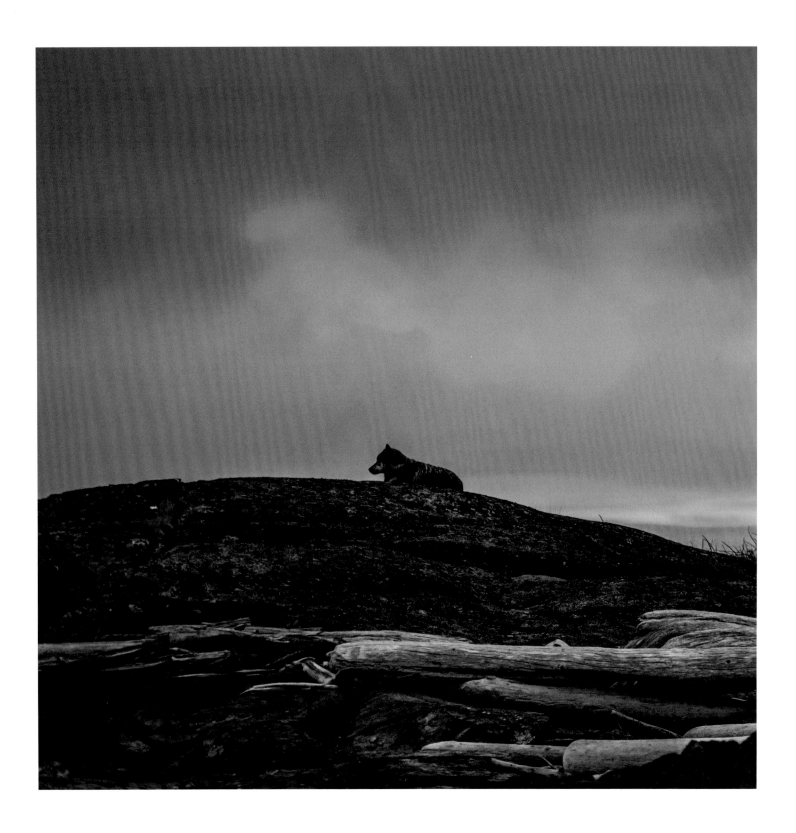

ZEN

Do you have the patience to wait until your mud settles and the water is clear?
Can you remain unmoving till the right action arises by itself?

LAO TZU

Perhaps New Wolf, or some other dispersing wolf, will eventually find her way over to the islands and mate with Takaya. Only time will tell.

For now, I will continue to visit the islands and document Takaya's life and his world. Until something changes and he is no longer there, I will be a silent witness to his remarkable existence — to his strength and tenacity, his resilience, his longing, his challenges and dangers, his peaceful acceptance that he is alone in his tiny kingdom. I will remain an advocate for the right of this wolf to live out his life, free from intervention.

For all of us, Takaya stands as a kind of sentinel at the entrance to the Salish Sea — as famed Canadian artist Robert Bateman so eloquently put it, "silently witnessing the deeds of mankind." Freighters bearing the stuff of humanity move back and forth along the straits surrounding his home; Takaya watches calmly from a rocky peninsula.

His presence in the islands reminds us that wildness and mystery exist still in a world increasingly dominated by humans.

With a backdrop of a city of half a million people just across the channel, Takaya maintains his Zen-like existence.

He continues to patrol the bounds of his island territory and mark it as his own. He swims in the dark and hunts for his food along the shores. His hunts are interspersed with rests high up on grassy bluffs, or in daybeds nestled deep in the forest. His mornings orient themselves to the rising sun, while the beauty of the setting sun guides his entry into night.

And when he feels the need, he howls to the heavens and stars and into the arbutus woods that provide him sanctuary.

Perhaps, just perhaps, New Wolf will hear.

Takaya watches a magnificent sunset from the southern shore of Discovery island

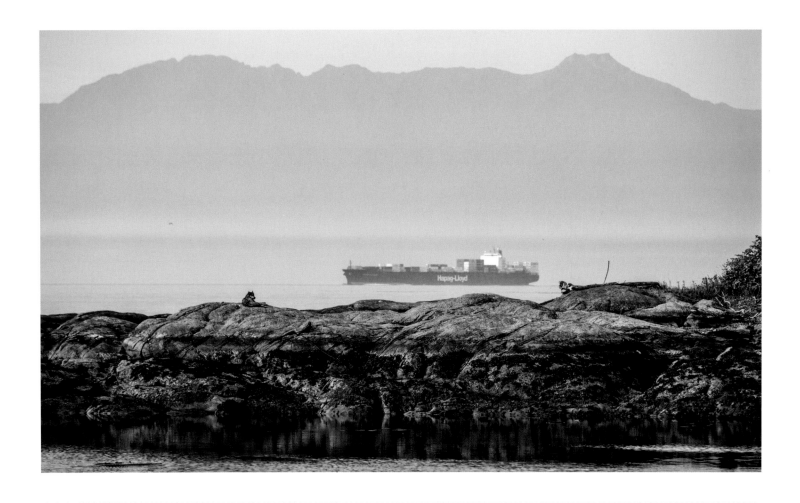

Sentinel

Takaya's islands are located at the junction of the Strait of Juan de Fuca and Haro Strait. His presence in these islands is like a symbolic sentinel, positioned at the gateway to the Salish Sea, one of the most biologically diverse and significant waterways in the world. Seven million people live around the Salish Sea and depend upon the health of its aquatic and terrestrial ecosystems and associated resources. Takaya is a unique representation of the relationship between these ecosystems, his life intricately tied to both. He reminds us that our very existence is also irrefutably bound up with maintaining the biological diversity and health of our ecosystems. If Takaya can survive here, so can we. If he can't, we might not either. Wolves and humans can, and must, learn to live together in our modern world. Protection of habitat is of paramount importance for humans as well as for wolves. And protection of our wild creatures goes hand in hand with protection of wild spaces.

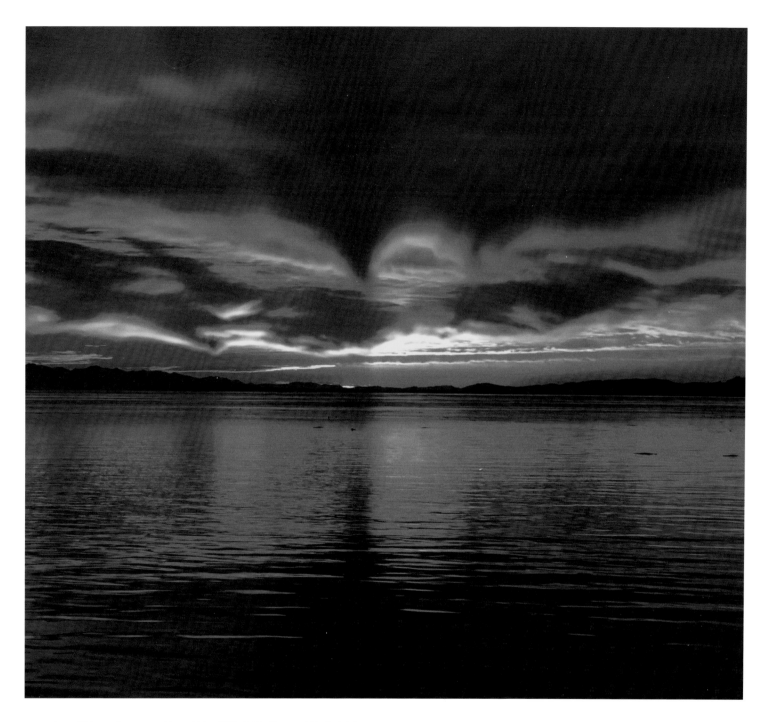

OPPOSITE Takaya lies on southeast tip of West Chatham while freighters
and tankers transit the strait

ABOVE Looking west towards the Pacific Ocean

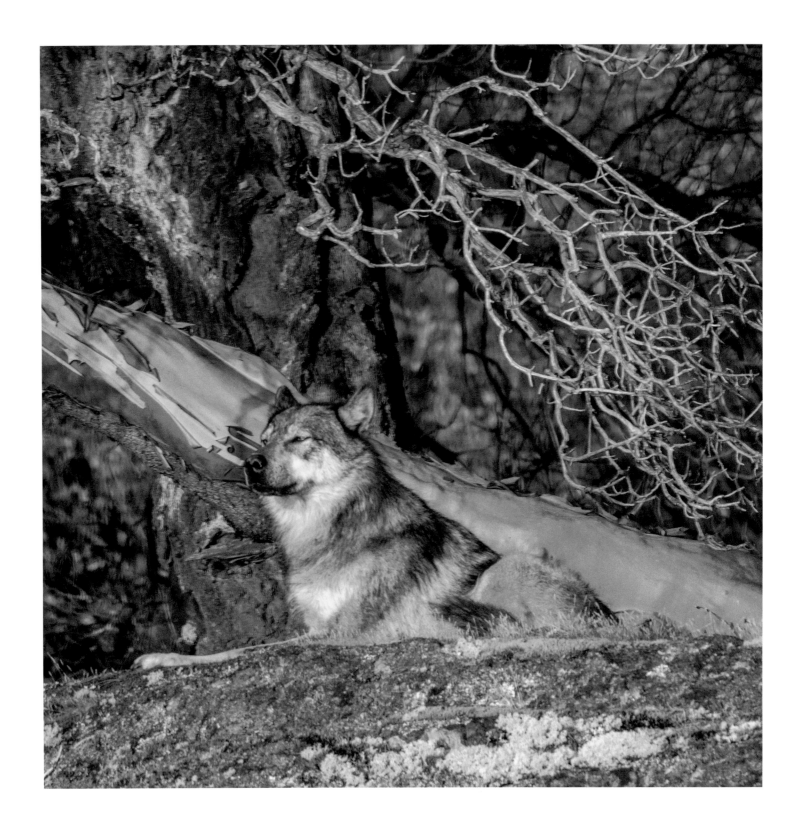

TAKAYA'S GIFTS

Ring the bells that still can ring. Forget your perfect offering.
There is a crack in everything, that's how the light gets in.

LEONARD COHEN

Looking into the eyes of this magnificent wild wolf, I have learned to sit still. I am sometimes alone with him in the lush undergrowth of his island world. It is a world of greens and rusts, a stunning forest of moss, arbutus and rocky knolls.

Takaya glances overhead at the enormous jet-black ravens as they perch in nearby trees, flicks his ears listening to the annoyed caws of crows overhead in the canopy and the deep swoosh of wings as the eagles dive through the treetops, trying to see where he has taken what was only moments ago *their* carcass. The ravens call with low, gurgling croaks followed by a series of complex sounds like knocks and chortles. It's deafening at times.

I've just watched this wild wolf drag a very large seal skeleton, with only the tail and a bit of blubber intact, deep into the forest. These are the remnants of his latest kill. He has dropped it in a nearby glade and circled softly back to lie near me on a mossy rock outcropping.

He calmly observes me, then lays his large head on his paws and closes his eyes, ears constantly alert. I marvel that I've been given this gift of companionship, sitting deep in the forest, alone with a wild wolf.

Takaya remains wild. He has accepted the presence of humans in his territory with patience and grace. He has accepted me, for which I am grateful. I realize that it is a rare and unusual privilege to be able to observe the life of a lone wolf in the wild.

And humans, for the most part, accept and intensely value his presence in these islands. Wolves are awe-inspiring and mystical, virtually embodying the spirit of our quickly vanishing wilderness.

For Jim and Jamie Dutcher, who lived with and extensively studied a family of wolves, they are the embodiment of family. "Wolves can be described in many ways, but above all they are social," says Jamie. "They need each other. As hunters, as parents, as keepers of home territory, wolves succeed as part of a group. They've evolved to live and function within a society. They communicate, cooperate, teach their young, and share the duties of day-to-day life."

And yet Takaya lives alone. He is a wolf with a difference. I feel like he has chosen survival and home territory as the imperative, and yet still searches for a mate, hoping that one will come along.

Takaya and an arbutus tree in the auburn glow of sundown

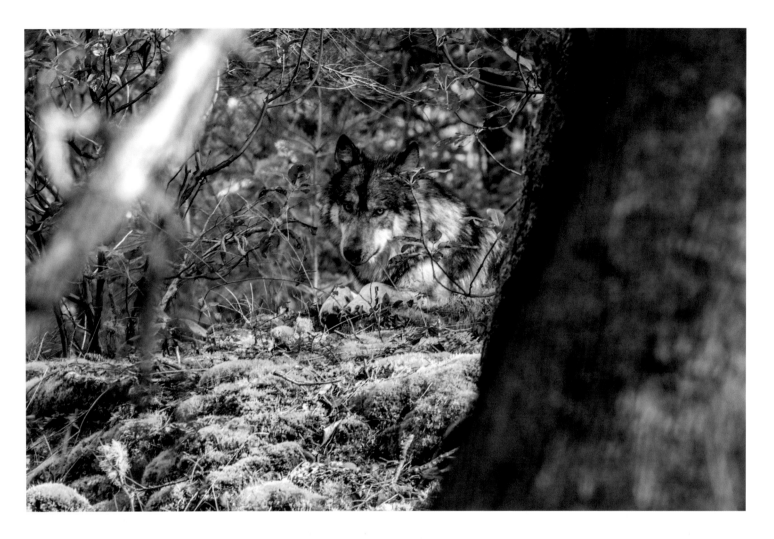

The Dutchers' observations clearly show that wolves have emotional lives, much like we do. So how does Takaya experience his life? He most likely had strong bonds with his natal pack, yet he ultimately had a stronger drive to explore, push the boundaries, find his own territory and, ultimately, to breed. He has unfinished business, yet seems content.

Our lives are richer if we can listen to what wolves like Takaya can teach us. He exhibits the strength of independence, the value of resilience and the capacity to adapt. He inspires with his self-contained acceptance of his solitary life. He shows us how to absorb the beauty around us, and to be simply present.

As our lives become more separated from the wilderness, humans long for a renewed connection with the natural world — with the healing powers, both physical and mental, of forests and other wild spaces. We crave connections with wild animals and value the insights they give us about the functioning of Earth and her systems. They provide a tenuous thread of connection to our past.

People often ask me if I think Takaya is lonely ... and sometimes the answer is yes. But mostly I believe that he is simply living a life he has chosen — that he is alone, yet self-contained.

Whether or not he ever has a family of his own, in a funny

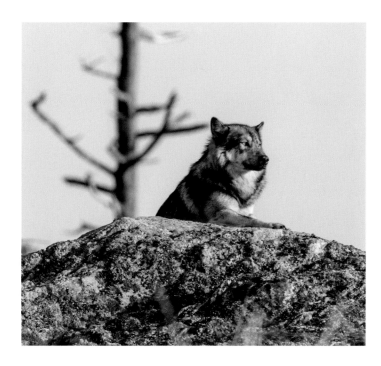

OPPOSITE Takaya circles round to lie near me on a mossy knoll after stashing a seal carcass

ABOVE Takaya, king of his domain

sort of way he is already part of mine. The wolf has changed my life and enriched the lives of my family. My grandchildren are growing up to respect and honour the wolf, and not to fear the "evil" wolf as portrayed in so many fairy tales. They will fight for the wild, and for wolves to remain free.

I have received great solace from Takaya over the years and benefit immensely from his company. Recently I encountered him high on a bluff, bathed in the most brilliant golden light of dawn. It was the day before one of my daughters was to go in for potentially life-threatening surgery, and I was in the islands seeking strength. As I sat quietly in his presence, he began to howl with such poignancy that it took my breath away. Later, when I recounted it to my close friend Zann in South Africa, she replied, "It's almost as if he is taking some of your anguish and releasing it up and out into the powerful holding space of nature."

I am thankful for this moment in the light.

But Takaya's legacy goes far beyond his impact on my life and family. His story may affect the way people think about and value the presence of wild wolves in our human landscape. It is very unique and rare to have a lone wild wolf living in such close proximity to a city. And it is so special because we can actually observe him and get to know a little about the life of a wild wolf. It's a real gift that we have been given, and I hope we cherish this.

Perhaps one of the most powerful gifts from Takaya is the chance to actually get to know an individual wild wolf, an exceptional character, an inspirational one. When a choice is made to kill or cull wolves, it is often made at the population level and fails to take into account that it is an individual — a mother, a father, a child — that is being destroyed.

Looking into the eyes of Takaya, we see reflected there ourselves and our struggles to live and thrive. Brenda Peterson, in her 2017 book *Wolf Nation*, emphasizes that "stories of individual animals must now be told. Hearing the story of one child surviving a tsunami or a refugee finding a homeland is what touches us the most. Not stats and population densities, but characters in stories that very much mirror our own daily struggles to survive."

The story of Takaya is epic, heroic, and an odyssey that ignites our collective imagination and awe. It is a story of resilience, survival and adaptability. It is the story of the possibility of compassionate coexistence. Takaya is a stunning example of the majestic wolf, an icon of wilderness, and the embodiment of strength and resilience. Against many odds, he has established a successful life in an unknown, challenging environment.

Through Takaya's story, I hope that people are inspired and encouraged to find creative ways to coexist with wild carnivores and to protect the wild spaces remaining on our Earth so that wildlife can continue to survive and thrive. Cherish the wild left in the world.

This is the story of a wild animal, alone yet at peace. His is

Lines for Winter

Tell yourself
as it gets cold and gray falls from the air
that you will go on
walking, hearing
the same tune no matter where
you find yourself—
inside the dome of dark
or under the cracking white
of the moon's gaze in a valley of snow.
Tonight as it gets cold
tell yourself
what you know which is nothing
but the tune your bones play
as you keep going. And you will be able
for once to lie down under the small fire
of winter stars.
And if it happens that you cannot
go on or turn back
and you find yourself
where you will be at the end,
tell yourself
in that final flowing of cold through your limbs
that you love what you are.

—Mark Strand

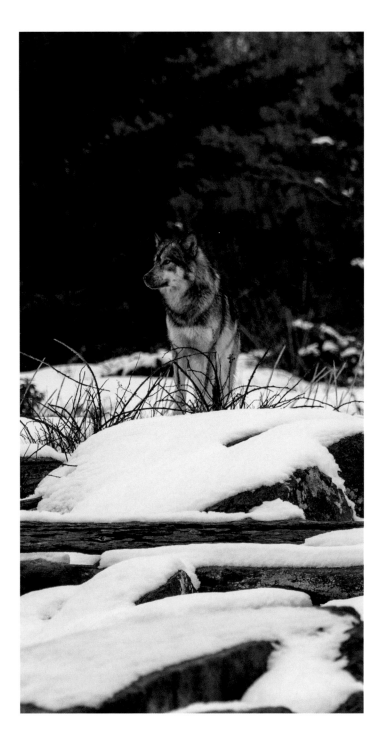

the story of the magnificence of that which is wild. His life
is to be admired, respected, valued. Looking into the eyes of
Takaya, I know that we should pay attention to what he sees.
We have much to learn from this wolf.

It is my hope that people will admire and perhaps fall in
love with Takaya, as I did.

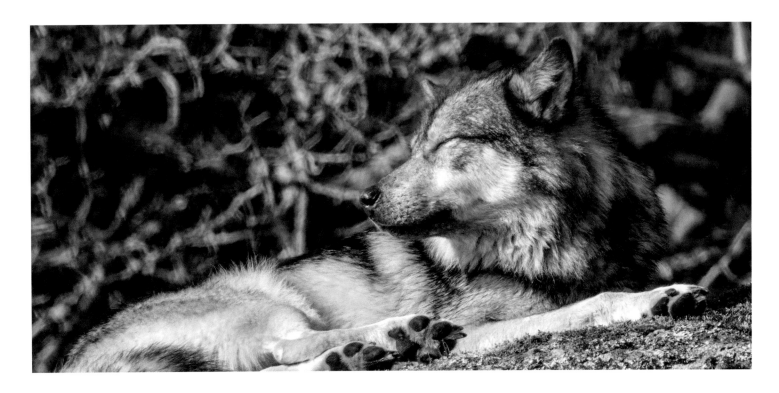

As the (symbolic wolf) shifts and changes, it helps us, giving us insight into our fears, our sense of awe and inspiration. Meanwhile, the physical wolf has its own right to exist for itself, for its place in the family of beings. Its continued existence enriches humans, feeding the symbolic wolf as our cultures shift and change. And, of course, some would dispute that there is any difference between the physical and symbolic wolf. Wolves, after all, are shapeshifters. Who are we to say where the killer whale ends and the wolf begins; where the symbolic wolf ends and the physical one begins; where we as humans end and wolves begin?

—*Wolves in the Land of Salmon,*
David Moskowitz, page 253

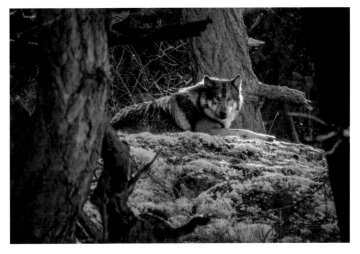

OPPOSITE Takaya during a rare winter snowfall

TOP Takaya rests before his nightly hunt

BOTTOM Takaya beautifully backlit

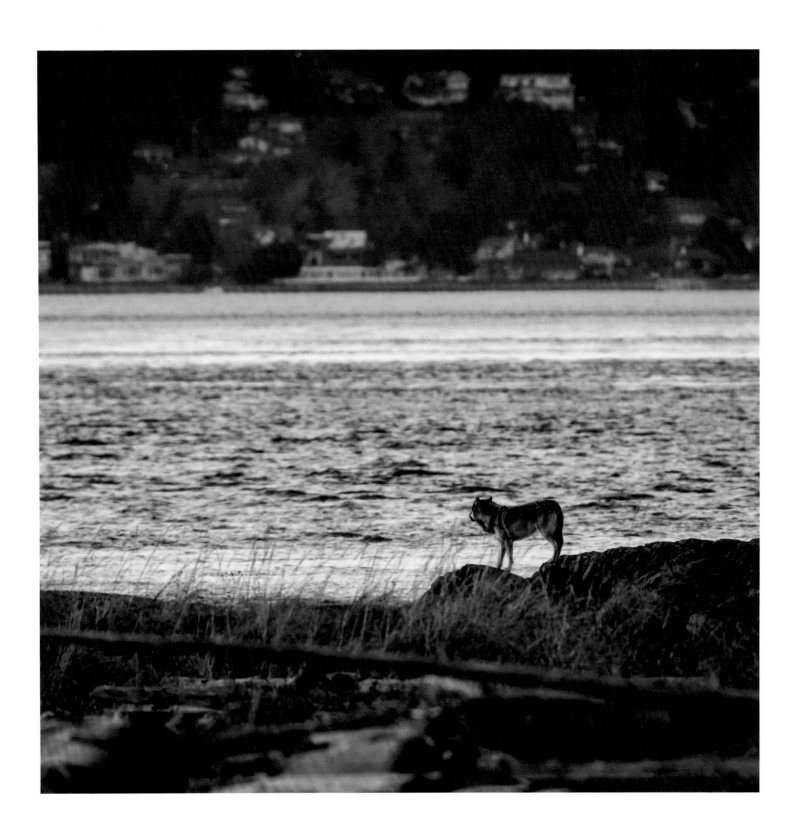

EPILOGUE

He left the shore of his island home, alone. Possibly at dawn. Likely afraid. Perhaps taken by the currents. Certainly on a new adventure — a next chapter in his life.

As he stood on the rocky bluff and looked out across the water toward the city, what was he thinking? He was an old wolf now. Much older than when he scrambled up on these same shores almost eight years ago.

We will likely never know why Takaya left his home.

Here is what happened.

On January 25, 2020 — a Saturday afternoon — I had literally just finished inputting the final edits for this book. It was complete and ready to go to the publisher. Within minutes I received a text from my eldest daughter, Maia: "Is your wolf in James Bay?!"

"What?!" I thought. "James Bay is in downtown Victoria." Takaya's islands lie off the coast of a suburban area about 12 kilometres away from the city centre — a good 20 minutes by car.

Maia then forwarded a text from one of her friends: "I hear your mom's wolf is in James Bay right now. The police are searching for it."

The unimaginable had happened. For some unknown reason, after living on the Discovery Islands archipelago for almost eight years, Takaya had left his home, his island territory. And he was running scared, deep in the heart of the city — a far cry from the uninhabited wilderness that had been his home.

He had been photographed in the city core — a neighbourhood that is home to the British Columbia Parliament buildings, restaurants, tourist shops and a US ferry terminal — running frantically down sidewalks, his tongue hanging long. He looked confused. Yet he still somehow looked confident.

As soon as we heard the report of a wolf in James Bay, Dave and I jumped in the car and drove to the area to try to locate it. If it was indeed Takaya, I thought he might respond and calm if he heard my voice. I wasn't sure what else I would, or could, do.

I later gleaned more details from social media, as well as from people who contacted me directly to report where they had seen him on his journey into the city earlier that morning. He had been sighted in a couple of community parks. He spent time in a friend's fenced yard, being pursued by her dog until he escaped by jumping on top of, and then over, a 5-foot fence. One woman nearly hit him with her car as he crossed a main road. He was seen in an underground parking garage of a hotel. Glancing out from inside her home, yet another woman saw him come right onto her patio and look in through the door. Strange behaviour for a wolf. Exceptionally odd for Takaya.

I was relieved when news reached me that the police had been ordered not to shoot him, but simply observe. He did not seem to be threatening anyone. As the story unfolded in those early hours, I wasn't certain that it was, in fact, Takaya. I found the idea scarcely believable. I imagined that this wolf everyone was talking about might possibly be the young female who had been trying to find Takaya last spring.

It was late Saturday afternoon by the time Dave and I reached James Bay, and the winter light was failing. We couldn't find him in the dark. The police had been told to stand down after

Takaya looks across the strong currents of Baynes Channel towards the city

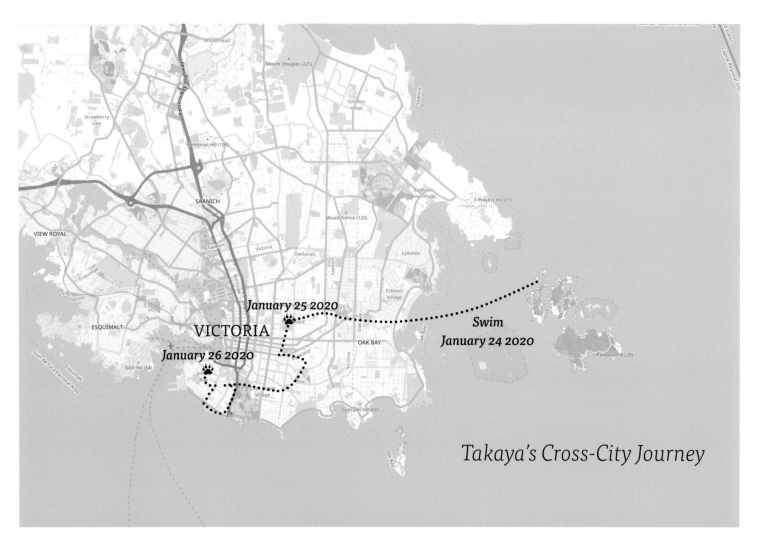

January 25 2020

VICTORIA

January 26 2020

Swim
January 24 2020

Takaya's Cross-City Journey

Takaya running in James Bay; Takaya darts between parked cars;
Takaya almost runs in the door of a seniors centre

no further sightings were reported. They believed that he might have returned to his islands or left the city.

He hadn't.

No further sightings were reported until late Sunday afternoon, when I received another text: "The wolf is on Michigan Street in James Bay right now." I was in my car and heading home after a television news interview. I immediately turned around and drove straight to Michigan Street.

At the same time, I received the frightening news that the police now had orders to shoot the wolf if he appeared threatening. Fortunately, at no point did the wolf behave aggressively toward people or animals, and the police behaved with restraint. Shortly after I arrived in James Bay, I received a note: "The wolf is contained [by police] and they are waiting for Conservation to tranquilize it."

My heart in my throat, I drove directly to the house where the wolf was reported to be contained.

The wolf had apparently been seen running down the street, then up a driveway to seek refuge between a wooden shed and a fence — a space of only about a foot in width. There, he curled up to rest, likely exhausted and afraid. It was here that the police "contained" him, at least five officers standing guard while they waited for the conservation officers who would eventually tranquilize him. The wolf never made any attempt to move or escape. He would certainly have been aware that all those people were near him, but he was clearly terrified, totally exhausted, or both. I hoped that my scent would give him some comfort as I waited on the periphery, where I had been ordered to stay.

After about an hour, the conservation officers arrived. One aimed a long rifle and shot the wolf from 10 feet away.

In my heart I already knew it was Takaya. Earlier, I had watched a video on the news. It showed Takaya running down a sidewalk. The wolf moved like him and looked like him, with the same coloration and defined markings. Standing near to where he was hiding, I actually felt his presence.

Shortly after shooting the wolf, I had unequivocal proof: the conservation officers reported it to be an older male with a broken canine tooth.

It was Takaya. My photographs of his teeth would eventually confirm the identification.

I had asked the officers to please let me see him once tranquilized. I was deeply saddened when they denied me this opportunity. I was not permitted to identify him, to say goodbye, or even to perhaps — briefly — touch this incredible wolf that I had come to know and care for over the past six years. I understand that they were likely preoccupied with the demands of the situation, but one brief moment of compassion would have been enough.

Once he was tranquilized, Takaya was taken immediately to the waiting government vehicle for transport to the provincial vet who was to assess him. I barely saw him as he was rushed down the driveway hanging upside down, surrounded by police, carried by the two conservation officers, and stuffed headfirst into a solid metal barrel. Looking back on it, I feel disappointment and frustration with myself that I behaved in such a typically polite Canadian manner. Instead of pushing through the media and men, demanding to see him, I stood speechless and watched. Me, the carrier of his story.

Yet I recognize that this is my way: to allow; to witness; to withhold from intervening; to observe; to document; to make sense of. I am trying not to judge myself for conducting myself in the same way Takaya has always known me.

But it hurts.

The provincial vet examined the wolf the next day and declared that he was healthy except for his broken canine, and therefore was suitable for release. Although I requested it, I wasn't allowed to attend the examination and to see him before he was relocated. The authorities decided not to return him to his island home. Rather, they elected to relocate him to an undisclosed coastal wilderness environment.

And so, this is how Takaya began the new phase of his life. And I began mine.

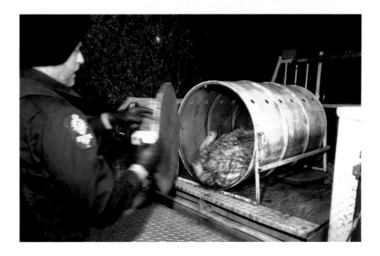

I am grateful to the conservation officers for handling the situation professionally and for demonstrating reasonable care for the wolf. And I am so thankful that they chose to capture and relocate Takaya rather than kill him, as is the current government policy for large carnivores who enter the human domain.

I am less certain that other decisions were made with due consideration of all of the possibilities. I wish that I had been consulted prior to settling on a course of action, as I know this wolf better than anyone. The conservation staff and scientists who were consulted concluded that Takaya had left his island home for a reason, and therefore he should not be returned.

But what if he didn't? We really have no certainty that he left for any particular reason. What if he didn't *choose* to swim away from his familiar shore? Perhaps something was threatening him. Maybe the duck hunter who illegally hunts in the islands during the winter was shooting too close. What if he was swept away by a strong tidal flow as he was crossing from one island to the next? What if he made a miscalculation?

And then: if Takaya *did* choose to leave his island home, what are the possible reasons?

The attending vet believes he was likely driven by hunger. She said that wolves are largely controlled by their stomachs. This seems a possibility for Takaya, as we have just come through more than a month of endless windstorms and extremely high tides, with logs tossed like pickup sticks onto beaches and shores. This may have affected the availability of seals, which were unable to haul out as normal, and therefore not easy for Takaya to hunt. However, he has managed to survive winter and storms for the previous seven years, so

TOP Takaya contained by police as he lies between shed and fence in a downtown yard

MIDDLE Takaya carried by conservation officers after being tranquillized

BOTTOM Takaya put into a barrel for transport and relocation

OPPOSITE Grade 4 children's letters to me about Takaya

I wonder what would be different now? His many kills scattered around the islands over the past few months definitely demonstrated that he was still a competent hunter, even though an old wolf. It is also ironic that I found an entire Steller sea lion dead on the beach just a day or so after Takaya left the islands. It would have fed him for weeks.

In the opinion of Chris Darimont, a researcher at the University of Victoria, the biological urge to mate probably overcame Takaya and he struck out in search of a female wolf. This makes sense in some ways, as the typical mating season for wolves is January or February. However, Takaya had already lived through seven mating seasons. If elevated hormonal levels were going to drive him, wouldn't it be probable that he would have given in to this urge before now, when he was younger and his drive to mate even stronger?

Is it possible that the kindest thing to do would have been to have put Takaya back on his islands and given him another chance? If he had decided to leave again, then we would know.

As it is, he has now been relocated to an area with many potential dangers: hunters, active wolf traplines, other wolf packs who might kill him rather than accept him, cars, bears and cougars. These are not dangers he has learned how to identify or deal with in his protected island life. As well, he has the challenge of being a lone wolf, hunting prey that he is not accustomed to being around, let alone eating. Feeding himself will take new skills. Hopefully an old wolf can learn new tricks!

A more positive way of looking at this is that he now has the potential for companionship and may possibly find a mate. Perhaps this is his chance to continue his strong genes with pups of his own. And significantly, he remains free, and wild. He is a strong, determined and highly independent wolf with a courageous will to survive.

I believe that he will.

Today I travelled back to the islands. It felt the appropriate place to write this epilogue.

It was heartbreakingly beautiful in the islands. Calm winds and seas. Glistening sunlight on the kelp, the intertidal wonders revealed as the tide ebbs. Eagles mating; I hear their cries in muted tones. Yet it seems unbearably silent. Knowing that there will be no howl. No greetings.

Takaya's tracks and the evidence of his life are slowly being erased, helped by the wind, rain and time. The bones and skin of his carcasses will be consumed by tinier creatures than he. His absence is felt in the mewling of the seals as they

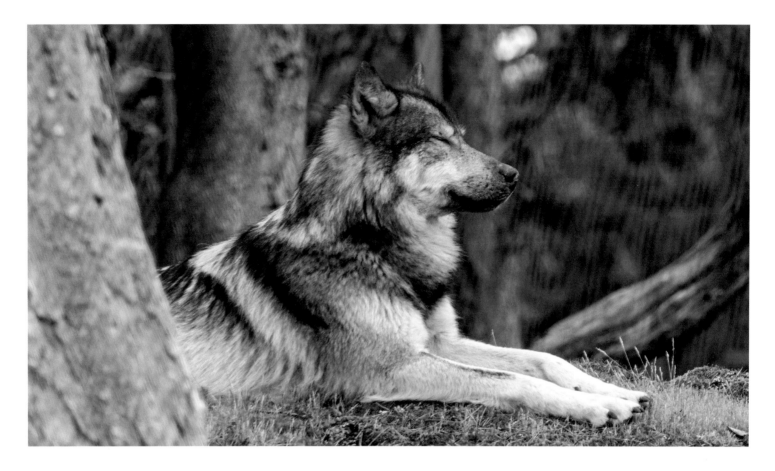

wait, alert, for a predator that will not come. Seals will once again haul out without fear.

The tide is low and the stretches of sand along the shores are an unmarked canvas. No tracks disturb the smooth grey surface. There is no possibility that something wild will pass by, leaving traces of vitality and hunger.

I walked through the trails and saw no evidence that Takaya had been there mere hours before. Each trail junction that used to show his ownership with either scat or scratches is no longer marked. Each of these surfaces awaits the return of the wolf.

How is it possible that the absence of one wild animal can create a stillness that not even the wind and the birdsong can interrupt? What was the energy, the primal force that Takaya brought to these lands? For me, this provides clear and poignant evidence of what we are destroying when we damage our wilderness. There are intangibles that we may never fully comprehend. We are creating a void that the human voice alone will never fill.

Yet I am consoled and encouraged that the legend of this wolf and his legacy will survive despite his absence. Children are learning about his life in school; adults from around the world are thinking about him, and about the insight we've been given into the wild world of a majestic creature. He has brought us closer to our relationship with the natural world. Through Takaya, we have glimpsed the unknown — the divine.

Takaya's story is not yet over.

Takaya, a most remarkable wolf ... Alone, yet at peace

Additional Notes

TAKAYA: LONE WOLF FILM

A documentary film about Takaya and his unusual life was completed in the fall of 2019. In October 2019, the film — *Takaya: Lone Wolf* — aired on *The Nature of Things*, a highly successful science and environmental series on the Canadian Broadcasting Corporation (CBC). It's available to watch online on the CBC Gem streaming service and on the CBC Docs YouTube channel.

In December 2019, *Takaya: Lone Wolf* aired on BBC Four in the U.K. And in March 2020, it was shown on the ARTE television network in France and Germany.

The response to the film has been remarkable and moving. People's reactions have inspired me and given me renewed hope for humankind and our Earth. Some of the accounts have moved me to tears.

Since the film has aired on TV networks, I have received hundreds of notes from people and continue to do so on a daily basis. People have written to me from across Canada and the UK, as well as Scandinavia, the U.S., Japan and Saudi Arabia to express what the film has meant to them. I have even received amazing gifts (a painting of Takaya; a glass art piece with a howling wolf) from those who were so touched that they wanted to make their appreciation concrete. And people have shared with me their own encounters with wolves. A small sample of these comments illustrates how hungry people are for connection with nature and how much they care about the wilderness and wild creatures of our Earth.

This was a profound, informative and yet simple documentary. Factual, in depth, physical, spiritual and emotional. This IS Sunkemanitu Tanka ... the Wolf. Being of Wolf Clan it touched me in ways different and seeing the soul, experiences and wisdom of Takaya reflected in his eyes and dignified demeanor made it all the more poignant. I was honored to meet this venerable elder of his nation, even if just through the media of a film. Wopila to Cheryl Alexander and all those who assisted with the documentation and making of this story. Wopila also to the traditional Owners and Carers of the Land, the Songhees First Nation, on which Tokaya made his home and for watching over him in a good way.

I have just watched the documentary on the lone wolf and I was so moved. It was beautiful but yet so profound. It was moving and yet humbling. Nature could really teach man a thing or too. Your dedication is really the key in all this and god bless on what you are doing.

I wanted to write and thank you for your wonderful documentary Takaya: Lone Wolf. *I watched it last night on BBC4 (I live in London, England) and was totally mesmerised. What a moving and fascinating story, and what a lesson to humankind to observe nature and leave it in peace.*

I just finished watching your documentary about Takaya. It is so moving and inspirational. Thank you so much for sharing your experiences with him. I love the powerful connection you have made with Takaya and the natural world. I feel a similar connection (on a much smaller scale) with the seals that live in the cove where I live on the east coast. I often go out on the water in my kayak as the sun is rising to soak up the natural beauty, and spend time with them. It fills me with peace and joy.

I just watched your documentary on gem.cbc.ca via the Nature of Things. This story was so profound and I wanted to send you a message to say THANK YOU for sharing Takaya's incredible journey!

It will touch me forever. The minute I looked into the eyes of this divine creature I understood your extended quest to commune with Takaya. What a splendid mission ... one so driven

by your heart and deep respect for the Wild. Thanks so much for your labour of love. I'm sure you had many questioning moments if exposing the life of Takaya would be of benefit on all levels ... for him primarily and then for the viewing public. Considering how his story penetrated my being, I'm sure there are many others of like spirit who feel most blessed.

Your film on Takaya probably was the best item I have seen on TV this year! Thank you! I am no stranger to Wolves, as you can see from my pictures attached. One encounter on a canoe trip in Algonquin Park, ON, three images, distance about 10 meters. Sitting in a canoe, my hands were shaking ... Just wanted to let you know that I admire and thoroughly enjoyed your work and totally understand your feelings about your encounters with Takaya. I attach my pictures just to let you know that I understand.

I watched your inspirational program on the BBC tonight. Wonderful and heartwarming. I would love to hear a wolf howling.

Thank you for your incredible pictures and wonderful documentary of this magnificent creature, Takaya. You are very privleged [sic] to be able to get so close to him and interact the way you do. I have had many encounters with Wolves in Algonquin Park and have also looked directly into their eyes. There is no way to describe that soul enriching and penetrating experience! I believe Takaya has reached out to you for some kind of companionship. It was especially poignant when he bark-howled at you to warn you of the plane going overhead — you were one of his pack! And he gives those long, lonely howls when you are sitting so close to him, as if to say — please send this message along.

A second book in this series is planned for 2021. It will explore the impact of Takaya's story around the world and examine the web of interconnections that Takaya, unknowingly, has created.

EDUCATIONAL EFFORTS
Government Organizations

In order to protect this wolf — and people — the BC Parks staff provide educational materials and guidelines for boaters and campers travelling to the islands. They have installed food bins at the campsite to prevent food habituation, and posted signs in the park and at boat disembarkation areas that clearly prohibit dogs on the islands. It is hoped that this will help to reduce the possibility of any negative human / wolf interactions in future.

Non-Governmental Organizations

Three significant not-for-profit organizations are actively working on broader efforts to educate the public, engage in research activities and affect government policy about wolves in BC:

Pacific Wild (pacificwild.org)
Raincoast Conservation Society (raincoast.org)
Wildlife Defence League (wildlifedefenceleague.org)

Some Suggestions for Further Reading

The body of literature about wolves is surprisingly large. I found this out as I began to browse the wildlife sections of bookstores and online sources. My bookcases began to bulge with two new sections and is now a veritable who's who of wolf research and wolf fiction. I hungrily devoured books with research, stories and photographs about wolves. I have accumulated and read more than 60 books and many scientific articles over the past six years. Here is a list of a few that I found most thorough, helpful, fascinating and provocative.

WOLVES

3 Among the Wolves, Helen Thayer, 2004

A New Era for Wolves and People: Wolf Recovery, Human Attitudes, and Policy, Eds. Marco Musiani, Luigi Boitani, and Paul C. Paquet, 2009

A Wolf Called Romeo, Nick Jans, 2014

Among Wolves, Gordon Haber and Marybeth Holleman, 2013

Brother Wolf: A Forgotten Promise, Jim Brandenburg, 1993

Of Wolves and Men, Barry Lopez, 1978

Secret Go the Wolves, R.D. Lawrence, 1980

Shadow Mountain: A Memoir of Wolves, a Woman, and the Wild, Renée Askins, 2002

The Company of Wolves, Peter Steinhart, 1995

The Hidden Life of Wolves, Jim and Jamie Dutcher, 2013

The Homeward Wolf, Kevin Van Tighem, 2013

The First Domestication: How Wolves and Humans Coevolved, Raymond Pierotti and Brandy Fogg, 2017

The Last Wild Wolves: Ghosts of the Great Bear Rainforest, Ian McAllister, 2007

The Return of the Wolf, Paula Wild, 2018

The Rise of Wolf 8: Witnessing the Triumph of Yellowstone's Underdog, Rick McIntyre, 2019

The Soul of the Wolf, Michael W. Fox, 1980

The Wisdom of Wolves, Jim and Jamie Dutcher, 2018

The Wisdom of Wolves: How Wolves Can Teach Us to be More Human, Elli H. Radinger, 2017

The Wolf: A True Story of Survival and Obsession in the West, Nate Blakeslee, 2017

The Wolf Connection: What Wolves Can Teach us About Being Human, Teo Alfero, 2019

White Wolf: Living With an Arctic Legend, Jim Brandenburg, 1988

Wild Wolves We Have Known: Stories of Wolf Biologists' Favorite Wolves, Eds. Richard P. Thiel, Allison C. Thiel, and Marianne Strozewski, 2013

Wolf Country: Eleven Years Tracking the Algonquin Wolves, John B. Theberge with Mary T. Theberge, 1998

Wolf Haven: Sanctuary and the Future of Wolves in North America, Brenda Peterson and Annie Marie Musselman, 2016

Wolf Nation, Brenda Peterson, 2017

Wolf Spirit: A Story of Healing, Wolves and Wonder, Gudrun Pflüger, 2015

Wolfer: A Memoir, Carter Niemeyer, 2010

Wolves: Behavior, Ecology, and Conservation, Eds. L. David Mech and Luigi Boitani, 2003

Wolves in the Land of Salmon, David Moskowitz, 2013

Wolves on the Hunt: The Behavior of Wolves Hunting Wild Prey, L. David Mech, Douglas W. Smith, and Daniel R. MacNulty, 2015

RELATED TOPICS

A Dream of Islands, Philip Teece, 1988

A Sand County Almanac, Aldo Leopold, 1949

A Shimmer on the Horizon, Philip Teece, 1999

A Year on the Wild Side: A West Coast Naturalist's Almanac, Briony Penn, revised edition 2019

Beyond Words: What Animals Think and Feel, Carl Safina, 2015

Day of Two Sunsets: Paddling Adventures on Canada's West Coast, Michael Blades, 1993

Hope for the Animals and Their World, Jane Goodall, 2011

Marine Life of the Pacific Northwest, Andy Lamb and Bernard P. Hanby, 2005

Our Wild Calling: How Connecting With Animals Can Transform Our Lives – and Save Theirs, Richard Louv, 2019

Reflections from the North Country, Sigurd F. Olson, 1976

Songhees, Songhees Nation, 2013

The Collected Works of Sigurd F. Olson: The Early Writings: 1921–1934, Ed. Mike Link, 1988

The Emotional Lives of Animals, Marc Bekoff, 2007

The Inner Life of Animals: Surprising Observations of a Hidden World, Peter Wohlleben, 2016

The Salish Sea: Jewel of the Pacific Northwest, Audrey DeLella and Joseph K. Gaydos, 2015

The Sea Among Us: The Amazing Strait of Georgia, Richard Beamish and Gordon McFarlane, 2014

The Singing Wilderness, Sigurd F. Olson, 1945

The Teachings of Don Juan: A Yaqui Way of Knowledge, Carlos Castaneda, 1968

The Wild in You: Voices from the Forest and the Sea, Lorna Crozier and Ian McAllister, 2015

Where the Wild Things Were, William Stolzenburg, 2008

FICTION

A Wolf Called Wander, Rosanne Parry, 2019

Happiness, Aminatta Forna, 2018

Lone Wolf, Jodi Picoult, 2012

The Dog Master: A Novel of the First Dog, W. Bruce Cameron, 2015

The Wolf Border, Sarah Hall, 2015

The Wolf Chronicles: Promise of the Wolves, Dorothy Hearst, (2009)
—*Secrets of the Wolves* (2011)
—*Spirit of the Wolves* (2015)

Acknowledgements

This has been a wild journey, for sure. And along the way it has involved many people, many animals and many wild places. I am deeply indebted and grateful for it all.

In particular, I have been blessed to share my life, to walk on the *Wildside*, with a true companion and love, David Green. He has made this journey possible, and full of adventure and delight. And, he has graciously accepted my passion for this wild wolf.

My children, Maia, Lara and Alexa, have also walked many wild paths with me and filled my life with much laughter and the force of love. They have put up with my desire to photograph every bit of the wild, including them. And they have been my company many times out in the islands. They have been joined now by three partners, Robby, Rob and Jean-Marc who have added immeasurably to the rich tangle of our lives. And now, the gift of grandchildren to accompany me on my wild explorations. Dana, Elliott and Lila all have watched the wolf with me and especially love to drive the boat. I have the joy of sharing this remarkable experience with the young who will not forget to fight in their future for what is wild. A true "commune," my family have supported me and encouraged me as I've gone in this rather wild, and unexpected, direction. This is what has given me the determination to write this book.

I want to also thank my mommo, Donna, for her ongoing faith in me and support to be different. Her love has always given me strength. She's even been willing to come out with me and sit in thunderstorms, which I love, but which she really isn't crazy about. My sister Jan and two brothers, Mike and Bruce, also enthusiastically have listened to my wolf stories and celebrated my successes.

I am so grateful for the friendship and support of Anna-Lisa Bond. She has been such an intrepid and enthusiastic companion on many of my early-morning or late-evening island

adventures. Together in my boat, we have spent hours looking for Takaya, or just sitting quietly absorbing the island world, the beauty of the light. And each time, we are equally delighted when he appears and accepts our company, giving us the gift of his.

My friend Harriet Allen has also spent countless hours with me in the islands and has shared many of my adventures with Takaya. As well, she provided invaluable scientific advice and connection to the world of wolf scientists. Her serendipitous presence in my life has enriched the whole experience.

To my island companions and protectors of the wolf and the archipelago, Mike Sheehan and Michael Blades, I can't express how much I've benefited from sharing the islands with you. I've learned so much and been challenged and stimulated by all of our many adventures out there. I will never forget that we ascended Mount Takaya together.

Tom Reimchen and Sheila Douglas have been a special support out in the isles and have shared my love of Takaya, as well as generously sharing their vast scientific knowledge. I especially appreciate our conversations with homemade wines and hot rums on cold days.

A special gratitude to my good friend Zann Hoad, who lives in South Africa but has made the long journey over to meet the wolf and did a first review of my draft manuscript. Most significantly, she has given me love and encouragement and invaluable insights.

To all the other island paddlers who watch over the wolf and the islands, and whose presence enriches that world, particularly Torsten and Cathy Broeer, Michael Jackson, Dan Gedosch, Olivier Lardière, Dan Ready, Paolo Ouellet, Peter Northover, Dave Wizinski, and the late Philip Teece and Dave Lock, you are part of the Islands Web.

To my friends who have all shared part of this journey and given me encouragement along the way: Paul Harder and Jutta Kaffanke (for adventuring and wolf exploring together), Sonja and Norm Mcleod, Sal Glover, Stuart Nemtin, Mike Newson, Martha McDonnell, Marcia and John Hills, Sandi Berry, and Julie and Graham Perry. Thank you.

For believing in me, in the value of telling my story and my ability to articulate what I've learned about the wolf, a special thank you to Gaby Bastyra and Martin Williams, who made the film about Takaya a reality. Andre Barro of Cineflix Media, Bruce Whitty and Bryan Sullivan of MBM TV also have been instrumental in the creation of the film. The film has directly inspired and added quality to this book.

For filming and photography assistance I am deeply indebted to April Bencze, Tavish Campbell, Anna-Lisa Bond, Cathie Ferguson, Matt Hood and Mike McInlay.

Joy Davis and Paula Wild have provided really helpful support from an author's perspective.

Many scientists contributed to my learning journey and some have also become friends. In particular I benefited from the knowledge of Jim and Jamie Dutcher, Fred Harrington, Kira Cassidy, Bob Crabtree, Camilla Fox, John and Mary Theberge, David Mech, Chris Darimont and Paul Paquette.

Thanks to Bristol and Libby Foster for enthusiastic support, and to Robert Bateman and Birgitte for being willing to come out to the islands and consider painting the wolf.

Thanks to Paul Nicklen and Cristina Mittermeier of Sea Legacy for supporting this project idea in the early part of my journey.

To everyone at Rocky Mountain Books, especially to Don Gorman, for so enthusiastically supporting this book from the very first moment I proposed it. He has gone above and beyond what I ever imagined a publisher would do in terms of giving me the freedom to create the book as I imagined it. A very special thank you to Alex Van Tol for her skilled editing and warm support throughout the drafting of the manuscript. She is a "wonder woman."

And a special thank you to my daughter Maia, who has been invaluable in the somewhat overwhelming process of selecting images for this book from my large collection of photographs.

If there are errors or oversights in this book, I take responsibility. The book is really a record of my personal journey and accumulated knowledge of Takaya. It isn't meant to be a scientific documentation, and any scientific musings are entirely my own.

Thank you, with respect, to the Songhees First Nation and all Salish Sea Coastal First Nations whose traditional territories provide a home for this wolf, and others who roam here. I am especially grateful to the Songhees Nation for initially fighting to ensure that Takaya remain free and choose whether to stay in the islands or not.

With recognition to BC Parks for honouring the request of the Songhees Nation to not trap the wolf, and for choosing to protect Takaya by investing in education, signage and food storage bins. It is exemplary that they have chosen a route forward that allows for the wolf and the public to continue to use and enjoy the wilderness parkland together.

I want to also acknowledge how fortunate we are to have areas of wilderness left where wild creatures can live and thrive. May we be able to keep it that way! It's important, even though Takaya will never know what he has affected, to acknowledge Takaya and the gifts of awareness and inspiration that he's given to so many. May his life long be remembered and treasured.

PHOTOGRAPHY AND FILM NOTES

All of the images in this book are mine, except as identified below, and have not been digitally altered. All have been taken in the natural and wild environment of the archipelago. Some of the images have been taken from the filmmaking process. Credit is given here by page numbers: Darshan Stevens page 5; David Green page 21; April Benzce pages 23, 31, 74 (top), 136, 156; Maia Green page 24; Mike McKinlay pages 29, 46, 54, 73, 147, 148, 158 (top and bottom); Doug Paton page 40 (top); Tavish Campbell pages 42 (top), 72; Meredith Dickman page 47; Cathie Ferguson page 70; Anna-Lisa Bond pages 87, 102; Kyle Artelle page 107; Lesley Wolfe-Milner page 164; Larry Taylor page 167; Colin Mann page 169; *Times-Colonist* page 182 (left); George and Anna Smith page 182 (middle); James Bay New Horizons Centre page 182 (right).

The film *Takaya: Lone Wolf* can be viewed in Canada on the CBC Gem streaming site or on the CBC Docs YouTube Channel. Canadian rights are owned by *The Nature of Things*, CBC. UK rights are owned by BBC Four. Rights in France and Germany are owned by ARTE. Worldwide rights are controlled by Cineflix Rights, part of the Cineflix Media Group.

CONTACT INFORMATION

I can be contacted at: cheralexander@gmail.com or via my website: www.wildawake.com.

You can follow Takaya's ongoing life in three ways:

Instagram: @takayalonewolf

Facebook: @takayalonewolf

Takaya's Website: www.takayalonewolf.com